MW00812258

INTELLIGENCE FOR DUMMIES
Essays and Other Collected Writings

Glenn O'Brien

PUBLISHED BY
ZE Books of Houston, TX in partnership with
Unnamed Press of Los Angeles, CA

3262 Westheimer Road, #467
Houston, TX 77098
www.zebooks.com

Texts by Glenn O'Brien
Copyright © 2019 The Estate of Glenn O'Brien
All imagery is reproduced with permission,
and copyright information can be found on
pages 330 and 331.

PUBLISHER'S NOTE
Each book in this series brings together in one place
the work of a writer or artist who has some relationship
to visual culture. All rights reserved, including the
right to reproduce this book or portions thereof in any
form whatsoever.

BOOK SERIES DESIGN
With Projects, Inc.
www.withprojects.org

ISBN
978-1-7335401-0-0

246897531
First ZE Books Printing, October 2019

Library of Congress Control Number
available upon request.

Typeset in Janson and Univers.
Printed on 55LB. Rolland Enviro 100 Natural.

Published and printed in Canada

Copyright © ZE Books

Glenn O'Brien and I were friends for forty years. We met when I had started a music company, ZE Records, in New York, and Glenn was writing his New York Beat column at *Interview*. For the first three years, ZE's record sales were scarce, but thanks to enthusiastic cheerleading from music critics, my distributor Island Records kept financing the label. Glenn was our biggest champion.

Our friendship far outlasted the record label. We went on to produce a movie together, *Downtown 81*, shared family holidays, and were present for each other's every important milestone celebration.

Two years ago Glenn—who was visiting me in Houston and reflecting on his life—asked whether I thought he was a good writer. I answered that I thought he was a *great* writer, but that because he worked in so many different and ephemeral

genres—always with the same distinct humour and gently quizzical eye—I did not feel that readers necessarily appreciated the breadth, craft and seriousness of his *oeuvre*. I believe that Glenn was asking me whether I thought his work would be remembered and I promised him then and there that I would do what I could to help it remain in the public eye and develop new fans.

This volume, ZE Books #1, is the result of that conversation. It's a collection of essays, culled from decades of Glenn's magazine articles, musings, and art writing. In one of his final Instagram posts Glenn wrote, "There is so much important writing in the magazines of the past that deserves to be exhumed" and *Intelligence for Dummies* takes this message to heart. I hope this book will bring attention to just how prescient and incisive a critic—as well as erudite, witty, and literary a writer—Glenn was. I hope he'd be proud to inaugurate ZE Books, and this illustrated series of portraits, self-portraits and joint -portraits of authors and artists as they look back upon their careers.

In life, whenever I was planning to branch out sartorially—mixing patterns for a jacket, shirt and tie, for example—I would photograph the combination and text Glenn to check that it was okay. In the same way, whenever I wrote anything—a letter to the editor, an opinion piece or essay perhaps— I would forward it to Glenn for a final polish that he generously provided. This, however, was written without that safety net, and I feel Glenn's absence in my life all the more.

Michael Zilkha, Houston, Texas, February 2019

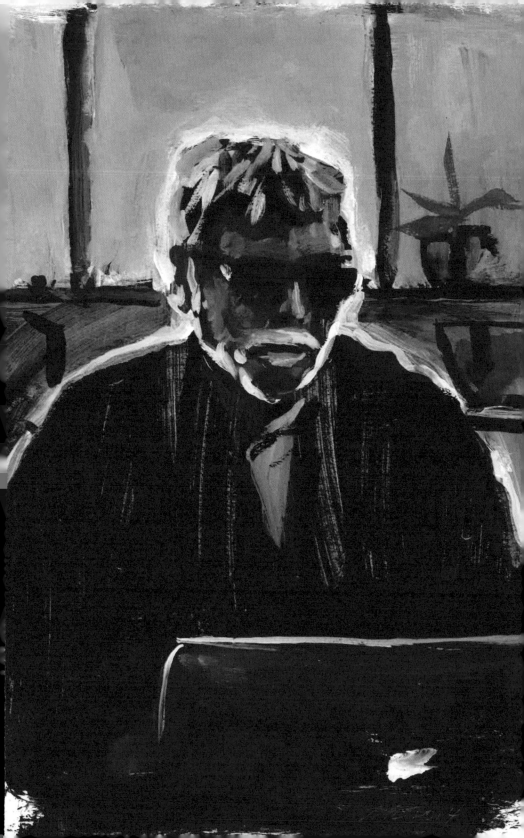

Table of Contents

Opposite: Walter Robinson

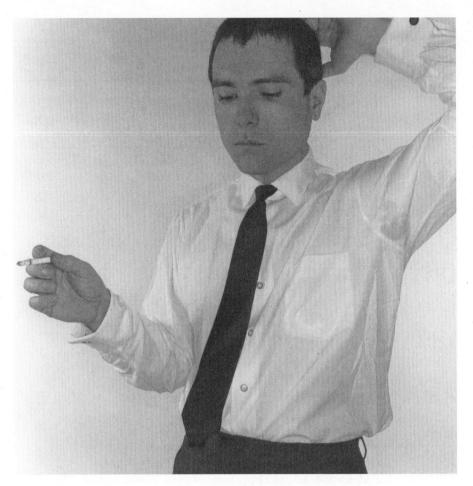

Edo Bertoglio

INTRODUCTION

Glenn O'Brien shouldn't be taken lightly. He'd laugh at
that sentiment (in a sense, this whole collection laughs
at that sentiment). Then he'd quip, perhaps, that in order
not to be taken lightly, he'd have to be taken in the first
place. Except in the sense of having one's picture taken,
O'Brien refused to be. His seminal work was accomplished
not only in the ephemeral medium of slick magazines,
but in nearly every other ephemeral medium or stratum or
atmosphere he could get his hands on: advertising, fashion,
local-access television, friendship, advice, influence, and
gossip. He also excelled at art writing, in introductions for
catalogs and in limited-edition art books. As someone who
often turns his hand to the same task, I can testify that it
is a fantastic way to publish writing that barely anybody
ever reads. In these perverse pursuits O'Brien was inces-
santly productive, leaving the fingerprints of his sensibility
practically everywhere you look, even while maintaining
the aura of a bystander-Zelig, an enabler and witness to
the cultural strivings and exertions of others. He was,
perhaps, the world's most louche workaholic.

I'm trying to work in O'Brien's own style, that of piling up insouciant overstatements that surround and illuminate a cultural area with irresistible insight—it's harder than it looks. What other claims should I make while I'm at it? Glenn O'Brien may be the most important cultural critic of celebrity culture who never accredited his importance (in the sense of attaining status either with official arbiters of literary taste, or with academia). Could he also have been the most important magazine editor of the 1970's and 1980's? These two claims complicate one another. The celebrity culture he dissected mercilessly was the same one he was complicit in creating, at *Interview*, which O'Brien credits—correctly, I think—with inspiring *People*. Therefore, it creates/predicts a whole lot else about the world we live in. So, one of the prognostications we should most credit O'Brien for is that of correctly forecasting his own influence. This puts him in a neighborhood with figures like Marshall McLuhan and Andre Breton, who seem to stand both enmeshed in and to one side of their cultural moment.

At one point in this collection, O'Brien muses on the fact that when he was both writing a column of advertising criticism and creating advertising he was accused of "working both sides of the street". He seems only amused, and faintly irritated, by the suggestion that anything's wrong with this. His career suggests that O'Brien read *The Philosophy of Andy Warhol* (*From A-B and Back Again*) and took its injunctions about the futility of the boundary between art and commerce even more completely to heart than did Warhol. I'm writing this while listening to Lou Reed and John Cale's wonderful *Songs for Drella*, a reminder, along with several of the essays in this collection, of how powerfully Warhol's passive ubiquity shapes the world of O'Brien and so many others (including those my age, growing up in the post-Max's Kansas City punk rock downtown NYC of the late '70's). Just as the quest for a "fifth Beatle" throws up at least four or five legitimate claimants, the question of who was Warhol's most crucial and influential proxy-or lieutenant- creator could be answered half a dozen ways. Has The Velvet Underground changed music more than Billy Name, Gerard Malanga and Paul Morrissey helped Warhol transform the worlds of fine art and independent film? Maybe O'Brien changed just as much, in his way.

The greatest revelation, reading these pieces, is how politically prescient a writer O'Brien was. His 1990 forecast of Trump's presidency demands first notice, but it's his article on Sarah Palin that most scrupulously assesses the coming storm: "The Governor speaks in sententious paragraphs of scrambled, cut up clichés, run-on sentences, and collaged clauses, stringing them together like signal flags flapping from a warship. Palin's words and phrases don't *mean* in the conventional sense. They are not ordered logically, but biochemically, forming a rhetoric of subconscious rhapsody." What's wonderful to consider is how O'Brien generates this perception from within his brief as a commentator on "style"; he's really acting as a semiotician, but one doing groundwork down among the signs and symbols themselves, unafraid of contamination. As with H.L. Mencken, a tonic dose of skeptical contempt for idealists of all stripes reveals itself in his flashes of satirical scorn. But O'Brien, though he's capable of shocking you, is a sweeter-natured writer than Mencken, and there's an undertone of flip excitement, a thrill at what culture or politics might produce next, that's adorable. At times, in this mode, he's like a Mad Magazine for grown-ups.

As a native New Yorker now aging into my fifties, I treasure O'Brien for providing a bridge to a lost world: when, as a teenager, I could run into Johnny Lydon or Nile Rodgers just by getting into the Mudd Club or Studio 54, and when Basquiat and Haring were still drawing on walls and were famous, yes, but only among people more or less their own age. It's a world I can still reconstruct, barely, using clues from my own experience fleshed out by the generosity of a recollector as ingenuous and honest as O'Brien. He may seem, to younger readers in some ways a startlingly dated figure, for his emphasis on a kind of slumming elitism among a tiny number of anointed downtown celebrities, but, really, they were *self*-anointed. In that regard, O'Brien's world isn't completely different from something like a "Blogosphere" or "Twittersphere". In another sense O'Brien's simply anachronistic—his courtliness and dandyism were often as much out of phase as they were in phase, and he remained an outsider-insider, like Warhol himself.

He was also ahead of his time in terms of sexual sensibility—which isn't a promise that he won't offend. His attempts to triangulate hetero horniness with poli-

tesse, and with a persuasive avowal of feminism—plus a genuine interest in, and respect for, actual women—makes him as much an experimenter in possible futures for human masculinity as Robert Bly. The results of such experiments are confusing, comic, and, yes, inspiring. Any "metrosexual" owes Glenn O'Brien a tip of the cap; he's a positive emblem of the exact reverse of homophbia. There are, at least among us coastal elites, now many thousands, if not millions, of teenage boys growing up feeling tormented with guilt at the realization that they're *not* gay. Well, those teenage boys have Glenn O'Brien here to tell them not to feel so badly about themselves, and not to worry: It Gets Better.

Jonathan Lethem, Claremont, California, February 2018

Being Glenn O'Brien

I'm sick of people talking about
"content providers." I'm not
content with content. I want to
be a contempt provider.

Tweet, 17 May 2013

Andy Spade

LETTER FROM BUMFIELDS

This missive is written from my country estate, Bumfields. It's vacation time and I'm out here trying to appear not to be working. I'm vacationing and that means I'm blowing the ballast, kicking decades back. I'm taking my time by the throat. In fact I'm trying to alter my whole sense of time, which is what you're supposed to do when you're on vacation, one day at a time. By listening to Charlie Parker solos and translating the Mayan codices into Gaelic I have managed to travel back to the fifteenth century during naps. I've saved up a lot of thinking to do and I'm doing it in my thinking studio. But I'm hoarding my thoughts until late fall when they're going up for auction, so lately I'm using quotations more and more.

Like, wasn't it Mark Twain who said, "Gossip's sole raison d'être is the maintenance of Judeo-Christian values." Or something like that.

My wife saves her old copies of Italian and French *Vogue*, and I recently came up with the perfect place to store them. There are now six cubic feet of foreign *Vogue* stacked on the powder room commode, which reminds me, didn't Fairfield Porter say, "Why is irrelevancy so often taken for profundity?" I sure think it is. And Fairfield wasn't even aware of the trend of fashion photographers taking themselves for fine artists, something that we're trying to put a stop to up here at Bumfields. Fairfield must be rotating in his coffer. Painting helps, but I think criticism is the key to fighting this fashion problem. Unfortunately, publications today do not permit fashion criticism, except at the *New York Times* where highly intelligent and surprisingly attractive persons with graduate degrees in fashion criminology go to great lengths to find meaning in where the hemlines are drawn.

Why don't other publications allow criticism of fashion? Because fashion brings home the proverbial bacon, Osbert. That's why we are so blasé that it's nothing getting the *New Yorker* with a two page Versace ad that features two five figure hookers on a bed on drugs, one passed out in a garter belt showing her complete ass and the other making goofball eye contact with the reader, as it were, and this is a normal thing, because fashion brings home the bacon. And when I see that the lipstick lesbian lovers in the Dior ads in *Vanity Fair* are now covered in motor oil, I wonder, is this somehow connected to oil spills on the high seas and Greenpeace, or is this just about bringing home the bacon.

This is no real concern of mine, however, because not only am I a close personal friend of the reincarnation of Francis Bacon, I am reading a novel by the great trumpet player, Artie Shaw, who once said "Love is an agreement between two people to overestimate each other."

Fashion victims don't interest me in the least and I'm not really going to concern myself with them unless Prada starts making armbands. As Frank O'Hara said: "Style at its lowest ebb is method. Style at its highest ebb is personality."

The whole point of this vacation is to further hone my personality until it pays for itself effortlessly. Meanwhile I'm going to allow myself the luxury of trying to figure out those Victoria's Secret cotton underwear television ads and what they mean and what the girls in them are supposed to be doing and what we're supposed to think they're doing and what they were really thinking when they were doing them. And shouldn't we be smoking some opium while watching them?

After that I'm going to think about what difference, if any, having a brass putter would make in my life. And is it too late for me to start working on a knuckle ball. And should I maybe watch an episode of "Chicago Hope" or would it be better for me to keep wondering what that title could possibly mean to someone who doesn't live in Chicago. Hillary Clinton used to live in Chicago. Is my hatred of her irrational and consuming or is it healthy and stimulating? Is there such a thing as a female cuckold and can it be cocky? Is it possible that hubris prevents cancer? Why is it that far more women keep diaries than men? Elaine (who was a lot more interesting than Bill if you ask me) de Kooning said that Anne Porter's godmother said, "You have to believe in hell, but you don't have to believe there's anybody in it."

En vacances I'm trying to mix things up in order to possibly rewire the circuits, for example during my annual reading of Laurence Sterne's Tristram Shandy, I'm going to try to listen to Busta Rhymes at the same time. I have 53 *New York Times* crosswords saved up and I'm going to do them nude. I'm hoping that this will synch up my cerebrum with

my medulla oblongata, because Marshall McLuhan's colleague Ted Carpenter, the famous Jesuit advertising creative director, said that it's more difficult to do the puzzle nude.

Which reminds me, should something happen to Dick Cheney (Don Cheney is the basketball coach, right?) wouldn't Bill O'Reilly make a fine vice president of the United States of America, a country with far too few marsupials and decent health care providers. On second thought, give me Tom Clancy any day.

I think that frequent vacations greatly increase one's chances of achieving immortality one way or another. As Frank O'Hara said, "Getting old is not so bad, it's non-existence that hurts."

I'm going to rub my feet in rose oil and clip my nose hair. After that I'm going to take a nap. After that I'm going to make a huge batch of gnocchi using genuine Idaho potatoes and free-range quail eggs and freeze it. After that I'm going to write an open letter to Hillary Clinton about her wardrobe which has been bothering me quite a bit lately. Is that sky-blue suit, perhaps, the prototype for an air force uniform she plans to wear as President? Do you think she would like to meet Bob Mackie? He did wonders for Carol Burnett.

Paper Magazine, 1999

TV PARTY
MEMORIES OF MAKING TELEVISION HISTORY

I spent most of my childhood in Ohio. It seemed like another place I'd heard about: Siberia. We had grand libraries, a famous symphony (that no one I knew attended,) a fine art museum, all the trappings of high culture, but nothing was happening. I knew there had to be more to life. I found it in the window of television.

I discovered wit and intelligence on the talk shows and game shows broadcast from New York. Steve Allen, a clever comic who played jazz piano, hosted

Bobby Grossman

a show featuring his friends, from the most out-
there hipsters like Jack Kerouac and Lenny Bruce,
and comic geniuses who would revolutionize TV
like Ernie Kovacs and Buck Henry, to a host of wild
young comics. And Jack Paar, a bright, emotional
conversationalist, basically invented the civilized
chat show. He brought on famous guests like
the talk shows of today, but he also cultivated a
roster of fabulous personalities such as Jonathan
Winters, Joey Bishop, Mike Nichols and Elaine
May, Shelly Berman, Buddy Hackett, Peter Ustinov

and David Niven, as well as fabulously monstrous personalities like Oscar Levant and Robert Morley.

But more importantly it wasn't all about the star of the new hyped movie selling a product; it was about conversation and wit and it was fascinating. Even the game shows were urbane and witty. The language sparkled. It came through the air from New York. I knew that one day I would be there. Fast forward twenty years to 1978. I was writing a column for Andy Warhol's Interview called Glenn O'Brien's BEAT about what was going on in music and nightlife culture, and a lot was going on. Later it would be called punk or new wave, but back then we just thought of it as life. I also wrote about whatever was on my mind, so I suppose it was a window of weirdness that had a following.

One day a funny girl who was loosely associated with the Yippies, the political hooligans, invited me to come on her public access cable TV show "If I Can't Dance You Can Keep Your Revolution." I thought the show was silly, but oddly the next day lots of people told me they had seen it. People I didn't know came up to me on the subway and said, "I saw you on TV last night."

In 1977 the federal government had mandated that cable television companies provide "public access" to the community. This meant that anyone could have their own show on cable. Public access shows were homemade and amateurish but surprisingly they had an audience. Back then there were only the three big networks and public broadcasting, there was no HBO, no MTV. I realized people were

watching shows like "Tele-Psychic," and "The Robin Byrd Show," a porn star's talk show, and "Wallowitch," a cocktail pianist playing gay show tune telephone requests for an hour. Cable was a campy, crazy alternative to network numbness. A year before, my band had broken up. It was called Konelrad—an acronym for Control of Electromagnetic Radiation—after a network of government radio stations that would come on the air in case of nuclear attack. The idea of the band was Socialist Realist rock and roll, and we did songs like "Seize the Means of Production," "Own Your Own Home," and "Industrial Accident." The idea was to rock hard and be funny and political. I thought, maybe I could take the same ideas and do a new kind of talk show. And so, TV Party was born. "The TV Show that's a cocktail party but which could be a political party."

TV Party was inspired by Hugh Hefner's shows from the sixties, one called Playboy's Penthouse, the other Playboy After Dark. Hef's format was a sophisticated cocktail party. Beautiful Playboy bunnies served cocktails to dapper guys who sat around chatting and casually performing. Cool comedians and jazz musicians like Sarah Vaughn and Nat King Cole performed. It was a glimpse into a totally aspirational, ultrahip world and that's what we aimed for with TV Party.

The network talk shows all had co-hosts, so I enlisted my best pal, Chris Stein, the guitarist of Blondie and boyfriend of Debbie Harry to be my sidekick. The Tonight Show had funny, stylish bandleader Doc Severinsen and the NBC

Orchestra, so I enlisted Walter 'Doc' Steding and the TV Party Orchestra. Walter was an eccentric violinist and painter and worked as Andy Warhol's painting assistant. He also worked as a one-man band, opening for groups like Blondie and Suicide on the C.B.G.B.'s circuit. Walter invited a drummer named Lenny Ferrari to come on the show to play Indian tablas one night early on and he never left, also developing a magic act as his Italian cousin, Luigi Ciccolini. Richard Sohl of the Patti Smith Group was a regular when that band wasn't on the road, answering the TV Party telephone on which we took calls live from viewers at home.

Debbie Harry, Fred Schneider of the B-52s, John Lurie of the Lounge Lizards, Nile Rodgers of Chic, Kid Creole and Coati Mundi (of Kid Creole and the Coconuts), and Tim Wright of DNA were all regular guests. Fred Brathwaite aka Fab Five Freddy showed up and became the "token black," appearing on camera as well as operating one. (A few years later he was the host of Yo! MTV Raps, the first hip hop TV show.)

Jean-Michel Basquiat first came on the show to be interviewed when he was eighteen years old and writing graffiti under the name SAMO©. He loved the scene and became a regular, sometimes appearing on the air, but usually sitting in the control room at the character generator, typing surreal subtitles onto the screen. The show was usually directed in an anarchic style by Amos Poe, the downtown filmmaker known for The Blank Generation and The Foreigner, sometimes by Betsy Sussler, the editor of Bomb Magazine,

and sometimes by Debbie Harry, or Kate Simon. Amos Poe, however, created TV Party's anarchic visual style, which switched from camera to camera to camera in time with the music and directing the camera operators to shoot ears or shoes or crotches.

Often the sound was bad but we embraced poor quality in homage to Warhol's early films. I wanted the show to look like art. Our production values might have been crude, but I preferred to think of it as minimalism. We didn't make it easy on the viewers, which may have been why young New Yorkers loved the show. They loved the psychedelic editing, the dead air, the rude language of the phone calls, the violation of every TV convention.

I invited the coolest people I knew to come to the party every week. I started with my friends, but I also invited people I'd run into at clubs or bands who came to town to perform. Soon TV Party evolved into the Tonight Show of the New York underground. Even though it was made for less than $100 a week, the people who showed up comprised a who's who of the scene: David Bowie, Iggy Pop, David Byrne, Andy Warhol, The Clash, Robert Mapplethorpe, George Clinton of Funkadelic, Kraftwerk, The Brides of Funkenstein, Jeffrey Lee Pearce, Tuxedo Moon, James Chance of the Contortions, Alex Chilton, Chris Burden (the conceptual artist who had crucified himself to a Volkswagen), Klaus Nomi, and Steven Meisel, who performed a beauty makeover, transforming a transient hillbilly bar-fly girl into a glamorous beauty in about forty five minutes.

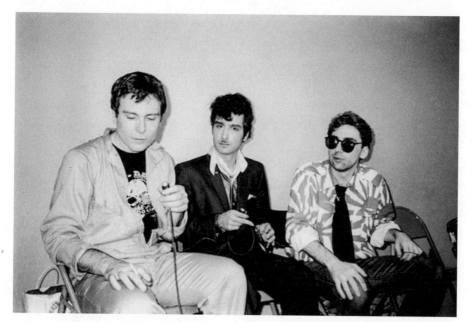

Bobby Grossman

We did our own updated version of the cocktail party—one show featured magic mushroom frozen margartitas, and often funny cigarettes were passed around.

We didn't do skit humor or satire or lampoon. We didn't play characters; we were characters. I thought what we were doing was considerably cooler and more artistic than that other new show, Saturday Night Live (which I later came to appreciate). We were combining humor with pushing things to the limits in music and visuals. I guess we were The Velvet Underground to *SNL's* Beatles. When the funniest guy on *Saturday Night Live*, Charlie Rocket, was kicked off the show for saying the word "fuck," we added him to the TV Party gang. Sometimes he played his accordion with the

Bobby Grossman

Most people don't write because it's so hard to use words without really saying something.

Tweet, 31 May 2014

band, blasting it through a stack of Marshall amps and getting feedback like Jimi Hendrix.

Rocket was part of the band when we did our first Heavy Metal Special. We did do theme shows, where we had an inspiration that carried through the show. The first Heavy Metal Show was actually done at the Mudd Club where we had the TV Party Heavy Metal Orchestra, consisting of 12 guitar players, one bass player, one drummer, and one heavy metal accordionist. We did a Middle Eastern special in Arab dress when the Ayatollah Khomeini banned music. That night the band, with John Lurie and Tim Wright as guests, performed a song called "The Funkatollah." Country & Western night featured David Byrne singing "Tumbling Along with the Tumbling Tumble Weeds." "Primitive Night", a pagan freak out inspired by the Pope's visit to New York, was such a hit we did it again in a night club as "Savage Easter."

Even though we were all poor we were famous. At least to our friends and a few thousand other people in New York, L.A., San Francisco, London and Paris. But we were getting noticed. I wound up on the cover of New York magazine and David Letterman, the new network talk star kept mentioning TV Party on his show, saying it was the greatest TV show ever.

TV Party's four-year run was pretty good by TV standards. We took a long break in 1981 to make the feature film Downtown 81 starring Basquiat. When we came back I changed the show to color which was more expensive, and so I had to move

Bobby Grossman

to a channel where you could have ads. I sold ads to clubs and small record companies, but it was a time consuming and difficult task. And the TV Party gang began to have problems. Suddenly Blondie was breaking up and Chris Stein was sick. We didn't know it, but he had a very rare, genetic disease that was, until rather recently, 99% fatal. Luckily, after a long, long treatment period and recuperation he survived, but Blondie didn't and neither did TV Party.

I got married, and started to think theoretically about making money. Walter Steding was trying to go commercial with his band. Lenny Ferrari went on the road with Lou Reed. Other people moved away to get away from the drug scene or went to rehab. I was getting itchy with no place

to shoot my mouth off, so I started thinking about performing. I memorized the 1960 Copacabana act of my favorite rat pack style comedian B.S. Pully. I put on an iridescent sharkskin tuxedo and performed it, very early one morning at Danceteria. David Johansen happened to be in the audience. He came up to me afterward and said he was starting a lounge thing called Buster Poindexter, working every week. Would I be his opening act?

Would I? Sure! And I was on to my next career, rat pack style stand-up comic.

Last year we made a documentary about TV Party, and it's now out on DVD, as are a half dozen complete shows, each packaged with bonus features. It seems like a long time ago, but when I watch it I can't help but think "what a good idea for a show." Maybe we should make a comeback. We looked so good. And we had such wonderfully crazy ambition. I actually planned to run for mayor of New York on the TV Party but we never got out of bed early enough to get all those petitions signed to get me on the ballot.

I suppose it's natural to look back at photos of your youth and have certain thoughts, like how cute we all were back then or, maybe more to the point, if I'd only known how good looking I was, but other things pop into my mind as well. For one thing, I'm impressed by how great we all looked without spending any money. There was no such thing as designer clothing then, at least for young people. I did have a t-shirt I bought at Boy in London and another one from Malcolm and Vivienne's Sex Shop on the King's Road, but

I think I hung that on my wall. Almost everything I wore was vintage or new old stock or stuff I'd had in my wardrobe since my parents were paying the bills. Everyone put together their own look. People had really distinctive styles and designers had nothing to do with it. And it wasn't at all like that tribal London punk look. It was individualistic. I'm really gratified that TV Party is still, somehow, weirdly alive. I was walking down the street the other day by the super-hip skateboard fashion store Supreme and there I was on their eight big TV monitors in the front window, in my sunglasses and motorcycle jacket. They seem to think there's room for a cocktail party that could be a political party too.

L'Uomo Vogue, 2006

BLACK IRISH BLACK RUSSIANS

My mother says that the first time I saw a
black man I said, "Look at the dirty man."
I hated hearing that anecdote repeated over
the years. I had probably been using words
for several months at the time, but still
it sounded phony to me. I was sure I never
said that. Then one day I realized that the
black man in question (I'm sure he wasn't
the first I'd seen, just the first I'd commented
on) was in fact the guy delivering coal. Now
I'm sure I said it, but I wasn't talking about
the man's complexion, just the way he
was dressed. I'm sure I thought he himself was
very beautiful.

As far back as I can remember, even
before I knew any personally, I thought black
people were where it was at. So did most
of my friends: we baby boomers were almost
all blues brothers of some sort. It was radio
and TV that did it. That media contact was
enough to transmit a contagious cultural
essence that would begin to interact with
our own cultural essence and give birth to
some flyly miscegenational dance steps. I
still remember the day I heard Major Lance
singing on the radio: "Mm-mm-mm-mm-

mm-mm. Mm-mm-mm-mm-mm-mm!" We were a strange tribe, associate Zulus living in the bodies of white dudes. We were a mass movement of racial dislocation.

How did it happen? It was just a consequence of growing up global. First, you're simply human and everybody looks good. Mom, Dad, the neighbors. You're popular. Then you learn how to talk, you enter society, and suddenly you get typecast—black, white, red, yellow, male, female, queer, straight. Maybe you don't mind your particular situation, your gender or your race or your ethnic thing. But maybe it's all wrong. Maybe you grow up thinking that you are a foxy black female trapped in the body of a hairy Italian male. Or vice versa.

If your perceived misplacement is gender-related, you can always switch, even though you may not prove to be a crossover knockout. If your perceived misplacement is ethnicity-related, you can always switch cultures. You can learn to cook Italian, massage Japanese, and speak Yiddish. For these misplacements there are easy solutions. But if you feel you're enrolled in the wrong race, you've got a more serious problem. Usually all you can do about it is become a bohemian.

Transracialism is a common affliction. For some people it's a phase. For some it's a life's work. But it's a knotty problem that's rarely discussed. It's actually a taboo that complicates all racial politics, and it's one of the forbidden grounds of art. If you deal with it, you're bound to be misunderstood on all sides (see Spike Lee's *School Daze*). Racism isn't all about hate. Sometimes it's about love gone wrong.

By the '60s there was a nucleus of confirmed cultural mutants with consciousness tuned by A.M. vibrations beamed in from the otherwise hermetically sealed-off alien-culture community across town: white kids profoundly altered by the Radio Free

Soul Station. When I was an adolescent my
first white cultural heroes (aside from May-
nard G. Krebs, the Stepin Fetchit of white
bohemia) were the Rolling Stones of 1963.
That was before the Stones recorded original
material. What made the group a hit was
that they played covers of R&B songs that
we had heard on black radio. But these
weren't like Pat Boone covers of R&B that
had characterized the '50s. These were
nasty. The Rolling Stones doing Slim Harpo,
Willie Dixon, Rufus Thomas, and Bobby
Womack songs seemed finally to allow that
it was possible for white children to grow up
into hip blacks.

Later we would buy Norman Mailer's
pamphlet "The White Negro" and smoke
a lot of marijuana as we read it. But to kids
of my age it was tired. We weren't "white
Negroes," we were "white niggers." If you
were a white nigger you had strange hair,
weird clothes, bad habits, exotic dialect, and
were someone that your girlfriend's father
would hate as much as if she came home with
a black.

But all those struggles are many years
behind us, and today I feel that in my
heart of hearts I am a de facto soul brother,
an etheric bro. In fact, I feel like a Druid
Rastafarian Neturei Karta Nyabinghi
33rd-Degree Black-Belt Mullah of whatever
race I feel like at the moment. And I'm sure
I'm speaking for my homies when I say that
my well-groomed "Caucasian" appearance
and my Middle American "accentless" speech
belie a heart of darkness and sheer funkiness.
Some days I feel like Kurtz auditioning for
the J.B.'s. Some days I feel just like Johnny
Otis, the white jazzman who lived black in
Watts. I feel all right. I feel like dynamite. I
feel like what time it is.

Of course, there are limits. I don't look
right in a Kangol hat and a black medallion.
The Raiders cap and Nikes look O.K. And

the Georgetown sweatshirt works. (I'm class of '69.) But still these are hard times for in-their-heart-of-hearts white niggers.

I think the only thing to do is to embrace the goddamned contradictions. I am white. I ain't no redneck. I am black Irish. It's O.K. My skin is the color of paper. But my ancestors went into battle naked painted blue.

Wynton Marsalis don't mind playing Beethoven. Duke Ellington knew his fugues, Jim. And hip-hop is my culture too. Not only do I like the Beastie Boys, I think they have a strange importance. These white boys doing hip-hop ain't a rip-off. It's as much theirs as it is anybody's with a radio. They are as white as the bleached-out, macho, leather-clad drag queens of heavy metal with their distorted blowouts of R&B riffs appropriated thirty years ago. They are as black as the headlines of the *New York Post*. But above all they are alive. White hip-hoppers are part of a living culture. Rock 'n' roll is dead. It's a decadent, downward spiral of reductive minimalism. It's a zombie of self-referentiality.

Hip-hop, on the other foot, is a fresh medium sampling everything in the public domain. What we are often calling black culture is a lot more than black culture; it's the cultural essence of all of us, and it happens that its mediums are black people. Culture, much of which is born black, is a system of enlightenment, a gnosis, the origin of which is "the Word." As in "In the beginning was the Word."

In *Mumbo Jumbo*, Ishmael Reed writes the history of a benevolent plague, a dancing bug called Jes' Grew, like the dancing plagues of the Middle Ages, that periodically asserts itself in the human race creating endemic, uncontrolled dancing. It's a parasite that improves its host. It's characterized by a rhythm. According to the witch doctors, it's a music seeking its text. And that's what it is. It's the word as a dance. It's communion with the gods.

And that seems to be where hip-hop is at. Hip-hop is Jes' Grew with an All-Star Krewe. While the fine art world touts the sophistication of its appropriations as it congratulates itself on its use of media as material, as it speaks of carrying on the liberating Dada idea of the ready-made, hip hop acts out the Nike slogan "Just Do It."

Whereas other music uses material sounds imitative of nature or urban noise, hip-hop takes its rhythms and sound, words and constructions from everywhere, from nature and from every sound and every word ever recorded. It is the most advanced case ever of art using art as its source. Hip hop is the ultimate dialectical art. Sample and rhyme. Receive and send. It's the most synthetic of arts, but organically synthetic. res Dada, Cubism, bop, and testimony too.

America isn't the only hip-hop nation. They're toasting in Jamaica. In Africa and all along the equator, gods mount spokespersons at late-night religious dance parties. In Beijing basements they're breakdancing to "Fight the Power." In Belgrade there's a restaurant called Def Jam. They're scratching Biz Markie records in Lithuanian garrets. Raiders caps going for $100 on Red Square. They're smoking Kents and listening to. L. L. Cool J in Romania. Noriega squirmed inside the Vatican embassy through the Hendrix and Bowie music the American troops blasted at him, but I bet it was only when they put on "Terminator X Speaks With His Hands," by Public Enemy, that the dude did check out. And slowly but surely, day by day, one step at a time, the true word of hip-hop is manifest in the world. Take it to the bridge.

Interview magazine, 1990

Andy Spade

You're going to have trouble getting to the Valley of Dolls without a Sherpa.

Tweet, 23 April 2014

IN THE FUTURE

A few days before Election Day I was sitting around trying to imagine what the future would be like, and the big ideas were just not arriving. I couldn't even imagine what the next four years would be like. I had been advised that the next issue of the magazine would be about the future, and I didn't want to be left behind. But I wasn't getting the big picture. I was thinking stuff like, I predict that in the next few years Japan will get a new emperor. Scandal will rock the Koch administration. First-class postage will hit fifty cents by the turn of the century. I began to feel like I was in a rut.

That night I was invited to a party hosted by a multinational corporation, on a barge moored next to the Brooklyn Bridge, and I dropped by to check it out. The view was spectacular, the illuminated skyscrapers of lower Manhattan reflected in the black, subconscious-looking waters of the East River. It wasn't what I expected from a corporate gathering. It was kind of loose and fun, and the political and psychosexual subtexts seemed much more subliminal than at most company affairs. There was something really different about it, and I just couldn't put my finger on it. It wasn't a vice president throwing Kaiser rolls at the backs of

the heads of his subordinates. It wasn't the executive vice president walking around with a balloon under his sweater, transforming him into a hunchback. It wasn't even the color of the Chow Mein. I began to focus on the small stage in the main room of the barge. Here was a circle of young women, the prettiest and most carefully made-up women at the party, all wearing matching corporate sweatshirts. I suddenly realized that there were many more women at this party than men. I suddenly realized that this corporation was much more female than I thought, perhaps much more female than male. I suddenly recalled years of complaints from many of my women friends on the dearth of available men. And then something larger struck me. It wasn't a Kaiser roll. It was a big idea. The future was clear as a Tina Chow crystal brooch. The future was female.

"You know," I said to the marketing v.p., "the last time I saw a party like this was at the mansion."

He looked at me quizzically.

"The Playboy Mansion."

I looked at those appealing young women in voluntary uniform, and I looked up at those skyscrapers gleaming across the river, and I saw the future.

"In fifty years," I said to the marketing v. p., "there will be two women for every man."

Everyone looked at me like I was drunk. "In fifty more years there will be seven women for every man. That's the future. Isn't it amazing?"

No one else seemed amazed. But one man seemed interested. "Does this mean polygamy will become our way of life?"

I thought about it.

"No," I said.

The man went to the bar for another drink. No, it would just be more of the same serial monogamy.

As it happens, the parent company of this corporation is headquartered in one of the world's leading dairy countries. Suddenly this particular corporation seemed to be in the avant-garde of this enormous gender mutation of humanity. "Look around you," I said. "It's all women here. They developed this concept after thousands of years of keeping cows. It works. It's efficient. Females are better employees. They're more manageable. It's so obvious."

No one else seemed to think it was obvious. But looking across the Freudian East River at the glimmering beehives and anthills of the multinational conglomerates, I knew that our hive culture was for real. Drones, worker males, worker females. It was the future. Perhaps in another room of the barge two vice presidents were mating. Perhaps afterward the female would eat the male.

My reverie was interrupted by a large chorus of female voices. They were singing "Happy Birthday" to the company. Somehow I couldn't make my mouth move.

Was this a sexist vision that overtook me in the shadow of the Brooklyn Bridge? I don't think so. I just think women will prevail in the fluorescent atmosphere of Office World. It's evolution. They are better suited to the environment. They are less territorial. Less subject to the cardiovascular stress of moving from department to department. They can handle the long white-collar hours. They can handle collaboration as well as competition. They can handle the unnatural environment better because they carry nature within them. And, ultimately, they just last longer than men. Isn't that what the future is all about—lasting longer?

I thought of my friends with children. Almost all of them had daughters. Perhaps there were six girls being born for every five boys, but the ratio is climbing fast. It may take nature a while to catch up with the needs of the multinational hive culture. For the time being the excess boy drones will be eliminated before they reach maturity, eliminated by the rituals of drugs and heavy-metal culture.

Yes, I had seen the future, and it was, in the words of the bards Jan and Dean, Surf City:

"Yeah, we're going to Surf City, gonna have some fun.

Yeah, we're going to Surf City cause it's two to one.

Two girls for every boy..." *

GLENN O'BRIEN

SHOULDN'T I BE MORE FAMOUS?

I don't ask myself this question every day. But once in a while I start thinking, "if I were more famous I could be endorsing Mac computers or MAC lipsticks, I could be judging the Anchorage Film Festival, I could be guest hosting David Byrne's TV show when he's on summer vacation.

I mean I would hate giving more autographs, but I could just refuse like Charles Barkley does when he's not in the mood. I'd hate turning down more supermodels for dates or having more people paying undue attention to my pants size or blood alcohol level. But there are times when I think maybe I owe it to my art to be a little more profiley.

So I was up all night skimming through Bret Easton Ellis's new novel *Glamorama*, which is to celebri-

ties what *American Psycho* was to brand names, to see if my name was in it and I just couldn't find it and then I felt even worse, (but not as bad as if I had stayed up all night on drugs and Absolut Prune Cosmopolitans looking for my name there and not finding it).

I was going to read it anyway, but I wish there was an index to *Glamorama* so I could have been prepared for disappointment, but novels never have indexes and although I can't imagine why not, since you could go right to the hot parts, I'm sure that Bret knew that its really better not to have an index from a marketing point of view, a fact proved by the Warhol diaries. You had to buy a copy of the diaries to see if you were in them. It would have taken too long to stand in Barnes and Noble skimming. Genius! Later, at least two magazines published indexes to the Warhol diaries. (It didn't help them, however, and both Fame and Spy are now gone. And probably weren't mentioned in either book. More victims of the Warhol curse?) But anyway, more mentions means thousands more readers! It's like a rock song that mentions Detroit, Cleveland, Tulsa and San Bernardino. Mentions equals consumers.

I shouldn't feel terrible about not being in *Glamorama* because in all honesty I'm not out there every night working the rooms like I used to. I'm out there some nights, but I think I'm staying home too much reading the great books and skimming through magazines to see if I'm in them. I know I'm not in them, but I still look anyway, and at least I know that Patrick McMullan and Roxanne Lowit have great collections of unpublished pictures of

me, which are probably even more valuable than the published ones.

I've tried everything to get Bill Cunningham to take my picture. I've walked back and forth in front of Tiffany's and the Warner Brothers store. I've tried dressing like Anna Wintour and Liz Tilberis, I've even tried Ratso Rizzo's line: "Hey, I'm walking here!" but still Bill won't snap. So now I'm trying to spend more time standing right behind Steven Gan, that's bound to work.

But maybe there are more basic problems holding my fame back. Maybe I'm changing my clothes too much. Maybe I should simplify and refine my look. I think one secret of keeping one's profile prolific is sticking to a look. Andy had the wig and

Gina Nanni

striped T-shirt and the shades and the leather jack-
et. Steven Meisel has the floppy hat, the raincoat
and the motorcycle boots. I just can't figure out
what my look is. I have too many suits and shirts
and ties. Maybe I should just change my name to
Morgan Stanley.

Also I seem to be in the wrong category, *W* recent-
ly ran a poll where readers are supposed to check
off or write in the most stylish person in a wide
variety of fields—actors, musicians, athletes, art-
ists...but wouldn't you know it, there's no writer
section. I guess I shouldn't feel bad, look at all
that work Tom Wolfe puts into it, but I figure I look
a lot better than Joe Eszterhas or Mike McAlary
(granted he's dead). But still, it's not fair. Writers
are certainly as capable of being stylish as artists.
And we have less to prove!

Maybe I don't go to the hot clubs enough. I have
been to Moomba a whole bunch of times, but I
tend to feel like a chaperone there. And Donald
Trump doesn't? I guess it's all attitude. Trump's got
it. All Trumps have attitude. Look at Ivanka. Please!
I mean she's Ivanka™. She's not just another cyber-
deb, she's trademarked, thanks to her surely quick
thinking, allegedly slow paying mom. Maybe I've
got to a) have more attitude and b) get trademarked.
I don't think I can be Glenn™, and Glennka, well-
noted sex journalist Anka™ would think I was
copying her. Maybe Glennorama™. That's not too
David Mamet© is it?

That's what those rappers who are the core of the
new celebrity scene have going for them, besides
posses and chick posses, is that they have trade-

mark names. Usually their given names are like
Lloyd or Arthur or something but they ingeniously
invent brandable names, just like superstars did
back in the Pop days. Maybe Glennorama™ "Oat"
Brain. Sounds smart, healthy and glamorous,
huh G?

I'm still thinking about other ways. Joining the
Masons? Working out with High Voltage? Dating
Candace Bushnell and/or Bob Guccione Jr.? Hiring
a JAP heiress publicist who's fluent in inner city
argot? Punching out? A.J. Benza? Getting punched
out by A.J. Benza? Buying Richard and Nadine
Johnson a Hyundai? Trashing my hotel room? Wait
I don't have a hotel room! Hurling on Jewel? Dye
job? Breast implants? Nah!

(24 hours later)

I just wrote my name into my signed copy of
Glamorama. I'm on page 86 right between Clement
Greenberg and Flavor Flav. Whew! That's better.

Paper Magazine, 1999

Jean-Philippe Delhomme

WHY I STILL DON'T PAINT

I go into a gallery and see something and right off I think I can do better than that. I check the prices and I think, "Holy mackerel," but still I'm not painting today.

Jean-Philippe Delhomme

To do something better than someone who does it not well enough—well, that's not enough. Just because I could be a lot less terrible than some of the painters out there doesn't mean I should go out there and pick up a brush.

Every once in a while I'll read something a painter has written, a real painter, and I'll think, "I'm not painting for the same reason he shouldn't be writing." I think you know who you are.

This drunk comes up to me in a bar the other night and says to me, "Do you model?" I tell him I don't. He asks me why not. Here we go again. I mean,

I'm sure I could make even more modeling than
I don't make painting, but so what. If I modeled,
would it be fair to all those models who can't
write? Would drunks come up to me in bars and
say, "Do you write? Why don't you write?"

Frankly, modeling appeals to me even less
than painting.

Dorothy Parker, asked if she liked writing, answer-
ed, "Nobody likes writing. People like having
written." Or something like that.

I love to write. I can do it alone. I can sit there and
just laugh, laugh, laugh at the witty things I come
up with. Sure, I'd rather play third base for the
Yankees, but I know I can't do that, so I don't try.

Another great thing about writing is that you can
do it wearing any old thing, or nothing. (Although
there is a McLuhanite theory that it's harder to
read and write naked. I forget why.) Of course,
I guess you can paint in any old thing, too, although
a smock and beret would help me get in the mood.
Maybe that's another reason I'm not a model.
I couldn't say, "I can't work in *that*."

Performers have even more to worry about.
Look what has happened to musicians. It used
to be enough to be able to make music. Now you
have to be good at composing, playing, writing,
singing, dancing, posing and dressing—and your
good visual taste has to carry over into graphics
and video. It seems like too much responsibility.
Today's musicians just have more and more ways
to go wrong.

Sure, maybe you play great, but what if you've got on the wrong pants and your rhythm does not extend below your waist. I wonder if I'm the only one with nostalgia for specialization. I respect a musician that knows he can't sing or write words, a performer who wears black tie because he knows he is color blind.

I just got this record by The Happiness Boys, an EP called *Resident Alien* (Duotone Records); it is subtitled "Six Aggressive Structures for Dance." To me that's kind of sad. I really like the music. Why do they have to tell you that it's an aggressive structure for dance? Now I'm afraid that performers think they have to be critics, too. Twyla Tharp used The Beach Boys. Did they have to call "Little Deuce Coupe" a matrix for audiovisual interaction with choreography? I feel sad for The Happiness Boys. And I felt sadder when I read their press release. "Both Nester and Bobb command attention with the flair and style of their dress, their movement on stage, and the magnetism of their personalities. Along with their own personal appeal, the compellingly harsh images of their video, film and slides add the final layer to a driving, kinetic sound and performance."

I suppose if you knew what I was wearing you'd enjoy reading this even more, but I'm old fashioned that way. I like for there to be a little mystery. Besides, I'm not wearing such beautiful clothes to attract attention or enhance my writing. It's to help me not paint.

Paper Magazine, 1984

Ari Marcopoulos

WILL WRITE FOR MERLOT:
WHY WRITE RHYMES WITH PLIGHT

A major magazine that I write for every month and to which I am undyingly and contractually loyal happened to be working up a business scandale piece on a company that I happened to have done some work for. Would I please, my dear editor entreated, talk to the reporter doing the story?

Well, okay, I said, being a sport and generally in the service of truth. I don't usually talk about my clients, I had nothing bad to say about them and they were out of business anyway. So I talked. I said what nice people these e-commerce kids were, and how it was too bad that they had gone through such a huge fortune with nothing to show for it. And when he asked pointed

questions about my own experience I answered
the best I could. I did wince, however,
when he asked about my salary. I just said,
"call my agent."

So then the article appeared: all about
how the web fashion company Boo.com
went through more than $130 million, spec-
tacularly, in a year and a half. No mention
was made of the fact that they ran a huge
advertising campaign in nearly every major
magazine plus television approximately six
months before their site was up and running.
There were suggestions of overstaffing, over-
reaching planning, poor planning, profligacy
and partying, but the real climax of the
story seemed to be the fact that Boo employed
me for one week at £3,000 per day, to work
at their offices in London, while put up in the
decadently posh St. Martin's Lane Hotel.
I was, it seemed, the straw that broke the
cartel's back. I was cited as an example of
their extreme profligacy. At the time I tried
to put some positive spin on this for myself.
At least it shows I seem successful, I whis-
pered to myself.

Then, a month or so later, the *New York
Times* also mentioned my astonishing fee in
a similar story on the same corporate tragedy.
I was the writer made who made £15,000
in one week! Insane!

Never mind that I actually wrote
everything on the site in that week, edited all
the automated responses, gave a charming
voice to their animated "personal shopper"
Miss Boo, who, by the way, had several top
hairdressers flown in to redesign her cartoon
hair. Never mind that the company had
purchased warehouses full of time critical
merchandise for inventory. I don't think it
was mentioned that even after their way
delayed launch Boo.com was not accessible
by Macintoshes. No, aside from general
suggestions of mad expense accounts, office
bubbly swilling and staffers horning up

lines of illicit anesthetics, the real shocker was a writer making a decent living. I finally realized, this is really bad for me and inspired typists everywhere.

A few years ago, the *New York Times* reported that the average professional writer makes $5,000 per year. That was published writers; it didn't even include the wannabees. For years I had a cartoon clipped from the New Yorker in my desk drawer. Two people, drinks in hand at a cocktail party said, "You're a writer? Oh, I write too." The story of my life, our lives. I think the poet Michael Brownstein nailed it when he wrote "a writer is a guy who sticks it in the mailbox."

If a college dropout basketball player gets a contract for a quarter of a billion dollars, this is not even slightly shocking (unless he has felony convictions). Not like a writer making five large in about ten hours. Stop the presses, Mary, the sky is falling!

It's nothing for an NBA player to make $100,000 per game. Quite a few make about $200,000 per game or about $4,125 per minute, including of course, time spent sitting on the bench. Michael Jordan made over a million dollars every three games. Football players can make nearly a million dollars per game. Mike Piazza makes only $82,000 per game, but he plays 162 games a year.

Artists are expected to make some money, even if they're not dead, because they manufacture precious objects that can be speculated on. Just hold on to some of that early work, kid, because it could be that the stuff you gave away is what brings down the real cake. What have you done since you paid off the loft?

But a writer? Gore Vidal once wondered, "How can you sell so little of anything as a novel." The irony is, of course, that the worse your novel is, the more it may sell, but that's another jeremiad. For me the scandal is that one day writing dialogue for a cartoon

character on a website would earn me as much as the royalties earned for the first six months of my last book—and my book was considered to be doing well! I think the book could be doing a hell of a lot better, if I could just get arrested....

Writers are supposed to be starving. This builds character. It gives them ideas. They are supposed to live in a garret, except that there are no more garrets, they have been converted into penthouses. They are supposed to work hunched over a typewriter or on a legal pad, under a blanket, in the middle of the night. Well, I'm writing this on a G3 Powerbook in a luxurious loft fit for a lawyer. I managed to get it because I qualified for an Artist in Residence certification from the City of New York. I qualified for this because I am a poet. Not because I can write a web site, a magazine article, or name a best-selling fragrance and direct its advertising campaign. I got mine because poets need a lot of space! Because dreams can be big, Mister!

Now my friends and I, we came here to be artists and poets and musicians of the New York School, and back in the day we used to be able to live in a nice tenement on the Lower East Side and maybe drive a cab or tend bar one or two days (or nights) and make out and be happy. Maybe we'd get lucky and get to be a curator at MOMA like Frank O'Hara, or teach a class at the New School. But this is New York. You've got to be a millionaire to be middle class. So we're no dummies. We've got to hustle. Just like Bill Clinton. And we have to understand how the world has changed.

People are never going to understand that writers work hard, because they never see us doing anything but eating and drinking in cafes or taking our children to mid-level private schools. When we write we are just sitting there, staring off into space. And we're getting paid for it!

Perhaps the worst indignity for some-
one like myself, who writes poems and the
occasional side of a bus, is when someone
says, with all good intentions, "So, are you
getting to do any writing for yourself?"
What is the answer? "I only write for
the others." "I'm writing for Christ." I
wonder if that's what got to Andy Warhol
when he was drawing shoes for I. Magnin?
"Doing any drawing for yourself, Andy?"
The genius was that Warhol did every ad
like it was a painting for the Met (and
maybe vice versa.)

We have to find a way to make people
accept that working for food, even Beluga,
does not invalidate one's Parnassian creden-
tials, that writers deserve luxuries too. Writing
tag lines and care instructions or e-commerce
caveats does not detract from my sonnets
or essays. In fact, commercial practice frees
my mind from the fact that my gardener's
bill last year was $17,000. But it's still a strug-
gle. Last week, in the middle of the night, I
woke up and said to my wife (who didn't hear
me) "I have become a slave to my freedom!"

But I'm going to write my way out of
this. Like Spartacus I'm going to make
somebody pay or die trying. This spring
my new book of poems comes out. It was
beautifully printed in Germany. It comes in
a box. It has silkscreened illustrations by a
great artist, who drives an AC Cobra. The
cheap edition is $85. I'm working on the
hang tag and care instructions for it now.
So how's Seattle, Patrick Ewing? Have
another donut Julian Schnabel. I wrote this
in eight minutes.

New York Observer, 2001

XMAS X 12

On the first day of Christmas
my true love gave to me
a big thrill in a public place.

On the second day of
Christmas my true love
gave to me some incredible
posies and a big thrill in a
public place.

On the third day of Christmas
my true love gave to me
remarkably sage advice,
some incredible posies, and
a big thrill in a public place.

On the fourth day of
Christmas my true love gave
to me a bigger piece of
the action, remarkably sage
advice, some incredible
posies, and a big thrill in a
public place.

On the fifth day of Christmas
my true love gave to me
undivided attention, a bigger

piece of the action, remark-
ably sage advice, some
incredible posies, and a big
thrill in a public place.

On the sixth day of Christmas
my true love gave to me her
very best friend, undivided
attention, a bigger piece of
the action, remarkably sage
advice, some incredible
posies, and a big thrill in a
public place.

On the seventh day of
Christmas my true love gave
to me almost gnostic sim-
patico, her very best friend,
undivided attention, a bigger
piece of the action, remark-
ably sage advice, some
incredible posies, and a big
thrill in a public place.

On the eighth day of
Christmas my true love gave
to me the whole real story,

almost gnostic simpatico, her very best friend, undivided attention, a bigger piece of the action, remarkably sage advice, some incredible posies, and a big thrill in a public place.

On the ninth day of Christmas my true love gave to me her secret recipes, the whole real story, almost gnostic simpatico, her very best friend, undivided attention, a bigger piece of the action, remarkably sage advice, some incredible posies, and a big thrill in a public place.

On the tenth day of Christmas my true love gave to me a Get Out of Jail Free card, her secret recipes, the whole real story, almost gnostic simpatico, her very best friend, undivided attention, a bigger piece of the action, remarkably sage advice, some incredible posies, and a big thrill in a public place.

On the eleventh day of Christmas my true love gave to me a round-trip first-class upgrade, a Get Out of Jail Free card, her secret recipes, the whole real story, almost gnostic simpatico, her very best friend, undivided attention, a bigger piece of the action, remarkably sage advice, some incredible posies, and a big thrill in a public place.

On the twelfth day of Christmas my true love gave to me the rest of the day off, not to mention all of the above.

REGRETS, I'VE HAD A FEW
THEN AGAIN, ENOUGH TO MENTION

I am sorry. Let me just get that right out front. I don't know what I was thinking. I'm not perfect and when I screw up I want to be the first to admit it. I admit it! I am going to try my best not to let it happen again. Promise!

I was thinking about this recently when somebody told me that they were friends with Stephen Lack and they said he's still grumbling about a review I gave his paintings in Artforum maybe fifteen years ago. I said, if you see him tell him I'm really sorry. Really, really sorry.

I know that's not much con- solation for having your work savaged in a prestigious art magazine, but it's about all I can do at this point. After my review of his show came out I felt so bad about it that I gave up reviewing art shows.

Stephen Lack, who starred quite brilliantly in David Cronenberg's Scanners, is a painter and he makes bad paintings—sort of in the footsteps of artists like Neil Jenney—and, on reflection, I think his bad paintings are quite good, much better than most of the fashionable practitioners of this style.

Mr. Lack is also a good actor, because he really seemed like a depressed "scanner" with awesome psychokinetic powers and yet he definitely isn't because I can assure you if he were my head would have exploded like water- melon dropped from the roof years ago.

Gee, you know when you work in the journalism rack- et you find you have a lot of things to apologize for. Even though the case was thrown out of court I'd like to apologize to the importers

of Mexican jumping beans
if anyone really thought
they were really being used
to smuggle one and ones
of cocaine across the bor-
der in tiny backpacks. And
even though I believe you
got something out of that
lawsuit, I'd like to apologize
again to Dwayne McClain for
you getting mixed up with
your teammate Gary McLain
who told Sports Illustrated
he played the NCAA semi-
final game high on blow
and that he was also high
on cocaine when you cats
met President Reagan at
the White House. I guess I
always liked you better any-
way. It was the fact checker
at Spin's fault.

Speaking of Spin, I'd like to
apologize to Bob Guccione
Jr. for suing him about non-
payment at Gear. If you'd
only picked up the phone
Bobby! And what a shame
we never took The People's
Court up on their invitation
to have it out on TV!

While I'm at it, I'd also like
to apologize to the late Bob
Weiner for, years ago, tell-

ing him not to write a story
about a young singer song-
writer, that nobody would
ever make it with a name
like Billy Joel.

I'd like to apologize to Bryan
Ferry for throwing his P.G.
Wodehouse novel off the
veranda. I really am sorry.
I hope it wasn't a first edi-
tion. I should have stayed
away from that ouzo.

I'd like to apologize to my
old colleagues at the Playboy
Corporation in Chicago for
sneaking around the office
late at night and taking the
dirty pictures off the walls.
Yeah, it was me, not the
cleaning woman. Sorry, I
just thought it was too dis-
tracting a work environment.

I'd like to apologize to Bob
Colacello for stabbing him
in the back, especially so
quickly. I was just drunk with
power. I'd also like to apol-
ogize to Jann Wenner if he
thought I was leading him
on in any way.

I'd like U2 to know that I'm
very sorry that I lost the

tapes of the long interview
we did. The scary thing is
that I was completely sober.

I'd like to apologize to Lou
Reed for talking to Victor
Bockris when he was writ-
ing his biography of you.
I thought he was writing a
musical comedy.

Another mea culpa goes
out to Andrew Wylie for
throwing that punch at
Max's Kansas City. If I had
any idea that you were going
to be the biggest literary
agent in the world, believe
me I would have thought
twice about it.

I'd like to apologize to Lena
Lovich for walking out on
her during an interview.
Well, maybe I'll just apolo-
gize for giving you that joint
to begin with. I know Brits
are used to weak hash.

I'm really sorry that I didn't
vote for Al Gore. I guess I
gota little carried away when
President Clinton looked into
the camera and said "I'm
going to say this again.
I did not have sexual rela-

tions with that woman,
Miss Lewinsky.

I never told anybody to lie,
not a single time—never."

I'm sorry I didn't vote for you
Al. I'm sorry I didn't move
to Florida and vote for you.

I also am very sorry I got
married the second time.
I should have definitely
just gone straight to the
third, okay.

Paper Magazine, 2003

Art

I really put my soul into this painting and a hedge fund bought it and now it's in a really important storage facility.

Tweet, 20 January 2015

HISTORY OF THE FACTORY

Andy Warhol said that he started *Interview* in the fall
of 1969 to give Gerard Malanga, the poet who was his
painting assistant, something to do. When Gerard was on
the outs Andy would say that he started *Interview* to give
Brigid Berlin something to do. Or "to give the kids some-
thing to do." I would guess that there were a few other
reasons as well.

Andy wasn't the only artist with his own magazine in
those days. Maybe he started *Interview* to give Les Levine
a run for his money. Levine had a small paper called
Culture Hero, which seemed to exist to serve the areas of
the art world that the major art magazines did not. It was
intended to be a sort of *National Enquirer* or *Star* of the art
world, with a little *Screw* thrown in. It didn't last long, but
it was great while it lasted.

Interview was called *Inter/View* for the first few
years. I have no idea why. Maybe it was a tip of Gerard's
cap to *View*, Charles Henri Ford's Surrealist magazine of
the '40s.

Interview was quite a different magazine then: thin,
black-and-white, folded in quarters. The first issue had a
cover picture of Viva and Jim Rado and Jerry Ragni, the
creators of *Hair*, cavorting nude. It was clearly an under-
ground publication. It was a mess. But a beautiful, glamor-
ous, artistic mess.

During the first year of its existence *Interview* man-
aged to come out regularly although under the direction
of seven different editors (some more different than others)
including film critics Donald Lyons (who now writes
for *Details*) and Donald Chase. Donald Chase was a very
amusing film buff who did perhaps the world's greatest

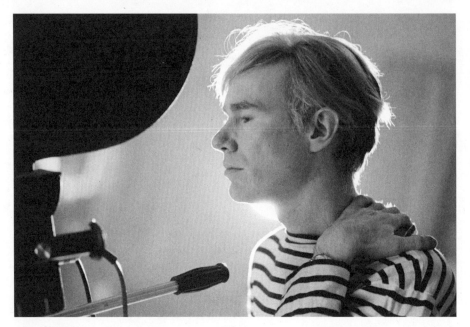

Stephen Shore

Stephen Shore

Bette Davis imitation. He had called up W.H. Auden as
Bette, and I believe that until his death the poet counted
Bette Davis as one of his greatest admirers. Donald was
unable to fool Joan Crawford, however.

After a year of heavy turnover, Andy and Paul
Morrissey, his film partner, who was also involved with
Interview, hired Bob Colacello as editor. Bob was discovered
in the pages of *The Village Voice*. He was studying film at
Columbia with Andrew Sarris, the *Voice*'s film critic. It
was Sarris's practice to allow his better students to string
for the *Voice*, covering underground film and such. Bob
had reviewed Warhol's *Trash* for the *Voice* and had compared
it favorably to Genet's *Our Lady of the Flowers*. That
convinced Andy and Paul that this was their man. Bob
wrote for a few issues, then he was in as editor. Finally, in
Colacello, Andy and Paul had someone who was not only
intelligent but also young and ambitious.

I was also a grad student in film at Columbia string-
ing for the *Voice*, and Bob hired me to come work for him
at *Interview*. After a year or so we were both out of school:
Bob graduated, and I dropped out. I had a full-time job as
editor of *Interview*, and Bob was working on *Interview* but
soon began concentrating on working with Andy: travel-
ing, walking rich ladies, and selling art.

The original *Interview* office was a room on the
tenth floor of 33 Union Square West. The artist Saul
Steinberg had his studio upstairs and always gave us dirty
looks in the elevator. The Factory was the sixth floor. We
shared the tenth floor with some architects' offices. One
day Andy was up in the office taking pictures of my Jockey
shorts for the inside cover art of the Rolling Stones' *Sticky
Fingers* album. He was kneeling in front of me with his
Polaroid Big Shot and Fred Hughes was heckling when the
door opened and several businessmen in suits walked in.
One said, "Isn't this the architects' office?"

Andy used to come up to visit every so often, and
sometimes we'd find that he'd accidentally left his little
Sony cassette recorder behind—running.

When Bob and I first arrived at *Interview* it was full
of articles on film and directors, most of them pretty badly
done. We decided to go along with the name and make
the magazine virtually all interviews. We would still run
the occasional article, if we could find a good writer, and
since we were still trying to be a film magazine we decided

to try to review every film that came out. For this we built
up a remarkably good staff of writers, and used the old
Cahiers du Cinema method of letting whoever most liked a
film review it. Sometimes there would be big differences
of opinion and we'd let two writers review a film. Generally,
we tried to be very positive about everything. In this Andy
was our guru, and I seem to recall that Bob and I and
basically everyone at the Factory spent those years walk-
ing around town saying, "Oh, gee, that's so *great!*" Films
that were spectacularly terrible were reviewed by Fran
Lebowitz in her column "The Best of the Worst."

Fran Lebowitz came to the Factory looking for
a writing job. She was a high school dropout who was
working for Susan Graham Mingus's underground arts
magazine, *Changes.* She was funkily dressed in a blue-jeans
ensemble and hippie buffalo sandals. One of her writing
samples was an attack on Andy Warhol films. I hired her
on the spot. Her writing was good and she obviously had
guts. Little did I know she couldn't type.

There were a lot of characters around *Interview*
and the Factory then. Billy Name was still locked in a
back room and nobody gave it a second thought. We hired
Ronnie Cutrone as an assistant. (Later he became Andy's
painting assistant.) Ronnie was great for the magazine.
He was hardworking, charming, and efficient. The only
problem was that he couldn't remember anything. (I think
Ronnie has since regained a normal mnemonic capacity.)
He'd make lists of things that he had to do and then lose
the list. But his hard work and wild attitude helped the
magazine get good. Bob Weiner was a part-time film
producer/full-time troublemaker whom Andy liked/hated
because of his energy and his vicious gossip streak. Weiner
did interviews and tried to write gossip items. When I
rejected scurrilous, libelous, and defamatory items he
handed in, he would quit and then put me in "The Toilet
Bowl"—a *Screw* magazine column.

When Bob Colacello and I arrived, the circulation
of *Interview* was probably about two hundred. We did
everything, including physically picking it up from the
printer and distributing it. Pretty soon we discovered the
professional way of doing things, partly because we wanted
the magazine to be big and partly because we didn't want
to have to drive vans, schlep boxes, or collect money from
testy evasive newsstand personnel. After a couple of years,

we had professional distribution in most major cities in the United States and here and there around the world.

As the magazine grew it changed a lot. The Brants came in as investors and pretty soon we had the best quality paper in the world from Peter Brant's paper company. We took advantage of it by doing color covers and using top photographers. Bob became great friends with Francesco Scavullo, who began doing covers for us. The cover pictures were painted, cut up, and arranged by Richard Bernstein, and they made a huge difference in the visibility and image of the magazine. Many people probably thought that those bold, newsstand-dominating covers were done by Andy. They were all Richard Bernstein's.

Although Scavullo was at the top of his profession, doing covers for *Cosmopolitan* and generally being in high demand at the big-time magazines he was totally devoted to working for *Interview*. It gave him, as it would give many photographers, a chance to stretch out and do a lot of large-format pages. Francesco did beautiful covers and many inside pages for very little money, if any. Since he and Bob were best friends I was the one who was always taking major heat from Francesco over his credits—they were never big enough to suit him. And when they were big enough for him, they were much too big for Andy. This may have had something to do with an extended period when Bob and I didn't speak, relying on intermediaries even at close range. It was just like in the movies: we'd be standing a few feet from each other and using an emissary.

Where once we had been able to wrangle interviews with aging directors like King Vidor or Nick Ray, or old movie queens, now we were able to get to the top stars and do interviews with them that were unlike anything anyone had ever read—especially the interviews conducted by Andy (he usually did one per issue). The *Interview* interview became a real style; it was full of chitchat and details, things that would never appear in the *Playboy* interview or the *Rolling Stone* interview. Andy loved doing interviews for the same reason we all did: it was a perfect excuse to meet the people you wanted to meet. Even the people you had a crush on. Berry Berenson interviewed Tony Perkins, whom she had always had a crush on but whom she had never met. She came in with about a sixty-page manuscript. I must have had a crush on her, because I printed the whole mammoth thing in two installments. But somehow

something got left out or slightly switched around, and she actually got mad at me. I had to print a correction in the third month. She and Tony got married and I don't even get a Christmas card.

Because of its page size, great paper, and ever-improving printing, *Interview* became a showcase for photographers, both the young, unknown, and ambitious and the old, famous and ambitious. Even if it was selling fewer than 100,000 copies a month, it was reaching fewer than 100,000 of the most fabulous people in the world.

When we were still small and I opened the mail I would get a subscription check from someone like Tab Hunter and have to decide whether to cash the check or keep it and send him a freebie. But as we got bigger we got people who would unquestioningly deposit Tab Hunter's check for us. We got a business manager and assistants and art assistants. We had an advertising sales staff which included Susan Blond, who later became a V.P. at CBS Records and a top publicist on her own. Susan was a painter at the time. I met her at Max's Kansas City and hired her to sell ads because she had an absolutely unforgettable voice and Gracie Allen logic, and she wouldn't take no for an answer. Pretty soon we were really selling some ads. We were taking off. Bob was out there in society. Andy and Paul's movie business was accelerating. *Interview* began to increase its scope. It had a fairly hot although perhaps solipsistic gossip column. It began to cover more music, art, and fashion.

Andy and Paul were listed as the editors, but usually they didn't see the magazine until it came back from the printer. This led to my almost being fired twice. The first time was when Paul was making *Frankenstein* and *Dracula* in Italy and hanging out with Roman Polanski. We published an extensive interview with Ed Sanders, who had just completed a book on Charles Manson. There were a few rather bland references to Sharon Tate and Polanski in the interview, but Paul went through the roof and ordered me to rip two pages out of 60,000 copies of the magazine. He cooled off after I spent about fifteen minutes ripping the pages out of three or four copies, rolling my eyes and protesting my innocence. I didn't even know Polanski was involved in their films.

At another point Paul decided that there was to be no nudity of any kind and no four-letter words in *Interview*. This

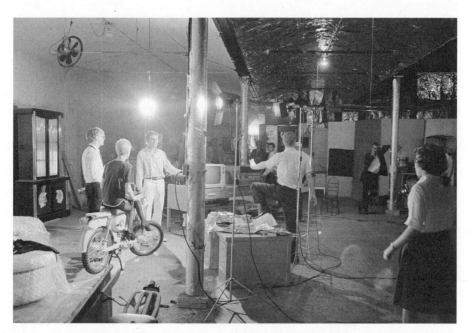

Stephen Shore

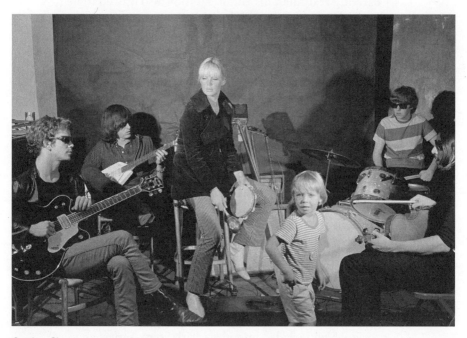

Stephen Shore

was a man who had built his career on nudity and had made a movie entitled *Fuck*. But Paul was a man of contradictions who tended to call his stable of actors "drag queens and drug trash." My mistake, although deliberate,was to feel that a comprehensive interview with Rudi Gernreich would be a travesty without an accompanying photo of his topless bathing suit, modeled by his wife. I can't remember how I got out of that one.

When I left the magazine in 1973, Rosemary Kent was brought in as an editor. *Interview* was getting more and more society and fashion-oriented and Kent brought to the job the credentials of having been accessories editor at *Women's Wear Daily*. Actually, she was one of the people behind the influential "Eye" gossip column, which had featured Andy and Fred extensively. Fred had even become a fixture on its best-dressed list, which he certainly deserved.

Rosemary Kent didn't last too long. Although she came from a society page world, it may have been her social graces that were her undoing. A high-profile job requires extraordinary stamina not to mention continence. She was quickly replaced by Peter Lester, *Interview*'s playboy gossip correspondent in London. Although Peter was dazzling at dinner, his editorial vision also proved to be somewhat spotty. Soon Bob Colacello was forced to come out of retirement, and suddenly *Interview* was back on track as a magazine with genuine vision.

Under Colacello's direction the formula continued to undergo refinement. Andy's interviews got funnier and funnier as he developed more and more confidence in his post-journalistic ability. Andy was rising to the top of disco society and therefore society itself; he was penetrating the White House, and no one seemed out of reach. And since Bob was as gifted as ninety-nine out of a hundred ambassadors to the U.N., *Interview* found itself with virtually unlimited access to people. The magazine became a brilliant mix of great photography and extraordinary interviews with all sorts of celebrities from film and the art world, from the Social Register, and from the corridors of power.

Bob, who as a college student had shown a definite leftist, SDS-sympathizing bent, had since bent the other way. He was now very interested in Iranian royalty, Mussolini's progeny, the Perón family, and the like. I recall an issue with California governor Jerry Brown on the cover which included interviews with Spiro Agnew and

two or three dictators' children. Bob was also publishing his social diary as the "Out" column. It was a well-written, amusing documentation of his obsession with high society, but it rubbed a lot of people the wrong way, since it tended to ignore the perhaps antisocial side of some of Bob's socialite friends. Whatever one's attitude toward Bob's subjects however, those were brilliant total-access records of the inner workings of people whose public profiles were otherwise formal and abstract. *Interview*'s chats with Ferdinand Marcos about golf (he was a cheat) or with Cambodia's Prince Sihanouk about jazz achieved a documentary quality that transcended liberal criticism. I never felt you could hold Boswell responsible for the crime of Dr. Johnson.

Still, I think Andy was less than thrilled about Bob's monarchist tendencies, being a Kennedy Democrat himself, and Bob's let-them-eat-risotto politics definitely contributed to his falling out with Andy. But that whole story is in Andy's diaries. And I'm sure another side of it will appear soon in Bob's long-awaited book.

When Bob left, the editorship of *Interview* was taken over by managing editor Robert Hayes, a bright young man with a great eye for photography. Robert was especially open to the work of young photographers, and his "Modern Masters" series helped introduce many of today's superstar photographers, such as Matthew Rolston and Herb Ritts. Robert died of AIDS in 1984 and was replaced by Gael Love who had worked her way up from answering phones to editing copy to running the magazine. Gael very much exemplified the Andy Warhol Enterprises way of doing things, a sort of studio system that encouraged such advancement. If you could do something well, you got a chance to do even more. Andy was a very smart employer. He hired people to do all the things he couldn't do himself. Andy couldn't say no, for example, so he loved Fred, who was brilliant at it.

Andy encouraged upward mobility in the ranks. When I started at *Interview* a young guy from California with shoulder-length blond hair was sweeping the floors and answering the phone at the Factory. When he wasn't busy he'd sit at the reception desk reading about Hollywood moguls like Irving Thalberg and Louis B. Mayer. Now Vincent Fremont is a mogul with the Warhol Foundation.

Interview's young art director under Robert Hayes was Marc Balet, an architect by training, who in a lot of ways put *Interview* over the top. It was under Marc's innovative art direction that *Interview*'s look caught up with its already widely imitated editorial concept. It was still not setting the world on fire with its sales figures, but it burned up the world several times over with its aesthetic. I think it has probably been the most widely imitated magazine of its time, the biggest influence since *Life*. What's interesting is that some of its imitators got bigger than their role model. I believe that archaeologists may someday discover that *Interview* actually inspired Time-Life to put out *People*. *People* was *Interview* for the millions.

By the time *Interview* moved uptown, to the former Con Ed power plant that had become the new, finally factory-like Factory, it was a real business, with a large staff and a regular turnover. But *Interview*'s turnover—unlike that of most magazines—was of a more voluntary sort. The kids on the staff were often socialites, and they usually left to go to graduate school or to take over the family business. Doria Reagan, the president's daughter-in-law, was an assistant to the editor. Another *Interview* staffer was known to cry every week when she saw the size of her paycheck. The day she left, all of her checks were found in her desk drawer, uncashed. Although *Interview* was now a professional business in many senses, it was also a sort of fine arts prep school, art world training ground, and literary proving ground. It was where young writers, photographers, and artists first broke out. It was where the old pros came back to do their own thing with perfect freedom.

I'm not sure where to leave off this reminiscence. I'm leaving out quite a lot of recent history, but maybe I should save all that for the thirtieth-anniversary issue. I do wish that Andy were around to see this twentieth anniversary issue. What started as something to keep the kids busy became one of his favorite things. It didn't get out of hand as the movie business tended to. Andy always had the "final cut" on *Interview*. It was an in-house operation, and Andy was the house. He might not have been the most hands-on publisher in the world, but he certainly had the biggest aura of any publisher. And Andy was usually able to create the magazine with his aura alone, so there was no point in giving too many direct orders. Andy ruled by suggestion. That's a supreme executive gift, and

I think that because of it *Interview* always reflected Andy's interests, aspirations, and tastes.

I remember when I was doing the art direction Andy said, "Gee, that typeface looks so great. Maybe the whole thing should be in that typeface." Andy had a way of making you feel that his idea was your idea. And that's where the corporation can get lovely. That's the hope of our team future.

I think what Andy liked most about publishing *Interview* was that it gave him something to talk about at parties. And it gave him something concrete to offer: being a cover girl or cover boy. If Andy met somebody he liked, he very often volunteered to put him or her on the cover. Then it was up to Bob, or Robert, or Gael Love, or whoever was in charge, to be the heavy. When Andy was around, *Interview* should have had several covers, at least a front cover and a back cover, and even that wouldn't have been enough to keep up with the demand for Andy-offered covers.

Andy loved to walk around town with a big stack of *Interview*s, which he would autograph and give out. As his paintings go for millions, it's easy to forget that Andy was the greatest practitioner and the most revolutionary theorist of Pop art. He was the one to broach the ideas of the artist aspiring to be the machine, the studio as a factory, the artist as a process director, the artist as a means of production. *Interview* was Andy Warhol's way of making art for a big audience.

Andy's favorite part of the magazine was the ads. He was always impressed when there were ads from big companies in there. He knew he was really doing some business. His best pal on the staff was advertising director Paige Powell, and the two of them were constantly working the room for *Interview* wherever they went. Although he would often complain about it, Andy loved being put on display to the advertising people who attended *Interview* luncheons; he loved the business side. And although he illuminated the world in many ways as an artist, one of the very brightest things he ever did was to show that art is business and business can be art. And to give the kids something to do.

Unpublished, November, 1989

FUN CITY GETS AN F IN ART.

Some years ago, I travelled to New Mexico
State University to give a lecture on art.
It was a long trip, but I arrived in plenty of
time to tour the campus, and no tour would
have been complete without visiting the cows
with port holes. This herd of bovines had
windows installed in their sides so one (or
more) might observe the digestive processes
of cows, something comparatively spectac-
ular in the world of peristalsis, as cows are
widely known to have four stomachs.

This was certainly an amazing and
educational sight, not so far afield from
Damien Hirst's sliced cows and pigs that are
preserved in formaldehyde and exhibited in
galleries. What makes one an academic curi-
osity and the other fine art is apparently the
context (muddy paddock vs. white walls) and
the intention of the perpetrator of the work.
Mr. Hirst is an artist and therefore his sliced
livestock are considered art and exhibited

in such places as the Brooklyn Museum
where they are sure to horrify the average,
naive museum visitor while delighting and
titillating the in-the-know museum visitor
who is, in fact, delighted and titillated not
so much by the object itself as by the horror
it precipitates in viewers far less sophisticated
and knowing than himself. Such was also
the main attraction of another work in the
sensationalistic "Sensation" show at the
Brooklyn Museum: a portrait of the Virgin
Mary executed in media that included porn
scrap and pachyderm poop.

Shocking? By the standards of Andres
Serrano's "Piss Christ," a crucifix immersed
in the artist's urine, this was pretty tame stuff.
But the Mayor of New York was offended.
This is blasphemy. This is sacrilege, he pro-
claimed. Well, "duh." The publicity inherent
in outrage would seem to be the entire
point of making such items. If artists were
sincere about attacking religious hypocrisy,
they might spend their time detailing in an
esthetically appropriate manner, say, the
collaboration of Pius XII with the Nazis, the
Jesuit Inquisition, or the genocide of the
Indians by Spanish missionaries—the kind
of thing an old-fashioned artist like Hans
Haacke could have sunk his gleaming with
integrity canines into.

But these Con Artists know no Ed.
They do know that they can get even more
attention out of sacrilege and blasphemy
than Koons or Mapplethorpe did out of porn
art. They know that if they can make their
work a first Amendment issue it will get a
lot of attention. This is not a sophisticated
notion. I discovered relatively the same
thing when I learned to throw diaper-stored
caca on the wallpaper.

Of course, we all know by now that
artists have the right to make art that is,
literally, shit. The question is, do they have
the right to make us pay for it? There are a

lot of other interesting questions provoked by this otherwise dull exhibit, such as what if it were an elephant dung smeared Torah or Koran? Maybe the problem is that art is getting too close to religion—not as subject matter, but as a role model. Institutional art has way too much in common with institutional religion—shushing in the temple, sleight of hand miracles, mumbo jumbo mysteries, sacred cows, sliced or whole. Why not just consecrate the Art world, register its congregation and give it non-taxable status.

I believe that the Government should be allowed to support Art exactly as much as it is allowed to support Religion, that is, not at all. Forget about it! If Government is allowed to support Art, whose Art is it going to support? The Nazis answered this question one way, when they banned what they perceived of as decadent art and sponsored art that promoted National Socialist values. Today it seems that the Art World mandate is to promote art that offends the general public and makes them pay for doing so.

Maybe this isn't really the First Amendment issue its instigators would like us to think it is. Maybe the essential issues here are more complex and involve a calculus of taste and bureaucracy. Most of our local museums seem involved in conspiratorial relationships with commercial galleries. To me the real controversial element of the "Sensation" show is the fact that the public is paying ten bucks a pop to see a show of works owned by a single collector (Saatchi), sponsored by the auction house that is going to auction them off after this hype-fest is over with (Christie's).

Now I'm sure not saying that Rudy's correct in trying to evict the Brooklyn Museum or withhold its funding. (His Deputy mayor actually called Michelangelo's *David* "unsuitable for children.") But the Mayor might correctly address the issues of corruption that

surround this show, and the question of who the hell curates the museums around here?

There is an ancient cult known as iconoclasm. I guess that's the tradition "Sensation" invokes. But the idea of iconoclasm was to prevent idolatry of the images of subjects held sacred. This doesn't seem to be a growing problem vis-a-vis today's Church. If anything is the subject of idolatry today it's money and fame, and real iconoclasts are artists like Tom Sachs who address fashion logo worship. He must be the dangerous one since the Mayor had his dealer, the dangerous Mary Boone, arrested for arms dealing.

Why is it that our institutions are funding art that's only visible motive is to destabilize the role of art in society, to make it seem more and more irrelevant, infantile, useless and depressing? If there was a glimmer more intelligence present, I'd almost suspect a conspiracy of deep cover Christian Right secret agents. But it's probably just regular greedy art students, speculators and their academic entourage, dumb and dumber and dumbest. Of course, the mayor is just as much a dumb ass, busting galleries and real artists. Free Mary Boone!

Paper Magazine, 2001

"The world is intolerably dreary. You escape it by seeing and naming what had heretofore been unspeakable."

Richard Prince, *Birdtalk*

EXILE ON MAIN STREET U.S.A.
RICHARD PRINCE IN AN UPSTATE STATE OF MIND

I remember when Richard Prince moved "upstate." It left shockwaves.

It was a heroic move. Not exactly Leif Ericson sailing off to see if the planet had an edge to fall off of, but definitely a bold and possibly brave gambit. To leave the capital of the (art) world to go live among the rustics, the hicks, the rubes, the inbred clodhopper rednecks we came here to avoid if not utterly deny, well, that was either ballsy or insane.

It seemed like a certain group of hipster illuminati and bohemian masters had been here forever, or at least since they were nobodies, and their presence was what made downtown Manhattan the rightful capital of the art world. A certain crew seemed to make it all happen. And even though that crew was constituted of notorious individualists and professional rebels, moves like this were unheard of. They were scary. You don't leave the club voluntarily, you have to get thrown out. And here was the upcoming guy, the leader of the cool school, the cat who gave us the Marlboro Man, the jokes, the girl-friends…heading into self-imposed exile or something like that.

Lots of people moved out of New York, but usually it was because things weren't working. They moved to L.A. to make it in the movies or to Minnesota to dry out or get away from the heroin dealers down the street. But people like Richard didn't ever move. Why would they? Everything was working. The work was great. He was getting his due. If he wasn't on top of the world, who was? And besides that, New York City is where it's at. Isn't it? Isn't it? It made one doubt one's most basic assumptions. Why are we here?

But there were signs, signs he was on to something. Richard is my friend and I trusted his judgement as much as his graceful golf swing. I knew he wasn't running; he was seeking. I figured he was addressing primal issues. Like how can you be an outsider when you're so in? I myself had thought about moving to Palermo or Kyoto, but I couldn't afford it. But upstate?

Before the move Richard lived around the corner from the Odeon, which was like the art world cafeteria. When Paris was where it was at, it was La Coupole. This was La Coupole on coke. Everybody went there or Barocco, an art restaurant a few blocks away or a half a dozen other art bars and bistros in the hood. This was where art forces conspired and held maneuvers. It was the center. (Just a few blocks North of the Trade Center, it was Art Ground Zero.) Richard had three big loft floors on Reade Street. He probably didn't need three floors, but he didn't want anyone living above him or below him. He didn't want to hear them walking around, didn't want to hear their music.

Richard had tried L.A. I remember one time when we were both staying at the Chateau Marmont in L.A. It hadn't been renovated yet but it was a great place to live for a while. We had real apartments with kitchens and there was a topless bar across the street full of dancers that wanted to be movie stars. Richard had been there a lot longer than I had and the only thing in his refrigerator was film and wine. He had bleached his hair blonde and was wearing leather chaps over white Levis. In the evenings we would go to a bar in a bad neighborhood called Club Fuck. What I mostly remember was Richard saying in that casual way of his: "I think I'm going to die soon."

Of course he could have. He had a perfect legacy all set up. A tremendous body of work that had barely been explored. An impeccably cool image. He was already a liv-

ing legend, living in a hotel suite where Jim Morrison had probably crawled out on the ledge to dangle over Sunset Boulevard. His art was the Marlboro Man and the world's largest Marlboro Man was right there outside the window.

But then he didn't die. He moved upstate instead. Good move. Far better than death.

And although it may have seemed insane to some of his peers, who saw his life as perfect, or at least something that they would shoot for or die for, especially when that famous actress was living in the loft, this escape from New York made total sense. Suddenly Richard was the Snake Plisskin of the art world.

Everybody needs room to grow if they're going to continue to live, and Richard needed acres. He went to a place where he didn't have to buy out the space above and below because there wasn't any. He had acreage on which to flaunt his cultivated sensitivity. And, of course, it was exotic. To most people—the punks, junkies, fashion models and conceptual artists of Manhattan, as well as the third world infrastructure—that was exotic. But for hardcore bohemians they were wallpaper.

But it was bold. It was like using the ejection seat just because it's there.

And so, Richard moved upstate. And upstate is a place, but it's also a state of mind. It's a place of ruined farms and abandoned drive-in movies. A place where, if you are lucky, the government pays you not to grow something. A place where everyone has a rusted-out car in back of the house, maybe with a tree growing through it. Where everyone is armed and that's a good idea. You've got bears, coyotes, baby eating bald eagles, rabid raccoons, angry veterans, trigger happy hunters, meth labs, cranked up long distance truckers, correction officers who commute and keep to themselves, and guys that just have that Federal Witness Protection Program look.

But that was before the farm. In the beginning there was a house in the village. It started out as a weekend getaway that Richard bought with his ex-wife. Then, according to local legend, when she started planting flowers he didn't like next to it they split up and he bought her out. They were married about as long as Michelle Phillips and Dennis Hopper or Ernest Borgnine and Ethel Merman. The house in the village had an almost farm-sized back yard behind it with a barn big enough for a studio and muscle car storage.

Richard Prince

The town Richard Prince calls home is closer to
Altamont (N.Y.) than Woodstock. It is basically a lovely
one street 18th Century hamlet, a tiny relic of decorative
gentility from the days when Dutch Patroons and
British gentlemen farmers rubbed elbows in the Catskill
Mountains. A mill stream rushes past the abandoned
mill, and pioneering New York weekenders and retirees
polish up the perfectly quaint homes filled with perfectly
quaint antiques. It's all so peaceful but it's a facade. Just
head out on the highway and it's heavy metal thunder,
and an orgy of roadkill mayhem under the wheels of
Dodge Rams with racks of loaded 12 gauges.

Surrounding the beautiful town there's a local society
of revolution-descended tattooed mutants, roadhouse
waitresses and paintball warriors, and custom car com-
mandos and they're loaded for bear. The hamlet, once in
the running for state capitol, has a name, but Richard likes
to call it simply R'ville. It's not that he wants to rename
it for himself; it's more like the way they use initials in
Alcoholics Anonymous. He doesn't want his town becom-
ing the next Marfa, Texas, that minimal art theme park
devoted to the work of Donald Judd. Which, by the way,

it has already been called by the *New York Times*. Richard laughs at the idea that this nowheresville is the new Marfa, but still he'd rather call it R'ville.

Which might seem a little paranoid on the surface of things? This is the boondocks. It's nowheresville. You'd have to be paranoid to think this redneck area could be a sort of theme park suddenly descended upon by hordes of eggheads and big shot art collectors, but as William Burroughs said, "a paranoid is a man with the facts," and stranger things have happened. And what happens when the locals discover that the guy with the paint splattered jeans who looks like them in his pickup and baseball cap is really a famous painter? Jeez, I thought he painted houses…. A paranoid is a man with the facts.

And cool, modest, low key, elusive reclusive Richard is now Andy Warhol. Somebody's got to be. Norman Mailer used to say that being a novelist was like running for President. Being an artist is like that, except it's more like running for Pope. And now Richard is the Pope, as much as Drella was back then. He did it with the old Muhammed Ali Pope-a-Dope. A secret footwork and sleight of hand technique. He's our reigning American art champ. And now his work is going for millions. Somebody's has got to. And nobody's better. That's the way it works. The old guys die, and your guys inherit the chairs and thrones and driver's seats. And why shouldn't R'ville be Marfa North? It's easier to get to. It's not as hot and dusty. And with all due respect to Judd and his crew, Richard and his locals are more strange and exotic than some minimalists and cowboys who spend their time like our President, "clearing brush." Besides, Marfa is Texas, and Texas is Texas. R'ville is America. The real America, all crew cabs, smokeless tobacco and 64 oz. plastic bottles of corn-sweetened soft drinks.

This is the heartland. Beautiful farms taken out of production by tax codes. A gorgeous foothill region, as beautiful as anyplace aside from the defacements of the American dream. Rolling green hills dotted with the ruins of ambition and the architecture of folly and madness. Welcome to Un-Tuscany. Here people tie yellow ribbons on their old oak trees. Giant dishes pull down evangelists and NASCAR and porno from space. They have shrines to the Virgin right next to a ceramic troll sitting on an Amanita muscaria mushroom. The ruined basketball hoop

in the fallow field, the abandoned swimming pool filled
with algae, Richard didn't make this stuff up. This
is America's heartland. And it needs a pacemaker and a
triple bypass. But as ruined and fucked up as it is, it's fertile
and that's what Richard is doing up here. This is compost
culture. He's cataloging the unspeakable. Why is the un-
speakable unspeakable? Because the language hasn't been
invented yet. The real facts of America just get plowed
under and irradiated by Dawson's Creek and the O.C., but
by going out into the field, like Walt Whitman or Vachel
Lindsay or Margaret Mead or Gaugin, he's sending back
images of a truth so ignored it's amazing.

Richard Prince's place is high up overlooking the
village on a dead-end road. In the distance one can see the
Catskill Mountains. That's where the jokes come from that
Richard puts in his paintings. There's the house, a couple
of garages, one resembling a gallery, and a studio that's like
loft in the middle of nowhere. Plus various barns and sheds
and birdhouses. It started simple, but now it's a full-on
compound dotted with structures and with vehicles—pick-
ups, racing cars, bicycles and a fantastic full-dress Harley.

Down in the village is Richard Prince's library.
It's sort of a successor to his old bookstore which was just
down the main street—R'ville Books. The bookstore was
open a few years back, on weekends and/or when he felt
like it and could find somebody to work there. It was part
store, part installation, part deaccessioning of a collection
gone out of control. I found some fantastic things there,
a few at ridiculous prices. It was more concept art than
retail and one almost looked around for the hidden cam-
eras. You could find amazing books there, but you knew
Richard had four more of them stashed somewhere.

The library is extraordinary. It's the next step
after a bookstore. It's when you decide to keep everything. A
beautiful eighteenth-century townhouse, perfectly re-
stored, it contains the crown jewels of a lifetime of obsessed
collecting. It gives the impression of the ultimate men's
club, a sort of blend of the Players Club and the Century
Club and the Explorer's Club and the Playboy Club, but
with only one member. Leather sofas, great art, and shelves
of great books and rare magazines, and exotic ephemera.
Here you'll find the only collection of *Black Mask* maga-
zine, the pulp magazine started by H.L. Mencken where
Dashiell Hammett, Raymond Chandler and Erle Stanley

Gardner published. And here's Nabokov's own copy of
Lolita, and bound galleys of *On the Road*. There are shelves
and shelves of first editions and exceptional association
copies and important LPs. A lot of it's about the sensibility
bounded by the authors and artists Richard loves: William
Burroughs, Richard Brautigan, Phillip K. Dick, Harry
Crews, William Gibson, Larry Clark, Milton Berle, Tim
O'Brien, Helmut Newton, Andy Warhol, Christopher
Wool, and Bob Dylan. It's more than a connoisseur's col-
lection on display; it's a compendium of initiatory texts
containing the arcane of the secret society of which Richard
is Grand Dragon.

The artist still known as Prince is one of the few art-
ists to understand that in American culture shopping
can be art. This is the ultimate society of conspicuous
consumption, so why not practice that as art. Donald
Trump's "Art of the Deal" is not art. But Richard Prince's
bookstore was art. And the library is a sort of personal
museum as art work.

The plan was to open the library to the public.
Of course there is no public here, since this is not Marfa
North. There could be, but as Richard Prince looks
around at what he's built he voices doubts. Maybe it is
a one-man club. "Maybe I'll sell it with everything in it,"
he says. He's not kidding. Richard has a way of trying out
ideas to see how they sound.

Outside the town is Richard's other museum. "Second
House" is an unfinished "ranch" home in the local style.
A sort of bombed out construction site of the kind one sees in
America's rural landscape. An unfinished ruin, it sums up
the broken dream. The house was begun as a hunting lodge
on a beautiful patch of land looking out on the Catskill
Mountains, but it was never finished. Richard says it belonged
to a cop. It's basically an All-American outdoorsman crash
pad. There is no trace of a woman's touch here.

The exterior is silver, exposed installation. It's kind
of a look in this ramshackle landscape, where it seems that
a lot of the houses have big Tyvek logos all over them. That's
the name of the brand of choice. Richard even has a Tyvek
wall on his own house, which is under construction. But
for Second House that's all there is. There will never be
pretty white clapboard on it, or even vinyl siding. It will
always be bare insulation. It's a house as flayed as a
skinned deer. And the more you look at it the more it looks

like a descendent of the old silver Factory where Warhol
made Pop Art happen. There's no logo here. Just silver.
Reflecting the sun for miles. It's very retro futuristic.

"Second House" is so called because Richard made
"First House" in L.A. in 1993. He acquired a crummy L.A.
pad, the kind of place where crack is usually smoked before
the arsonists arrive and he trashed it beautifully, filling it
with art for one last blast before oblivion. "First House" is
gone, having fulfilled its destiny of beauty then blast-off.
And actually "Second House" is actually Prince's third
"private museum." In 1983 he rented a storefront on New
York's Lower East Side and opened "Spiritual America,"
where he exhibited the work of the same name. (Spiritual
America re-opened in the original location for a few days
recently, featuring a reprise of the original work with a
grown-up Brooke Shields.)

Meanwhile "Second House," remarkably, has gone
from being Richard's private museum to belonging to the
world. Or the Guggenheim Museum, anyway. It will be
open to the public, in some form or other pretty soon. It
would have been opened already except that local govern-
ment officials determined that this delightful architectural
detritus had to be made wheelchair accessible, which means
ramps and bathrooms. Ridiculous. Shucks, hereabout folks
is in wheelchairs cause they's too fat to walk. They've been
supersized into another dimension.

Imagine making crack houses wheelchair accessi-
ble. That makes about as much sense. But a museum is a
museum is a museum. "I guess Chuck Close might want to
come," says Richard, with zero humidity dryness.

Behind "Second House" a 1973 Plymouth Barracuda,
painted flat black, sits in the weeds like a sleeping predator.
It's got custom scoops in the grille and despite the run-
down appearance of the house, the car at least looks ready
to rumble. There's usually a muscle car sitting in the back
yard of the houses around here. Sometimes a bunch of
them in various states of repair/disrepair. This one looks
like it's ready to scream down the asphalt ribbon outside,
leaving an abstract rubber trail, but it's as much an art work
as the hoods hanging on the walls inside, or the concrete
barrier sculpture in "the living room."

Richard isn't the first artist to do his own museum,
but it seems like the future. When an artist curates his own
museum nobody has to pretend to be objective, nobody has

to write things in academic jargon, nobody has to show anybody for political or financial reasons. Keeping it small may be the way to preserve a certain integrity. The Guggenheim Museum, which purchased "Second House" from Richard Prince, was founded as a museum for non-objective art. But over the years they not only wandered into figurative painting, they seemed to stray into the field of big business, mounting shows of BMW motorcycles and Giorgio Armani fashions. Maybe "Second House" is a way for them to save their soul. Meanwhile the big show at the Boston Museum of Fine Art this summer was Ralph Lauren's automobile collection. But I suppose every art museum starts out with integrity. Maybe in a few years "Second House" will be doing a show of Sprewell Rims. Anyway, I think this single artist museum thing will catch on. It's too good not too.

Godlike. That's what it is. It's godlike to create your own world. To make your own personal heaven out of nothing, or what other would-be gods would take for nothing.

Richard Prince is Pop Art The Next Generation. He's to Andy Warhol what Jean-Luc Picard is to James T. Kirk. Sort of. Or the other way around. But anyway, this Pop Art is way different from the first round. It's much less primitive. There are a lot more bytes. The memory banks are customized. And where the first round of Pop was sort of media-based—newspaper photos and comics and commercial packaging—this one is more human. Richard's work is sort of a weird fusion of Pop and the Hudson River School of painting. Imagine Frederic Church doing Mel Ramos. Or Ray Johnson doing Asher Durand. Except that's not it exactly either. It's big and smart and deep behind a fantastic façade of picayune, stupid and shallow. Or something.

Art used to present the bigger than life, the richer than rich, the divine and mystical. And then it used to present the horror, the nightmare, the monsters from the id. But Richard came along and used it as a carnival mirror, showing the way things really are to people who don't look for that. Who'll do anything, watch anything on TV to avoid what's right across the subdivision street. Yeah, Richard Prince is the great American artist. His work is universal but it's of this place. This place at the end of the road that never ends. Richard's discovery is a deadpan miracle, the weird landscape of the American soul. It's like

the end of the Wizard of Oz: "…It wasn't a dream. It was a place…and you and you and you were there."

Ashley Bickerton, a contemporary of Richard Prince who left New York eleven years ago for Bali, had some interesting comments in a recent interview that bear on Richard's exo-Gothamism: "When I used to walk into a gallery to look at some new show, the only thing in my head was, 'tell me something I don't know!'" Well, I guess finally it came around to asking that same question of geography. There are of course, serious ups and downs built in. The difference between work and career is drawn into sharp focus. "The description 'deep studio' could not be better understood than from this remove. The distractions of 'the game' are almost nonexistent, and time becomes porous and without fabricated constraint… From this distance it is seemingly impossible to pull a hard focus on constrictions and nebulous imperatives that have no urgency."

The art world has this insidious way of enforcing style. The market is part of it. The marketing mechanism and the P.R. machine are part of it. And somehow the artist begins to think that repetition in the studio is natural, that it's like getting up in the morning, when really it's just marking time, as they say on the parade ground. The real artist invents art every time he works.

Richard Prince has always moved on to something new, even when it would have apparently been in his interest to stick with what's working, and the ability to do that, the quick footwork, could have something to do with his exile on main street R'ville. Not only nobody to tell you what to do up here, but nobody to say good going or I told you so. It's not achieving nirvana, that's inside. It's putting nirvana on, outside.

The real thing about upstate is that it's so out it's in. It's going nowhere. It's renunciation. It's in Richard's head. Like he said a few years ago: "The thing is I really don't see art. For me it's there everyday. It's a world, an inside world. And I like a world I can go in and out of when I'm done."

Another Man, 2005

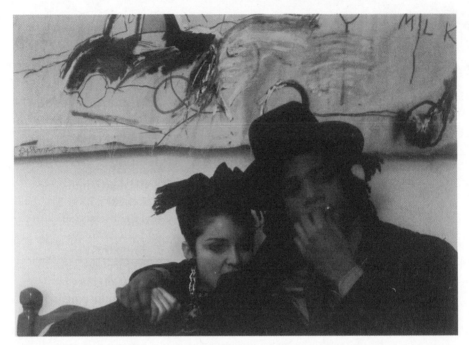

Glenn O'Brien

I REMEMBER JEAN-MICHEL

Every once in a while, Jean-Michel stars in one of my dreams. He always looks good, his skin clear, eyes white. Usually he has his antler dread-locks on. One time he told me he was feeling a whole lot better but he couldn't visit for too long because he was on his way to Chicago. He told me that if I ran into any of his friends who owed him money that he still wanted it back. In one dream he was painting outdoors at an easel with-out a shirt on. He told me he was cold. It wasn't the first time he told me that in a dream. Maybe you still feel your body over there and you feel how cold it is. Or it may take even longer to shake a jones in the twilight zone.

I remember when we got stopped by the cops in Harlem at 3AM. I said "Don't worry. They can't search us. It's not legal." He said, "the cops can do anything they want." And that was before Michael Stewart died in handcuffs.

I remember Jean-Michel giving me an orange t-shirt with Greek letter on the front. It turned out it was from a black fraternity. I always felt like Jean-Michel had pledged me to the black fraternity and I still feel that way.

I remember Jean-Michel drawing a crown on the back of my motorcycle jacket. I think I had the first tagged jacket in town. It made me feel even more like a king than usual. And I still feel that way.

I remember when Jean-Michel sold a small painting at the Fun Gallery that he said it took him ten minutes to do it. He figured he was making $60,000 an hour.

I remember Wendy laying on her chenille bedspread where she was always losing

a big rock. She had left
a twenty lying on her bed-
room floor to see if Jean-
Michel would take it. He
did and that was the end
of their brief romance. I
remember hundred-dollar
bills lying all over Jean's
place. If Wendy had still
been around she would
have scooped those
motherfuckers.

I remember when he was
19 Jean-Michel got spots
all over his skinny legs.
He freaked and went to the
hospital for a few days.

I remember Jean-Michel
inviting me over for a big
steak dinner. That was the
night I met Vrej. He had on
a big gold watch.

I remember Jean-Michel had
every Hitchcock film money
could buy.

I remember when Jean-
Michel had the front half
of his head shaved and the
back half short and dyed
platinum, wearing an Army
Surplus jumpsuit.

I remember when Jean-Michel
modelled in the Comme des
Garçons show in Queens he
looked like he was doing
community service work as
part of a plea bargain.

I remember Jean-Michel
saying Boom all the time.
It was an exclamation point
with right on built in. Boom.
Boom. Boom for real. It was
better than Warner Wolf
saying "Swish!"

I remember going to a
chi-chi party with Jean and
some rich guy coming over
to us and saying to him "And
what do you do?" Jean said
earnestly "I'm the manager
of a McDonalds" and the guy
just turned and walked away.

I remember Jean-Michel
bringing this guy Jeffrey
around. Jeffrey was hand-
some and dressed straight.
He was a painter supporting
himself as a drug dealer
or the other way around.
After a few years Jeffrey
still looked sort of straight.
He wore a sharkskin suit
but no socks. Jeffrey carried
his base pipe in a briefcase.

His girlfriend was a dominatrix whom he terrified. I remember the night Jeffrey discovered you could make base with heroin in it. He called it Hawaiian Punch.

I remember the way he talked, soft but really fast and forceful. Urgent you might say. With Jean-Michel everything was urgent.

I remember the way he danced, I remember the way he laughed.

I remember Jean-Michel's great love for Funkadelic and particularly "Not Just Knee Deep."

I remember Jean thought Arto was a great artist and he was right.

I remember Ramellzee thinking he was a greater artist than Jean-Michel and Jean liking him anyway.

I remember when I was dope sick and Bobo Shaw beat me out of a hundred, Jean-Michel did a Bobo drawing. Every time I need

to feel like a fool I look at it. I remember Jean-Michel calling someone a bad fool. I don't know if he made up that expression, but he certainly made it his own and it was a merciless and infallible judgement.

I remember Jean-Michel hanging out with Danny Rosen. They were the two most exquisitely judgmental people I'd ever met—both walking a razor's edge between cynicism and idealism—breaking the hearts of every girl and half the boys they met. I remember Danny Rosen cleaning windshields on Bowery and Houston wearing a tuxedo. Not long after that Danny became a commercial fisherman and when Jean-Michel's ship came in he bought Danny a commercial fishing boat.

I remember Jean-Michel going down to Vieques in Puerto Rico when Danny and Leisa Stroud lived there and coming back with an incredible batch of paintings that he showed at Annina Nosei. I especially remember

the one with the turkey in it. I remember Jean-Michel working in the basement of Annina's gallery. He was cranking the shit out and it was great. People talk like she had him chained to an easel in the boiler room feeding him blow. I don't know if Annina ripped him off. But it was a nice basement and he was having a great time. I know she bought a painting from me for three grand and when I tried to buy it back she told me it was a hundred grand. I remember, though, that she was the gatekeeper of the studio and when she wouldn't let Henry Benvenuti into the studio I threatened to throw her down the stairs of the Mudd Club. Of course I was bluffing. Steve Mass was my good friend and I would have never thrown anyone down his stairs.

I remember DJing Monday nights and Jean-Michel sitting in the booth with me scratching and me playing Car Wash by Rose Royce and him mixing in this flexi disc of a McDonalds commercial

that I had with exactly the same groove.

I remember one night late in the history of the club we showed up at the front door and they wouldn't let us in. This was unbelievable. Finally the doorman said that no blacks were allowed in that night. They were trying to keep the drug dealers out. Outraged, we called up Steve. He came down and let us in the club and then worked the door himself until 4AM.

I remember the night I met Valda at the Mudd Club. She said to me I crave you. I didn't know what to do. I think she might have said the same thing to Jean-Michel later and he seemed to know what to do.

I remember Jean-Michel's eyelashes very very well.

I remember making Jean-Michel a movie star. He spoke so softly he was almost a silent movie star but he had that star quality. I remember

the co-producer Patrick Montgomery calling Jean-Michel "boy." He didn't take it too well. Later Patrick made a movie about the Beatles.

I remember Jean-Michel always had great pot. I usually had great pot too. Sometimes we had great pot smoke-offs.

I remember Jean-Michel laying on my floor with typing paper and crayons watching TV. He liked to watch anything.

I remember Jean-Michel painting big canvases on the floor and walking over them.

I remember Jean-Michel painting a big canvas on the wall and nodding out in mid-brush stroke for thirty seconds and picking up right where he left off.

I remember Jean-Michel bugging me all the time to take him up to the Factory to meet Andy. He had sort of met him once on the street trying to sell him a t-shirt. I

remember introducing them. Later Andy asked me if he was dangerous. I don't know if he was scared for himself or for Doria Reagan, Ron Junior's wife who worked at *Interview* next door.

I remember being really jealous when Andy became Jean-Michel's friend. Really jealous. Jean-Michel was the only person who ever smoked a joint in the Factory except for Richard Bernstein.

I remember talking to Andy on the phone years later and him moaning "Oh, he's so on drugs. I mean what can you do?"

I remember being drunk and standing on a chair at the dinner Vrej had after the posthumous retrosp- ective and toasting Jean- Michel with a joint instead of a drink in front of a few hundred people. At least Ouattara dug it. He and Jean totally understood each other even though they had no language in common.

I remember Joseph Kosuth putting his portrait by Jean-Michel in the closet because he was a painter and Joseph could support painting to that extent. Also I think he didn't like the fact that the drawing showed Joseph smoking a cigar holding a bottle of cognac and it said Joe Kosuth on it. Nobody called Joseph Joe. Right Joey?

I remember the "Whole livery line bow like this with big money all crushed into these feet/plush safe... he think."

I remember "Pay For Soup/ Build a Fort/Set it On Fire".

I remember cooking Thanksgiving dinner on Mott Street and Jean-Michel bringing his new girlfriend Madonna over for turkey. She had long, dark braided hair and she was a singer. I'd never met anyone named Madonna before. I thought she was black. She tells me that was the only tan she's ever had. Jean and I smoked joint after joint and the girls got hungrier and hungrier. When they broke up I thought it was too bad. They seemed like a good couple. A few months later she had a record come out. It was really good.

I remember Jean-Michel calling Jerry Wexler an "art pimp."

I remember him dancing in the basement of Nell's with a double shot of tequila in one hand and a joint in the other. I remember one night at Nell's he showed up with his face totally covered in aluminum foil. Maybe that was the beginning of his skin problem.

I remember him being really bugged by his skin problem. I remember him asking me about dermatologists and if I knew anyone who could help him with the splotches on his face. I was more concerned with trying to get him to go to an acupuncturist to kick the dope habit, but he seemed more worried about his face than his habit. I always thought that the skin

thing was caused by the fact that he had no spleen. He was hit by a car when he was a kid and it ruptured and was removed. I think that's why he had such a hard time detoxing and why his skin was so fucked up.

Because of his skin, people thought he had AIDS. He told me he didn't. William Burroughs said he told him he did. Peter Schjeldahl wrote that he did, although I don't know how he could have known that. I don't think he did. I think he might have mentioned it to me before Burroughs. Although Burroughs is a bit more priestly than me. And maybe Burroughs fancied him gay. He wasn't gay. He might have slept with a guy at some time or other but it wasn't me and nobody else told me they did. When somebody'd asked Tallulah Bankhead if Montgomery Clift was gay she replied, "He never sucked my dick."

He had two portraits of himself in his studio. One was an oxidation painting by Andy, a piss portrait, and one was a self-portrait. He thought that they were prophetic because he painted himself missing a front tooth and shortly thereafter it got knocked out. Then Andy pissed on his metallic silk screen and splotches oxidized on his face and then he got them boom for real.

I remember when Jean got his first apartment. Actually he shared it with Suzanne Mallouk. It was on First and First. He had great paintings all over the place and she had bad paintings all over the place and little poems taped up on the wall, like next to the light switch. She was beautiful but could not have been more pretentious. I wonder if she ever met Ruth Kligman. Anyway I remember when she got pissed off at Jean she threw all his paintings out the window. You could look out their window and see them all there on the tarpaper of the shorter building next door. I think that was the garage that the Bush Tetras practiced in.

I remember Jean had the copyright on almost every-thing. I remember Jean-Michel was never really a graffiti artist. He just painted and wrote on everything. But he was the one who told me the theory of the ever-lasting tag. The everlasting tag was the graffiti tag that was so high up or out of the way that it would never be remo-ved or covered. There was a SAMO© on the top of the monument in Union Square for years until they completely redid the park. But I bet there's an everlasting SAMO© out there somewhere.

I remember asking Jean who his favorite artist was and he said Keith Haring. Pretty soon I started seeing Keith's black and white subway drawings and I met this nerdy looking guy with pink glasses. Then I found out he had been the guy to do body outlines on the sidewalk in front of Hurrah's and put up post-ers of Daily News head-lines that said Hero Cop Shoots Pope.

I remember Jean writing on the windows in the stairwell in the tenement building on Mott Street where I lived. He was doing Aaron draw-ings then. Robert Aaron the sax player who lived next to me thought they were about him. Then Fab Five Freddy started writing on the stairwell because Jean had done it. Pretty soon I got a note under my door: "Glenn O'Brien we know who you are." I asked Jean and Fred to cool it and they did.

I remember when Jean did a big beautiful poem on the stairwell at 33 St. Marks Place when I lived on the sixth floor. It must have been painted over a dozen times by now. I wonder if it could be restored.

I remember when Jean-Michel had his opening at the Fun Gallery, there were hundreds of people in the street. It was like a block party and the cops didn't know what to do. I remember thinking how utterly cool it was for Jean to go from the relatively estab-

lished Annina Nosei gallery to the funky Fun Gallery. The fact is the Fun was utterly elevated by his presence. But I guess maybe it was a business decision too.

I remember Jean-Michel wearing what looked like a woven wastebasket on his head. It looked pretty good. I think he might have been the best dressed guy since Brian Jones.

I remember Jean-Michel smoking Chesterfields. He was the only person I knew who did. I guess he was saving the coupons.

I remember being mad at him when he moved into the studio on Great Jones, renting it from Warhol. It was because it meant that my friend Walter Steding wouldn't be able to live there for free anymore. I myself wrote some unkind graffiti on the door but it was only there for a couple of days before it got sprayed over. I felt stupid about it later and enjoyed hanging out there with Jean-Michel. It was kind of a weird place

though. Especially when Jean died there and then Eric, the brother of Jean's ex-girlfriend took it over for his studio. I just remember passing the studio a couple of days after Jean blasted off and seeing this beautiful little voodoo shrine attached to the door. It was a lot better than any headstone.

I remember him painting a painting that was so great and then just painting over it and that was so great.

I remember how into Flats Fixed signs he was or any-thing homemade commercial.

I remember that the spring before he died, Ethel Scull used to call his house really late at night. I thought that was weird.

I remember that Anthony Haden-Guest was writing a profile of Jean-Michel and he was scared to death about what it was going to say. He asked Anthony to lay off and he did, although why he laid off I don't know. Maybe he was too hung over to

write it. But he eventually did, after Jean-Michel died. I remember Jean-Michel was really strung out before his last show in 1988. He had a habit big enough to get into the Rolling Stones. He had a large bag of hypodermic needles in his bedroom and was shooting a ton of dope and coke. He was trying to stop shooting coke. He was really worried about the coke with some justification. I was clean and I was saying, "can't you just snort it" and I remember people saying the same kind of shit to me. It's not all that simple but then again it is. He was worried about what people were saying about him. Worried that they had built him up just to tear him down. Worried that he couldn't do his show. He had a big block.

Basquiat, Tony Shafrazi Gallery, 1999

A lot of artists today think
that cryptic or elusive will pass
for difficult and deep.

Tweet, 10 July 2014

NAN GOLDIN

I've known Nan Goldin for about 33 years, mostly from
across the room. In the '80s, that room might have been at
the Mudd Club or a party at Cookie Mueller's apartment
or at a crazy little house where Nan's friend Bruce Balboni
lived in Little Italy. I still think about that enchanted/disen-
chanted nighttime world every time I walk down Elizabeth
Street. It was really another world, but maybe realer than
this one. It still flickers in my memory, and it exists in Nan's
work, the best history of life at a certain time and place that
now seems like crucial history.

Cookie, a hard-boiled but unspoiled glamour-girl
actress, writer, and amateur doctor, was Nan's best friend back
then and a tight friend of mine too. Cookie and I had the same
birthday, same sense of humor, and same taste in bad habits.
Oddly, I was wary of Nan for some reason, and maybe she was
wary of me. I knew she was okay, though, because Cookie loved
her, but still we were always across a room. I think our
wariness was the wariness of watchers watching one another.

Now I believe that kind of wariness comes from seeing yourself reflected in someone apparently unlike you. But I knew Nan from her art and always loved seeing exactly what she saw—on a wall or in slide shows at the Mudd Club or wherever. She captured this strange world we occupied from the inside, in all its awkward grace and wounded beauty. She was more than the fly on the wall; she was the wall, and the light too. Maybe I was just saving Nan for later. Now, it's much later, and I find her not across the room but across the table, and I can't help but love her. She's a radiant soul and one who knows what matters.

I visited her in a quiet part of West Berlin, where she lives on and off (she also spends time in New York and Paris). Nan's life has had big ups and downs, and I didn't know what to expect when I saw her, so I was pleased to find her, at 58, seeming together, if a little cranky and jittery around the edges. We finally hooked up after a lot of back and forth. (At one point, she texted me, "I have a terrible relationship with time.")

When I picked her up from the big old apartment where she was staying, she was smoking cigarettes (her only current vice) and fussing over a computer and an espresso machine (neither of which she's master of), preparing to show her newest slide show, *Scopophilia*, at the Matthew Marks Gallery in New York (which opened October 29), and a film festival she's curating in Denmark. We found an outdoor café where she could smoke and we could watch the passing parade. Nan is a wanderer and the closest thing we have now to a classic expatriate. She has mostly been away from New York for years, living in Paris or London, and now in Berlin. Her absence from the United States is on principle: "I decided if Bush stole the election, I'd leave, so I left," Nan says, adding with a laugh, "But it didn't seem to have any affect on politics."

Everybody has been saying that Berlin now is like bygone New York, a place where life comes ahead of business—and is cheap, energetic, full of artists, and open all night, and that was how I found it. When I saw the wildness of the weeds in the parks and trees sprouting from sidewalks, I felt oddly at home. I was staying in a house around the corner from Bertolt Brecht's theater, and the title of Nan's famous slide show and first book, *The Ballad of Sexual Dependency*, was taken from a song in Brecht's *The Threepenny Opera*.

But that was just a title. Nan's pictures were never really about sex but about need, people's need to merge, to be close. The people she photographed were those she felt were extraordinarily beautiful, extraordinarily brave, or both. She felt a particular affinity for drag queens and bodybuilders because of their determination to transform themselves. At the very beginning, she was recording her memories for later use. "I used to think that I couldn't lose anyone if I photographed them enough," she wrote in her 1998 book, *Couples and Loneliness*.

I had just missed Nan in New York when she was here this past summer showing a slide show, the way she has for more than three decades, color photo after color photo tuned to a perfect soundtrack (from James Brown to The Velvet Underground). But I hadn't really missed the show; my friend Michael Zilkha, another survivor of those times, showed a few to me—*The Ballad, The Other Side*, (which begins during her days in Boston), and the self-portrait *All By Myself*. I knew much of her cast of subjects, but I saw the pictures differently now and was quite astonished by the beauty of the pictures, the perfect pitch of the framing, the sublimity of the light.

I always knew that what Nan does was extraordinary, but suddenly it seemed more important, even more urgent than ever. And casually talking to Nan in Berlin I knew why. I was in Berlin on a trip through the art world, and I hadn't seen much in it that moved me. All that money, fugitive from more transparent financial marketplaces, has had a strange effect on what's called "art." What people talk about as art now is often about elaborately conceived, industrially fabricated, and obscenely priced publicity-stunt totems—monuments to senselessness, trophies of hog-wild consumption.

Don't get her started: "For me, the '80s and '90s have been all about cynical joke art. I mean, there are still a few great painters out there, but the YBAs and a few New Yorkers and a few Japanese certainly brought in joke art. I'm still stuck in [Mark] Rothko and Otto Dix. And from doing that work at the Louvre, I have much less patience for contemporary art. Why bother? Can't anyone paint anymore? It fits into my theories about artists. My work might not look like that, but it's still my belief system. Art dealers might as well be drug dealers or weapons dealers. There's not much difference anymore. There's not any difference between the art world and the fashion world, that's for sure."

Nan Goldin

Nan doesn't mind working around the fashion world, and many people from that world appreciate what she does, including Marc Jacobs (whom she shot for *Bazaar* last year). But some get it wrong. "It's really hard for me to do commercial work," she says, "because people kind of want me to do a 'Nan Goldin.' They don't understand that it's not about a style or a look or a setup. It's about emotional obsession and empathy." And it can even be disturbing. "I shot one of the top models for *Vogue* in Paris," she recalls. "She didn't know what the word *ballet* meant."

I have long been aware of a sort of blight on the art world, but seeing Nan brought it into sharper focus. Art has gotten in a habit of ignoring humanity and what comes with it: beauty, desire, and love. "The work has always been misunderstood as being about a certain milieu of drugs and parties and the underground. And although I'd say that my family still is marginal and that we don't want to be part of normal society, I don't think the work was ever about that, Nan said in Jean-Pierre Krief's 2000 documentary short *Contacts*. "I think the work has always been about the condition of being human, and the pain, the ability to survive, and how difficult that is."

Survival is hard, especially when you're sensitive and want to survive sensibility intact. Nan has that double curse and gift of sensitivity, as it seems most great artists do. I can see how much effort Nan puts into her own survival by channeling her spirit into her work.

Nan has been making extraordinary photos since her student days at the School of the Museum of Fine Arts in Boston, where she was introduced to the sexual underground by her friend, classmate (and great photographer) David Armstrong. Eventually, she began exhibiting her work as slide shows, for which she's now renowned.

"I think the first slide show I did was with my friend Bruce Balboni, whom I've known since '72. We did it to entice Cookie and Sharon [Niesp, Cookie's girlfriend at the time] over to our house," Nan remembers. "Since I took a lot more pictures than Bruce did, I started doing them when I was living in Provincetown and had to get credit at art school. I wasn't printing anything, so that's where I got the idea to do slide shows. At first they were just boom, boom, boom. But then Bobby Swope, who was my boyfriend in 1980, started DJing for the slide show."

Today, the slide shows, like *Scopophilia*, which was commissioned by the Louvre, are more technically perfect. Gone are the slide projectors, and sometimes they even feature specially commissioned music. She seems to be evolving the slide show concept toward film, or perhaps opera. I think her disenchantment with what she sees spurs her to keep pushing herself. Of her early naïveté, she says, "We didn't know anything about the art market. I never heard about it until '79, when [artist] Donald Baechler told me about it. I remember the night. We didn't read art magazines, we didn't know they existed. We sat in the parking lot with the teachers and drank. Basically, I learned to drink really well in art school."

"We really believed at that time that most artists ended up starving and that you had to give up your whole life to be an artist," she continues. "And that only 5 percent of the people who went to art school became artists. Now there are more people applying to art school than business school."

"A lot of them wind up in business anyway," I noted.

"In those days, they'd end up as morticians," Nan countered. "Or in other interesting jobs. We were taught that being an artist was really a spiritual calling, and I never got over that. I can't believe in the market. I have a really naïve belief system that makes the world difficult to live in—unless I stay at home. I'm most connected to the world, most alive, when I'm shooting or making my slide shows. I find it hard to be alive, especially in this period."

But doing the hard thing never scared Nan. And this transitional period in art desperately requires what she possesses in her eye and in her heart. She's a survivor because she's a witness for beauty and treasurer of endangered truth.

Nan Goldin: Diving For Pearls, Steidl, 2016

Christopher Wool

OUTLINE FOR A
BOOK ON CHRISTOPHER WOOL

1.
PAINTING
AS LABOR
SAVING DEVICE

"What's holding you back from success? It may be little inefficiencies that added up to make one big inefficiency. If you try to screw on a toothpaste cap wrong, how can you hope to make a clearer decision at work? As Colonel Sutton Smith discovered you can bring everyday objects into order and acquire skills you never even dreamed of. Skills which are rightfully yours..."

"D.E. is a way of doing. It's a way of doing everything you do. D.E simply means doing whatever you do in the easiest most relaxed way you can manage, which is also the quickest and most efficient way...

William Burroughs and Colonel Sutton Smith in The DE Method (The Do Easy Method) from the Burroughs Academy Bulletin ≠ 23

A good plain look is the best look.
–Andy Warhol

The outraged painter screamed at his wife: "I don't sell my work by the yard!"

The use of:

stencil

roller

prefabrication

to achieve effortlessness.

The use of ambient vernacular to achieve artlessness.

2.
DRY PAINTING

Why Dry?

No Wet Paint.

No Aftertaste.

New Process.

3.
THE BREAKS

Low key arbitration as philosophical tool and sales device:

hyphens

Kurtis Blow

the return key

iamb dactyl anapest spondee

scratching

drum solo

breaths

4.
RATES

hourly rate

day rate

weekly rate

monthly rate

word rate

book rate

page rate

standby

beats per minute

cycles per second

by the yard

by the frame

flat rate

Christopher Wool

Christopher Wool

5.
PARTIAL
ASSEMBLY
REQUIRED

sufi double entendre spelling in persian calligraphy

Spy anagrams

military and establishment acronyms vs. reformer and humanitarian acronyms, eg.:

NORAD vs. CORE

SAC vs. SNCC

NATO vs. AMFAR

6.
WORD UP

Gridlock:

Is Alan Alda the biggest celebrity in crosswords, replacing his father Robert?

Doubletalk:

Powerless Over Time and Space, Living One Megabyte At a Time

Double Jeopardy:

It's Not What You Sayin It's What You Don't Say

Final Jeopardy:

You who was who was who was you?

7.
THE
PITY
THEORY
OF STYLITES

An unbroken succession of truth:

St. John

Elaine Pagels

Umberto Eco

Brion Gysin

Rammelzee

Gracle Allen

Edit de Ak

Professor Irwin Corey

Cab Calloway

Pray

Belle Barth and Pearl Williams

Ella Fitzgerald

Babs Gonzalez

Lambert, Hendricks and Ross

Jimmy the Greek

the Hunt Brothers

The Kabbala

Leo Perry

Win Four

Pick Six

8.
TANTRIC
BROMIDES

Recycling surplus meaning:

Sacred herd rodeos

Pavlovian doggerel

Grounding buzzwords

Hypothetical danger deflection:

amnesia

quicksand

flesh wound

evil twin

Christopher Wool: Cats in Bag Bags in River,
Museum Boymans-Van Beuningen, 1991

WARHOL BARDOT

Andy Warhol was born on August 6, 1928. He always wanted to be a famous artist, but he wasn't quite sure how to do it, so he started out drawing shoes for newspaper ads, illustrating books and designing record album covers. He was so good at commercial art that he bought a house and started collecting Jasper Johns. After reaching the top of the illustration field he began painting Pop Art, and his first one-man exhibition of paintings at the Stable Gallery in New York opened on November 6, 1962. It was a traditional show in that it consisted of still lifes—Campbell's soup cans, Coke bottles, dollar bills, and one portrait—Marilyn Monroe.

Marilyn Monroe had died three months to the day before the opening, and the day before Warhol's 34th birthday. The portrait was a diptych. Marilyn's image appeared 25 times on the left panel, in yellow, pink, red and green on gold, and 25 times on the right panel, which fades out toward whiteness from left to right. The silkscreen was made from a publicity photo taken by Gene Korman on the set of the 1953 film *Niagara*. She was made up by Alan Snyder who was her uncredited makeup artist on ten films.

In 1963, shortly after the assassination of President John F. Kennedy, Warhol began painting portraits of Jacqueline Kennedy, using news photos from Dallas before the assassination, and from the President's funeral, as well as from his inauguration. In the same year he painted Elizabeth Taylor whose blockbuster film Cleopatra was released that year. Not only did he make the glamorous, colorful Liz, but also silkscreen paintings of her as she appeared in

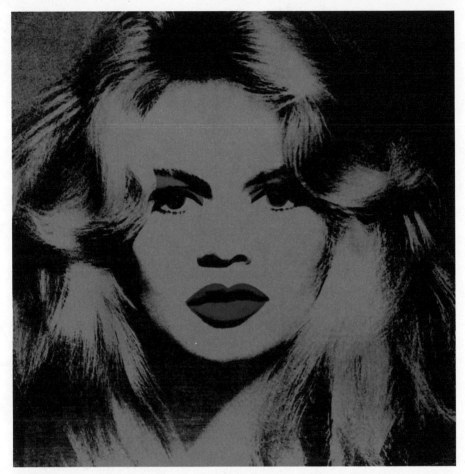

Andy Warhol

National Velvet, and with "The Men in Her Life (Mike Todd
and Eddie Fisher.)" and in character "Liz as Cleopatra".)

In 1962 Warhol also produced portraits of Troy
Donahue, Elvis Presley, Warren Beatty, Natalie Wood,
Merce Cunningham and Robert Rauschenberg. The portrait
was already iconic for him, a veneration of one sort of her-
oism or other, from sexual to artistic transcendence. Even
"The Most Wanted Men," the portraits he had created to
be installed on the New York State Pavilion (designed by
Philip Johnson) at the New York World's fair, which were
painted over during the fair after widespread criticism, had
a religious feeling to them, transforming the mugshot into
the new gargoyle.

Warhol's adoption of portrait painting was extremely
radical at the time. Although portraiture had survived in
Europe to some extent in the wake of the stylized portraits
of Wyndham Lewis, Francis Picabia, Pablo Picasso and
other groundbreaking artists of the early 20th century, and
as a viable mode in the practices of Lucien Freud, Francis
Bacon, Balthus and others, it had been in gradual decline
throughout the modernist period, having been eclipsed
by abstraction. It was near dead in America, save for a few
tolerated eccentrics like Alice Neel.

Obviously the movement away from representation
contributed to the decline of portraiture, as the style and
intentions of the artist were expected to predominate a
picture rather than mere subject matter. Also portraiture
had been traditionally religious, heroic or commercial, as
in portrait commissions, all modes which were no longer
looked upon with favor by the critical elite. While most
Americans loved Norman Rockwell, the art world didn't,
and even Andrew Wyeth was considered a quaint illustrator,
like his father N.C. Wyeth. The legacy of Winslow Homer,
Thomas Eakins and The Ashcan School was dead in an
Abstract Expressionist world. Warhol's outspoken admiration
of Andrew Wyeth and his son Jamie, with whom he traded
portraits, was a brow-raising departure from the standard art
world view of things.

Warhol, raised by a strict if not somewhat fanatical
Eastern Rite Catholic mother, knew the power of the icon.
In the old country, icons had been known to instigate phys-
ical assaults, and had even been eaten by some iconodules,
the over-enthused and idolatrous faithful worshippers who
might have, centuries later screamed at Elvis. There is in

Warhol's early star portraits a great deal of the Christian
icon, and its polytheist classical predecessors, adapted to
the mass media world. Marilyn, Jackie and Liz are canon-
ized, if not deified, by these portraits. If they were the
new Madonnas or Olympian goddesses, Warhol's Elvis was
Dionysius redux. His Mona Lisa paintings, contemporane-
ous with the Marilyns, seemed to equate the two. That was
then, this is now. There is a striking echo of Mona Lisa
in the Marilyn and Liz paintings, in the eye contact and
ambivalent expressions. Warhol seemed to be declaring
a new pantheon of racy divinity.

The idea of the commercial or commissioned por-
trait, which Warhol would come to rely upon to bankroll
the entire Factory operation, including films and *Interview*
magazine, seem to have occurred to him gradually, begin-
ning with quid pro quo portraits of Ethel Scull, who with
her husband Robert, was among his most enthusiastic
collectors. Warhol painted many of his collectors and deal-
ers and curators: Ethel Scull in 1963, Sydney Janis in 1967,
ten artists from the Castelli stable in 1967, Dominique
de Menil in 1969, Ivan Karp in 1972, Ileana Sonnabend in
1973, Ronald Feldman in 1974, Lucio Amelio and Leo
Castelli in 1975, Henry Geldzahler in 1979.

In May, 1965, at the opening of his Flowers exhibi-
tion at Sonnabend Gallery in Paris, Andy Warhol referred
to himself as a "retired artist." He was quoted as saying that
he was giving up painting. "It's too hard." He told the *New
York Times*, "I've had an offer from Hollywood, you know,
and I'm seriously thinking of accepting it. At least that way
you can eat. And then I can come back to Cannes next year."
In fact he was very busy making films, literally hundreds
of films as well as managing The Velvet Underground
and putting on multi-media happenings in the form of
the Exploding Plastic Inevitable as well as staging various
publicity stunts. He continued to make portraits, but on
film, in the form of "Screen Tests," single rolls of black and
white film. He made 500 screen tests between 1964 and
1966. But making money making movies proved even hard-
er than painting, and painting was problematic, especial-
ly when Warhol's friend Henry Geldzahler was made Com-
missioner of the Venice Biennale and neglected to mention
it to him. They fell out. The dramatically exiting Henry
wrote on a blackboard at the Factory: "Andy Warhol can't
paint anymore and he can't make movies yet."

Warhol did go to Cannes as he promised, but it took him two years not one. In 1966 he was releasing a film a month at various venues, and he had had theatrical success with film such as *Vinyl*, which was based on Anthony Burgess's *A Clockwork Orange*. He had actually paid $3,000 for the rights, a lot of money for him at the time. But he knew that he needed to make a big film to break through and he pinned his hopes on *The Chelsea Girls*, which was shot in the summer of 1966, during his "retirement."

The Chelsea Girls was a 210-minute split screen spectacular starring the Factory stable of stars, including Mary Woronov, Gerard Malanga, International Velvet (Susan Bottomly), Ingrid Superstar, Ondine, Rene Ricard, Mario Montez, Eric Emerson, and Brigid Berlin. Music was provided by The Velvet Underground. On September 15th, 1966 *The Chelsea Girls* opened in New York at the Filmmakers Cinematheque, but because of the crowds it drew it was moved to a commercial theater, Cinema Rendezvous on West 57th Street and it played at the Regency Theater to packed houses. In April 1967 *The Chelsea Girls* opened at the Cinema Theatre in Los Angeles, and in May Warhol took it to the Cannes Film Festival, arriving with an entourage of Gerard Malanga, Nico, Ultra Violet, Eric Emerson, David Croland and Susan Bottomly (aka International Velvet.)

Warhol recalled in *Popism*: "When we got to Cannes, we discovered that the guy who was supposedly arranging everything hadn't set up even one showing of the movie. Even Lester (Persky), who'd come over to help us publicize it, couldn't do anything; it was too late.

"We decided to hang around anyway and just have fun, which we were always good at. We met Monica Vitti and Antonioni, who'd filmed *Blow-Up* at the same time we filmed *The Chelsea Girls*. And we met Gunther Sachs, the West German ball-bearing heir who brought us home to meet his wife Brigitte Bardot. She came downstairs and entertained us like a good European hostess, and I couldn't get over how sweet that was—to be Brigitte Bardot and still bother to make your guests comfortable."

David Croland recalls: "I was in Cannes with Andy, Susan Bottomly—International Velvet—and Nico, Gerard Malanga, Paul Morrisey, Eric Emerson and Ultra Violet. We were there to show *Chelsea Girls* at the Cannes Film Festival but they wouldn't show it because they thought it

was too smutty, too dirty for their taste, so we were just
hanging around. One day we got into a car a strange car
with three rows of seats to go to St. Tropez.

Nico was driving which was like taking your life
into your hands, and Paul was sitting in front with her,
Susan and I sat behind and Andy and Ultra were in the
back. We got to St. Tropez and Andy said we were going
to have dinner with someone. We arrived at this little
seaside restaurant and there was six of us and four other
people. This beautiful blonde woman sat across from me
and we talked through the whole meal. She was with this
good-looking man with a German accent. I didn't know
who they were. Then we went dancing at this great tiny
discotheque and I was dancing with this woman and
Andy was sitting there watching, and she sat and talked
with Andy, and after a few hours we left.

I said to Andy, 'Oh that girl was so pretty!' and Andy
said, 'David, don't you know who that is?' I said 'No,' and he
said 'That's Brigitte Bardot!' I said 'Who's that?' He said,
'She's the biggest star in France, in the world practically.' I
said, 'Goodness.' I didn't know. I was eighteen years old."

I asked Ultraviolet about the evening: "The party was
half in the house and half on Gunther Sachs' boat. The house
was very nice. Minimal but in good style. He even had servers
on the boat. The dinner was just delicious and champagne
galore. We were swimming and drinking champagne. Bardot
was outstanding. Gorgeous, gorgeous, gorgeous. She looked
like a goddess and Gunther was much in love. This was a new
affair for them. Warhol was impressed by the whole set up.
Of course he was a celebrity hound. We wound up at some
club. I think it was called VroomVroom or something. She
was so gracious and when she danced all eyes were on her.
She didn't jiggle, she had grace. I think Gunther probably
ordered the portrait then. That's all I remember, but you
can make something good up and say I said it."

Andy loved movie stars, but he wasn't taking the
meeting with Brigitte Bardot to make a film with her.
Cannes had probably been the handwriting on the wall for
him, the end of his mental retirement from painting. She
wanted her portrait painted by the man who had done
Marilyn, Liz, Jackie and Elvis. Andy must have realized
then that even if film was his future, painting was still the
way to bring home the bacon.

—

Brigitte Bardot was born in Paris on September 28, 1934. She studied ballet, modeled in a fashion show, and at 15 she appeared on the cover of *Elle* where she was noticed by the director Roger Vadim.

Bardot made her first film in 1952, and made a total of 43 before she retired from the screen in 1973 at the age of 39, announcing that she wanted to get out elegantly. She had made some lightweight comedies but also worked with such directors as Roger Vadim, Louis Malle, and Jean-Luc Godard.

Her status as a living legend had become official with the 1959 publication of Simone De Beauvoir's *Brigitte Bardot: The Lolita Syndrome*, in which the existentialist intellectual made a case for Bardot as a sort of secular saint whose very image was a liberating force for humanity.

De Beauvoir wrote: "'I want there to be no hypocrisy, no nonsense about love,' BB once said. The debunking of love and eroticism is an undertaking that has wider implications than one might think. As soon as a single myth is touched, all myths are in danger. A sincere gaze, however limited its range, is a fire that may spread and reduce to ashes all the shoddy disguises that camouflage reality. Children are forever asking why, why not. They are told to be silent. Brigitte's eyes, her smile, her presence, impel one to ask oneself why, why not?"

Or, as the novelist Elaine Dundy quipped, "The most imitable thing about Bardot, I guess, is her stripping-ness." BB was the sex kitten who, more than any other sex symbol, ignited a sexual revolution. Warhol also saw himself as being in the sexual revolution business. When *The Velvet Underground* had gone in the studio to record he instructed them to leave in all the dirty words, not to change anything just because they were making a record. And he was the director of such films as *Blow Job*, *Hand Job*, *Taylor Meade's Ass* and *My Hustler*.

Even if the eighteen-year-old David Croland didn't know who Brigitte Bardot was, Warhol did. In his archives is a cover of the sensational tabloid newspaper the *National Enquirer* (then billed as The World's Liveliest Paper) from July 22-28 1962, with a scantily dressed Bardot on the cover and a coverline proclaiming "Lies! Lies! Lies!" Warhol knew the power of sex. He knew very well the Supreme Court's definition of obscenity and he was echoing it when he said in defense of his *Blue Movie* (originally titled *Fuck*): "I think

movies should appeal to prurient interests. I mean the way things are going now—people are alienated from one another. Movies should arouse you. I really do think movies should arouse you, get you excited about people, should be prurient."

Andy Warhol loved movie stars, especially sexy movie stars, and in 1966 Bardot was the sex kitten extraordinaire. She was getting exactly the kind of publicity he wanted. Bardot was also everything that Andy looked for in a portrait commission. He probably would have done her portrait in the same manner as Marilyn, because of her iconic star power, but for that St. Tropez meeting. In 1966 Bardot had just married Gunther Sachs, a handsome German playboy whose wealth, for Warhol, was more alluring than Bardot's sex. His maternal grandfather was Wilhelm von Opel, an auto magnate, his father was a magnate. He was magnatic and magnetic. The handsome Gunther Sachs, born in a castle, wooed Bardot by flying over her villa on the Riviera in a helicopter and bombing her with roses. Once Bardot was Mrs. Sachs, it was unlikely the artists would paint her without a commission. That commission would take nearly eight years to finally complete. Sachs also commissioned his own portrait and that was delivered in 1972. In it he is handsome, with tousled hair and sensual mouth. Unlike most Warhol portraits, Sachs' does not have a flat background. He must have been photographed outside, but the out of focus background eerily resembles Warhol's "Flowers" paintings.

Warhol's commissioned portraits were generally organized by Warhol's social secretary and aide de camp Fred Hughes or Bob Colacello, sometimes *Interview* editor and full time socialite-schmoozer on commission. Warhol's cynical friend Nelson Lyon called Fred and Bob "the head waiters," because it was their job to attend parties and corral commissions.

In his memoir Holy Terror, Colacello recalls: "Andy asked me to help organize the New York premiere of *Heat*, on October 5 at the Lincoln Center Film Festival. He told me that he and Fred had to be in Europe on that date 'to do some work for Bruno Bischoffberger'—the work turned out to be commissioned portraits of the German industrialist Gunther Sachs and his then wife, Brigitte Bardot."

Actually Sachs and Bardot were divorced in 1969, but it's most likely that Warhol was actually completing a transaction that had begun that night in St. Tropez.

Usually Andy would have his sitters up to the Factory for lunch and shoot lots of instant pictures of them with his fixed focus Polaroid "Big Shot." He would pick some, have screens made and create paintings. Bardot, however, was a bit more complicated. Getting her to sit was not the easiest thing to accomplish, but more than that by 1974 she was divorced, forty, an elegantly retired movie star who had, realistically, looked better earlier. The solution was to use the Marilyn/Liz mode and take an existing photo as source material. The 1974 Bardot has a face as fresh as 1959 because that was the vintage of the photo Sachs supplied to Andy, cropped by himself.

But what made these portraits particularly unusual was the photo used. It was no wire service press picture, no on location production shot, but a Richard Avedon portrait of Bardot at her peak. Richard Avedon had photographed the actress 15 years earlier, in January 1959 in his Paris studio. She was wearing a Lanvin dress and her hair was done by Alexandre of Paris, then the world's most famous hairdresser. In the typical Warhol portrait there was no hair or makeup unless supplied by the sitter, and certainly no stylist and that may have affected how much paint he had to use. The Avedon picture was a sort of readymade, like the Mona Lisa it was a work of art already. Avedon's Bardot portrait was eventually issued in an edition of 35, and one print sold at Christie's in 2008 for $181,000.

There is something already Warhol-esque about the Avedon portrait in that there is a peculiar sort of double exposure effect. Bardot's face is cleanly defined, her strong brows, her full lips, her nose and chin etched in shadow, but her hair seems double exposed, as if it were moving independently. It echoes that vibrant feel that Warhol achieved by using his silkscreens out of register. I originally suspected that this "special effect" resulted from the hand of Alexandre (the original "haute coiffeur" who also "collaborated" unknowingly on at least one other occasion with Warhol, in that he created Elizabeth Taylor's hairstyle for Cleopatra). According to the photographer's daughter Laura Avedon, however, the vibrant hair results from Richard Avedon's darkroom manipulation. In any case, Warhol had never worked from such a masterful photograph.

Avedon and Warhol had a complex relationship. Warhol seemed to feel a lot of resentment toward Avedon, although the photographer took the most iconic photos of the artist and his Factory entourage, as well as the most intimate photo of Warhol ever taken, showing off the scars from his shooting. Avedon's group portrait is the best record of the weird glamor of the Factory denizens. And Andy never looked more glamorous than in Avedon's photos.

From the diaries:

Wednesday, Dec. 1, 1976 "China Machado was there and she said she's known Ambassador Hoveyda for ten years or more from when he and her husband were in France hanging around the French filmmakers in the sixties. We talked about how horrible Avedon is, she said he gets what he wants out of a person and then drops them. I agreed and then everybody screamed at me that I do the same thing."

Friday, September 1, 1978: Fred's been invited to Avedon's for dinner before his show at the Met. He's buttering up to Fred. He wants something. I still hate him. He wouldn't give an interview to Interview *because he said it wasn't "right" for him. After he got Bob to do publicity on him in* Interview, *he turned around and said that. I mean, he's just somebody who worked for* Bazaar. *He took those pictures of my scars and of all the Factory kids and we signed releases for him and everything and then he never even gave us prints. Viva's in his new book, but at least she got some prints."*

Typical Andy. You know that if he had run into Avedon he would have purred "Oh, gee you're so great," but in the privacy of his diary. Andy could be jealous even of the poor. Maybe, just maybe, there was a tinge of jealousy over Avedon being Dick Avery in Funny Face or being admired by Fred Hughes, who was by then modeling his personality on Diana Vreeland.

In any case Andy was lucky to be working from an Avedon photo. These are among the strongest and most iconic of his seventies portraits. The color combinations in these paintings are as bold as in the Marilyns and the Mao series. All of them have a powerful chromatic impact, the perfectly wrong colors looking so right together, and

what should have been collisions become revelations. Some of the paintings are almost searingly psychedelic, radiant to the point of radioactive. Where many of Warhol's portraits are flat, almost color-field painting, these elicit the feedback of The Velvet Underground and the black lights and strobes of Exploding Plastic Inevitable. Although he was the least mystical of artists, Andy was ingeniously good at rendering in color the aura of a human or a goddess; he knew the Pantone combinations of immortality.

Warhol: Bardot, Gagosian Gallery, 2011

James Nares

"I am outside of history. I wish I had some peanuts. It looks hungry there in its cage."

Ishmael Reed

JAMES NARES

James Nares' work is so strong and affecting that it would be possible and perhaps even appropriate to discuss it without reference to the current climate in the arts. Nares is a particularly independent artist, and his work has little relation to that of his contemporaries, and his milieu does not appear to be a source of inspiration, a stylistic influence or even a footnote to his work. I have always admired him for coming out of left field, being so *ab ovo* and apart, for making work that is totally independent of whatever movement critics are conjuring at the moment or what attitude is being championed. He is a painter. A rare thing, considered obsolete by some, retro by others. But Nares exists outside of the modernist now (and the post-modernist, and post post-modernist now), outside and untouched by that theoretical moment that is by definition a progression from then. He is outside that system, untouched by fashion or notions of cultural evolution. He is free.

This was brought home to me not long ago when I walked through The Armory Show, a large art fair located on the Hudson River Piers that serve the cruise ships and are often the scene of antique fairs and other gatherings of precious merchandise. Walking through the booths of galleries from around the world is one of the best ways to become instantly current with the direction of the art world. This big trade show is ironically named for the first International Exhibition of Modern Art, held in 1913 by the Association of American Painters and Sculptors at the

69th Infantry Regiment Armory (Lexington Avenue and
25th Street.) The irony is no doubt lost on the organizers
of the new armory, but is apparent to anyone armed with
a knowledge of the original Armory Show where the public
first encountered Dada and Cubism, where Duchamp's
"Nude Descending a Staircase" provoked outrage that
echoes today.

The poet Max Blagg and I wandered the aisles
hoping outrage and epiphany. We found lots of irony
instead. The art world is in a most ironical mood, it seems.
We discovered little but gestural humor at high prices.
Tongues were impacted in cheek. Starved for the shock
of the new, we were offered instead the persistence of
the same old same old. The principal trends I noticed were
small bronze possibly feminist animals and the apoth-
eosis of Andreas Gursky and the big busy photograph
into the world gold standard. Everybody's doin' it. It's
like Chubby Checker and the twist. I realized, a bit
glumly, that the world has utterly lost the importance of
being earnest.

How does this all relate to Nares? Well as Blagg and
I walked down the hall one of James Nares' brushstrokes
spoke to us softly yet powerfully from quite a distance. We
were drawn towards it and as we got closer it seemed to say,
don't worry, art lives. Nares work is outside the mainstream,
or would be if there were one. It isn't funny or jokey or
ironic. It is what it is: pure painting. It is painting as a means
of expression and exploration.

James Nares is a renaissance man in what Mallarme
might have called "an age that has outlived beauty." Before
that he was a renaissance punk. What I mean by that
is that he was one of the central art practitioners of that
moment in the late seventies and early eighties when it
seemed like something important was happening. There
was an outbreak of energy and creativity that is still felt
today. Nares was a painter then, and his work today still
shows the early concerns and ground rules of that work.
He was also a filmmaker and a musician. Today he is a
secret guitarist, but music is still important to him. It fills
his studio, and the way he paints is deeply related to the
way a musician works.

For a musician beauty is an assumption.

James Nares, Skira/Rizzoli, 2014

ART

I REMEMBER THE FACTORY
(AFTER JOE BRAINARD)

I remember Andy saying,
"They're really up there,"
and "Geee, that's so grreat."

I remember Paul Morrissey
calling half the people who
came up to the Factory
"drug trash."

I remember Richard
Bernstein being the only
person who ever smoked
pot at the Factory. (Until
Jean-Michel Basquiat 20
years later.)

I remember having to take
some German journalist
through the Factory and he
thought it was a commune
and he asked where we slept.
After a while he said, "We
fuck now?"

I remember Louis Waldon
coming up and asking Andy
for $10,000 to put a zinc bar
in some place he'd bought
in Europe.

I remember Viva saying
how cheap Andy was and
that he'd regret it when her
book came out.

I remember how much Andy
hated it when somebody
wanted to shake hands.

I remember Paul yanking out
hunks of hair from his head
while talking on the phone.

I remember answering
the phone, "Factory," and
Andy saying, "Why don't
you just say studio?"

Lynn Goldsmith

I like artists who can draw
and paint. I can think of
funny ideas all by myself.

Tweet, 24 June 2014

I remember Fred Hughes on the phone saying, "Hughes, as in Howard Hughes."

I remember when David Bowie came to visit Andy saying, "Should we let him in?"

I remember Lou Reed calling me up and playing me a tape of a band from Boston he wanted to produce. All their songs were about him.

I remember Andy offering me a part in *"Women in Revolt"* and being really excited about it until I found out that Jackie Curtis was supposed to give me an enema.

I remember the day Billy Name came out of his dark-room after staying in there a year. He left a note for Andy that said, "I'm not here any-more but I am fine."

I remember Bob Dylan's bodyguards grabbing Andy's film at Mick Jagger's birthday party because there was a joint on the table.

Andy was appalled.

I remember Interview writer Donald Chase doing such a good Bette Davis imitation that he fooled everyone on the phone including W.H. Auden who went to his grave thinking Bette Davis was his biggest fan.

I remember Rene Ricard being the only person who still called Andy "Drella."

I remember Richard Bernstein calling the back room of Max's "The bucket of blood."

I remember Danny Fields talking about the "abstract expressionist alcoholics" who sat in the middle room of Max's.

I remember when Mickey Ruskin put hairy wallpaper over the red walls of the back room at Max's. We all thought it was to slow the cockroaches down.

I remember wishing Lisa Robinson would put a sweater on over her see

through blouse. I remember
Nelson Lyon using the word
"fruitcake" to Andy and Andy
not blinking.

I remember hearing that
Ondine had become a mail-
man in Brooklyn.

I remember Bob Colacello
saying that Robert Mapple-
thorpe deliberately peed in
his jeans.

I remember Andy asking me
why I didn't get rid of Fran
Lebowitz and asking me if
she was really funny.

I remember Candy saying
that she had songs written
about her by Lou, Ray Davies
("Lola,") and Mick Jagger
("The Citadel.")

I remember David Bowie
coming to the Factory to do
a mime act for Andy and
sing "Andy Warhol." Paul
wanted to throw him out,
but I told Andy he was
famous in England. After
the song Andy didn't know
whether to be insulted or not.
I remember Geri Miller say-
ing she wasn't a virgin but

was saving her ass for
her husband.

I remember being afraid of
Taylor Mead but not being
sure why.

I remember looking at
beautiful pictures of Steven
Mueller from *Lonesome
Cowboys* and thinking
maybe I should lay off
the Budweiser.

I remember the nipples of
Patti D'Arbanville, Donna
Jordan, and Jane Forth.

I remember Andy telling
me that Jack Smith really
invented the word "super-
star" and asking me if
Jack needed money.

I remember unfriendly looks
from Gerard Malanga who
was on the outs after making
Che Guevara "Warhols"
in Rome.

I remember Andy saying
at parties, "This is such
hard work."

I remember thinking Jackie
Curtis was really ugly as a

woman until I saw him as "James Dean."

I remember the door being guarded by a stuffed Great Dane that supposedly once belonged to Cecil B. DeMille.

I remember wondering what Paul Morrissey saw in Shirley Temple.

I remember Peter Beard with no socks in January.

I remember Maria Schneider coming up to the Factory after Last Tango came out and making out with her girlfriend to impress us.

I remember Paul calling the underground filmmaker Stan Brakhage "Stan Footage."

I remember wondering about if Joe Dallesandro was only Paul Morrissey's house guest.

I remember Nelson Lyon calling Fred and Bob "the head waiters."

I remember Andy accidentally leaving his tape recorder in the *Interview* office, so he could hear what Bob and I talked about.

I remember Andy shooting me in my underwear at the Interview office for the "Sticky Fingers" cover. And Fred kept saying, "Can't you make it any bigger." Then three businessmen walked in the door and said, "Oh, isn't this the architect's office?"

I remember Valerie Solanas calling up and asking for Andy, long after she shot him.

I remember Andy saying "I'm not here" every day.

Unpublished, 2001

Politics

From now on please refer to me as "billionaire Glenn O'Brien." Hey it worked for Donald Trump.

Tweet, 18 January 2014

THE LOST ART OF EMBARRASSMENT

Everybody seems to have a theory about what's wrong with
our society (and I'm not talking about the Hilton Sisters, I'm
talking in a much broader sense, and I'm not about Sophie
Dahl either). What I am declaiming on is the culture of our
great nation, which most of us agree is in a state of crisis,
decadence and peril.

Some people think the problem is smoking. Others
think it's trans-fats, the melting of Antarctica, welfare,
cooked foods, seven figure bonuses for the CEOs of failing
corporations, the inflated salaries of professional athletes
as a result of free agency, gay Scout leaders, Americans who
refuse to speak English, or the effect of SUVs on the rain-
forest. Quite a few think it is the lack of female members
at the Augusta National Golf Club, the location of nuclear
power generating plants on geological fault lines, or the
father of Venus and Serena Williams.

Millions more believe that it's automatic assault
rifles in the hands of squirrel hunters, the overfishing of
Chilean sea bass, the threat of MP3 technology, the lack
of an effective anti-ballistic missile defense, the invasion of
the Chinese dragon fish or the singing of Attorney General
John Ashcroft. Other millions believe it's the threat of
Saddam Hussein, the bursting of the NASDAQ bubble,
Starbucks and/or Barnes and Noble, or the lack of good
Creationist teachers in our schools.

Many of my friends seem to trace the perceived
decline as a consequence of Florida's election results, the
moral dilemma of William Jefferson Clinton, the price
of cigarettes in New York City, the size of carry on luggage

permitted on airlines, sulfites in wine, or the Eminem/
Moby feud, or the lack of suitable depression in rightfully
depressed Americans taking Prozac, Paxil, Zoloft, Celexa,
Luvox, Serzone, Remeron, and Effexor.

I am quite willing to admit that many of these are,
in fact, grievous problems which contribute to a general
downward spiral in the morale of the nation, but I would
suggest that most of these problems are not causal, but
merely symptoms of a far more serious and generalized
problem that is at the root of our collective plight.

In a nutshell I believe the problem is a pandemic lack
of personal embarrassment, an affliction so widespread that
it is no longer perceptible by the vast majority of the populace.

At first the decline in embarrassment was viewed
as a positive sign. It was widely believed that many of soci-
ety's (and I'm not talking about Suzy or Liz Smith here)
problems were caused by uptight, rigid, paternalistic atti-
tudes. Everyone, it was supposed, simply needed to loosen
up. Dress codes were relaxed. Organizations shed their
trappings of hierarchy and simulated democratic, leveling
fraternization. Our particular civilization (sic) eradicated
the formal ways in favor of the casual in the belief that
if manners or signs of what had long been perceived as
"class" were eliminated, that brotherhood and sisterhood
would heal the rifts that divided and alienated us.

Disaster! We have not just opened the floodgates to
boorishness, avarice, covetousness, gluttony, self-indulgence,
uncontrolled ego gratification, and flagrant tastelessness,
we have entirely dynamited the dam of the super-ego that
kept mankind's baser tendencies in check.

The landscape is now rampant with fast-growing,
burger scarfing, corn-sweetener swilling, road raging boors,
costumed in 3x to 5x facsimiles of the uniforms of profes-
sional sports screaming into cell phones in their sports utility
vehicles. They blight the landscape with mansion-sized
tract homes on subacres. They entertain themselves watching
fake wrestling and television programs about transsexual
incest survivor kleptomaniacs. Any problem, which might
have formerly been assigned their consciences, is now
routed directly to attorneys, 12 step groups and, in the
upper echelons, their publicists.

Civilization as we knew it has left certain post-
archeological reminders, such as Ralph Lauren ads, PBS
or the Rules of Golf, to which perhaps one percent of the

game's players adhere. A certain Roman emperor was once hailed for saving Rome from the "horrors of democracy." This, of course, meant mob rule at the time, and times are assumed to have changed but...

The Horror! We are mortified, repulsed, aghast and agog. The only hope of society (and I sort of am talking about Brooke Astor here, not to mention Nietzsche) is to vastly escalate the capacity for embarrassment of our populace. We must eloquently and continually express our shock, rage, repulsion, indignation, annoyance, nausea, and vexation. We must scoff, snicker, harrumph, cluck and titter without remorse. We must mock, revile, humiliate, scorn and ostracize. We must not kill them with kindness, but with ruthless powers of description. We must not embrace them; we must ostracize, deride, separate, alienate, ridicule, spurn and reprove them. We must not think of anger management but anger mastery. We must be angry artistically and superbly.

If we are successful and remain pure ourselves, if we can maintain a state of high grumpiness tempered by modesty, a posture of excoriation informed by altruism, then perhaps we shall succeed in conjuring massive cultural shame. If not, to say that our society has gone to the dogs would be, at best, wishful thinking.

Paper Magazine, 2003

Todd Eberle

THE RHETORIC OF CONFUSION:
SARAH PALIN AND THE RISE OF MEDIOCRACY

Whenever, in my blog, I venture beyond matters sartorial toward what is considered political, commentary from readers picks up dramatically. It almost seems as if there is a rightist media watch at work, chiding critics of the neo-cons—almost a cultural equivalent of U.S. Border Watch, that intrepid brigade of amateur volunteers who guard our Southern border with binocs in one hand and Lone Stars in the other, from the vantage of strategically placed lawn chairs.

 Angry commentators claim that they want to read what I have to say about style, and such vital matters as collar stays and wingtips, but should I veer toward the realm of politics, or even ideas, they not only protest but suddenly question my modest gifts of observation and charge me with blathering.

 In fact, it is in no small part matters of style that have occasionally led me into political critique. Style is a consistently reliable "tell" as to the hand being played in politics. I was raised on Marshall McLuhan, and the idea that the medium is the message is part of my intellectual DNA—it's against my nature to winnow content from

form. It's not just what you say, it's equally how you say it. In fact, I believe that what you say *is* how you say it.

The ideas George W. Bush has expressed overtly haven't been particularly shocking, but the seemingly scrambled and mangled words that have delivered his ideas reveal an alarming subtext of obscurantism. His individual slips are amusing on the surface, but in sum these confused messages constitute an attack on meaning itself. And the chief executive lowering the bar of intelligibility so profoundly is no joke.

The very concept of style begins in words. Style is the particular way we express our individual character, whether in writing, speech, or dress; and there is indeed profound meaning in the manners by which politicians express, comport, and garb themselves. With the surprise choice of Sarah Palin as the vice-presidential candidate on the Republican ticket we encounter a candidate with a style never before seen in these exclusive precincts. Palin's style came as a shock to some, a delight to others, and a perplexing mystery to me.

The eminently seasoned politico Bill Clinton seems to actually admire Sarah Palin's style—maybe it was the red, white, and blue bikini—and he has risen to her defense on style points alone, surprisingly arguing against those on the left and right who are aghast at her selection for the ticket. "I come from Arkansas," said Clinton, "I get why she's hot out there." Notice his choice of adjective: hot. Apparently, the Eastern European heads of state Palin photo-opped with recently found her hot, too. Let's not forget that she won Miss Congeniality in the Miss Alaska beauty contest, and Miss Congeniality is a title that requires both beauty and, well, congeniality. And the phenomenon of Sarah Palin is about more than meets the eye. A definition of congeniality is "having the same tastes, habits, or temperament," and it seems that Palin has been chosen precisely because she is congenial to the masses; she shares the tastes, habits and temperament of a significant portion of the mass electorate.

Sarah Palin represents a radical seismic shift in political strategy. Once leaders were chosen for being the best and brightest—we sought out orators, strategists, polymaths, and geniuses to lead us. Today our leaders may be chosen for their representation of American average and for an utter lack of distinction. It is part of the campaign against the intelligentsia, the quiche-and-arugula-

eating, Chardonnay-sipping elite. Because of profound changes in the structure of mass media—a shift from the literate world of newspapers to the sound-bite world of cable TV—we have a different sort of democracy today. We now have TV-driven elections and we are discovering that they are very similar to TV programs that involve voting, such as *American Idol*.

Governor Palin is the fulfillment of the promise of George Bush. Bush was sold to the electorate as the kind of guy you want to have a beer with (even if he's apparently drinking the non-alcoholic brand.) Bush is not an effete intellectual snob. He is quite the opposite; but if he is a good ole boy, he is a self-made good ole boy. Despite being the scion of the supreme elite, he devoted himself to transcending greatness and, through hard work (like clearing brush), achieving a demeanor of regularity. He shed that Eastern liberal veneer, the posh manners of his upbringing, the ivied aura of Yale, and the mystique of Skull and Bones. Bush lived in Connecticut until he was 13 years old, when Poppy Bush took the family down to Houston, and in those years, he attended Andover in Massachusetts, and then Yale. So, having spent apparently just five summers in Texas as a youth, George W. took to speaking with the dramatic drawl of a Texan cowboy. His cultural transformation is nothing short of remarkable. No one has ever done more to shed the trappings of privilege and appear "regalar."

But Sarah Palin is the genuine article. She didn't have to work to be ordinary; she was born that way. And she is so ordinary that she represents a sea change in American politics. She is the ultimate political candidate for a political system that resembles *American Idol*. She is far closer to Clay Aiken than she is to Hillary Clinton. What is proclaimed as her strength and virtue is her very averageness: a local beauty contest Miss Congeniality, a mother married to a working stiff, a newcomer to passports who doesn't live in a McMansion, who hunts and fishes and minds the kids, while somehow juggling chief executive duties the way other moms juggle PTA duties.

Somehow her ordinariness and lack of distinction and achievement are now considered to be a key manifestation of the democratic ideal. Palin's principal qualification is that she realistically represents the masses. The pitch selling her qualification is that the failures of Washington

are attributable the educated elites. To achieve real democ-
racy, we need someone who is ordinary in every way,
someone the little people can identify with, someone who
hasn't been tainted by Harvard or foreigners. Palin is
presented as not particularly gifted, educated, wealthy, or
beautiful, but as entirely genuine. Her utter averageness
is her greatest strength. So to pick on Palin is to pick the
American people.

The Republicans are traditionally the party of
the moneyed elite, and through perhaps the smoothest
bait-and-switch in history, they continue to serve this
constituency covertly while descrying their actual agenda.
Posing as the party of the people, the party of patriotism
and supporting the troops, they have forged an unholy
coalition of the religious, the gun-toting, the xenophobic,
and the resentful white silent majority, railing against big
government while quietly inflating it. By appealing to the
fears of the great middle they advance the agenda of the
ultra-elite super-wealthy.

But with Palin they have kicked their posture up
a notch, adopting the ultimate faux-populist stance by sug-
gesting that the leadership of the extraordinary is a failed
idea, and that true democracy is achievable only by giving
the absolutely average their shot at running things. And
in a masterstroke of re-positioning they have recruited this
paragon of puppetry to charm the masses. If the Repub-
licans manage to win, Sarah Palin, as Naomi Wolf has
suggested, will likely play Evita to cancerous old McCain's
Juan Peron, ready to step in and do the work of righteous-
ness in a moment of loss or crisis. And, lo, she comes from
the promised land! In Palin's evangelical world view Alaska
is the refuge where the righteous will seek comfort when
the End Times are upon us.

Palin is a great believer in what they call American
exceptionalism. She is a candidate positioned to appeal to
those who believe that America has a special destiny, like
its best friend Israel. It is the promised land of the chosen
people. And now the Republicans have revealed a great and
profound irony: that Americans are exceptional because
they are average and unexceptional. Indeed, God moves
in mysterious ways. As do Republicans. They have learned
that Americans don't want to be led by a charismatic
genius sprung from the educated elite, they now want a
surrogate in office, someone just exactly like them.

Bush, for all his wealthy upbringing, finally achieved mediocrity through his own determined efforts. But Sarah Palin is a natural; she was the genuine article from the get-go. She's that hyper-determined hockey mom, an over-achiever who feels a special destiny, eerily similar to Nicole Kidman's murderous newswoman in *To Die For.* But Palin is an even more special case because it was God himself who put her up to it. And though her résumé is unremarkable, it is clearly untainted by the elites. She is something entirely new. She is the chosen prole who embodies the mystical hand of destiny in manifest destiny America.

And while the intellectual snobs of the liberal elite may seek to ensnare Sarah, faulting her for her lack of experience or knowledge, they will not be able to trap her so easily by her words because her words are utterly indecipherable, even inscrutable. What is she saying? They can't make it out. She seems to be contradicting herself but it's hard to say for sure because even she doesn't know what the hell she said. She seems to recite by rote but in her playback she scrambles and encodes it, creating a sort of Gordian gestalt inaccessible to the literate.

But if the media doesn't understand what she says, the people do, apparently. Because she speaks their broken language. It's body language and patented catch phrases so charged with emotion, if not precise meaning, that they are positively ionized. Who needs literal precision when you've got the vibe.

Bush's slips and malapropisms seem comic—"putting food on your family"; "we look forward to hear your vision"; "people that had been trained in some instances to disassemble—that means not tell the truth"; "we will stand up for terror…" But Bush's gaffes are not simply the comic errors of a man who disdains academic grammar, elevated tone, and highfalutin usage in favor of the All-American vulgate; his style is a conscious deconstruction of meaning—the replacement of a language of precision by a language of ambiguity or even ruse.

It's not easy to achieve meaninglessness in the context of government and statesmanship. Palin goes beyond malapropism into a language of pure gibberish, into double talk that resembles the comedy of Professor Irwin Corey—who satirized the elevated jargon that academic elites employ to convey an impression of importance that is all flash and no substance. Palin's syntax is not that of the English

language, but a new kind of language in which convention-
al structure is replaced by blocks and stacks of code and
buzzwords, pre-digested button pushing ideograms that
simulate speech but are in fact its opposite.

This new form of communication, more signifying
than communicating is not new. The neo-conservatives have
been developing this code in the precincts of Karl Rove and
Rush Limbaugh, but Palin is the new grandmaster of
this radical, almost cubistic conservative brand of post
logical rhetoric.

It goes beyond doubletalk, beyond doublespeak, into
circumlocution combined with Burroughsian cut-up strate-
gies; so that logical thought is short-circuited, and meaning
can never proceed in conventional linear fashion. A sen-
tence—or its equivalent—begins conventionally, but then,
when the electrically charged keyword is reached, it is as if a
switch is flipped and a tangent kicks in, negating the previous
logical track while appearing to complete it. In Palin's dis-
course there are no actual diagrammable sentences. Instead
the Governor speaks in sententious paragraphs of scrambled,
cut up clichés, run-on sentences, and collaged clauses, string-
ing them together like signal flags flapping from a warship.

Palin's words and phrases don't *mean* in the conven-
tional sense. They are not ordered logically, but biochemical-
ly, forming a rhetoric of subconscious rhapsody. Her sing-
song tone is everything, and the phrases it beams are more
lyrics than argument. Palin's song is perhaps related to one
of the fundamentalist religionists' key practices, speaking in
tongues. What does one say when speaking in tongues? Is
it the Enochian language of the angels (or devils), or is it a
signification of language that is in fact its opposite?

One listens with a sort of horror as Palin simulates
speech. Surely others recognize that this is not language as
usual. Surely the interviewer knows! But then a suspicion
begins to take shape, a suspicion that, to many listeners,
this dance of words is recognized as meaningful speech. It
doesn't conform to any of the rules of grammar or logic,
but it serves as an acceptable substitute for those to whom
grammar and logic are not essential in communication.

I wonder what interlocutors like Katie Couric or
Charles Gibson really think and feel when listening to this
performance, when they recognize that their interviewee
is completely perplexed in the face of their questions, either
entirely baffled or unprepared to respond. But then corre-

spondents such as these are prohibited from freely questioning the nature of her mode of response for fear that they will be characterized as biased elitists and/or sexists who misunderstand and disparage the folksy colloquial style of the Alaskan governor. But what if she is not dissembling in this mishmash of hers? What is it she is doing when she speaks in cut-up tongues? What if she is invoking avenging angels using Aleister Crowley's parsing? What if she is summoning Baal and Beelzebub?

Responding to criticism of John McCain for saying, in the midst of the banking crisis, that the economy was fundamentally sound, Palin responded: "Well, it was an unfair attack on the verbiage that Senator McCain chose to use." Undoubtedly, she was unaware that verbiage means "a profusion of words, usually of little or obscure content." It is a common mistake made by those trying to sound important, trying to elevate their tone into something resonant with seriousness. But Palin was correct. McCain is a veritable font of verbiage, a coiner of trite phrases and a cryptologist who uses words that say one thing while suggesting quite another. But as a practitioner of verbiage, Palin doesn't have to take a back seat to anyone. She pours out catch phrases stripped of the connectors. Finally, white people have a signifyin' monkey of their own. Henry Gates defined signifying as employing tropes that have been memorized in an act of communication and its interpretation. And Palin's rhetoric is a jumble of tropes designed to grab the audience with a shock and awe of confusion. Imagine a Tourette's Syndrome of euphemism. Nothing is what it seems. Nothing is, finally, nothing.

Democracy is still new and it is, we must realize, highly experimental. It is not a fixed thing but an elusive, ephemeral concept that changes as the way people communicate changes. We possess, it is said, a government of, for, and by the people, and yet our lives are still ruled by secret intelligence agencies and mysterious forces like the Federal Reserve and bizarrely named, inscrutable institutions like Fannie Mae and Freddie Mac—titanic economic forces that sound like almost like the nicknames bestowed by George W. Not to mention the vast network of networks we call the media.

Yes, the people still have the vote, but do they really rule? What is democracy today? To answer these questions, we must question to what degree people rule their own lives, and to what degree, in an age of mass-media culture,

they are actually moved by strings invisible to them. And now that we have Sarah Palin as the proxy of the people we can study her movements. Can you see Sarah Palin's strings? Are they in the hands of Dick Cheney and Karl Rove or Jesus Christ, or even forces more occult? Is this ventriloquism on the grandest stage of all? It seems that we are finally within reach of fulfilling Oscar Wilde's quip: "Democracy means simply the bludgeoning of the people by the people for the people."

GQ.com, 2008

Giuliani says he lost the election in '89 because mentally disabled people were bussed into NYC. And they voted for somebody else?

Tweet, 18 October 2016

WARNING TRUCK POWER

For years I have said that the way to stop Communism in this hemisphere is to make friends with everybody, starting with Fidel. Any country with salsa music and the best cigars is not going to turn into Russia ever.

I think, and informed sources do too, that what Fidel really wants is to have major league baseball. A Havana franchise. Was it last month that I suggested he buy the Royals? Well, anyway, now the wheels are really moving. The Cleveland Indians have a new owner who wants to turn that perennial loser around. The old owner, Gabe Paul, was a remarkable cheapskate. The new owner thinks he can turn the team around without megabucks. How?

He wants to bring in Cuban players. He figures they make zip down there so they wouldn't mind the same terms here, and these Cubans, and Fidel, once not a bad ballplayer himself, would welcome the opportunity to show that they are world-class players.

Bárbaro Garbey is looking good with the astonishing Tigers and he's a player that they threw out. Set him up on the "Freedom Flotilla" for being involved in some game fixing. They say there are better players than Garbey down there, and if they come here with Fidel's blessing they could be very cheap. The Cleveland man says he doesn't care who gets the salary.

Well, I can't see Reagan letting Cubans come up here and play for the Indians with their salaries going to the Cuban government, which would no doubt spend money on Soviet cruise missiles rather than Louisville Sluggers. (They're hitting with aluminum down there now—they can't afford bat breakage.) But maybe Fidel would let 'em get paid some good bucks, as long as they went home to spend it. Anyway this is just the best idea for peace in a long time and I hope it leads to some kind of breakthrough.

If Fidel won't let his players come up and play for the Indians I say give Havana a team of their own. Hell, we let the Canadians have two teams and up in Montreal, where they have our Pete Rose, it's against the law to have public signs in English! The National League is now two teams smaller than the American League—how about a couple of expansion teams, like Washington and Havana. Imagine them playing the Cuban national anthem in RFK Stadium, imagine "The Star-Spangled Banner" being sung down there in Havana Stadium.

If it can't be an expansion team, let 'em buy a troubled franchise. The Havana Reds? The Havana Yanquis? If George Steinbrenner can own a team, why not Fidel Castro? How are they gonna be our enemies after they've met Yogi? Make runs, not war.

East Village Eye, 1984

Shouldn't all politicians and white collar criminals be wearing their flag pins at half lapel?

Tweet, 14 June 2016

THE GUILTY PARTY

Well, here's mud in your eye.

Every four years it's the same old grudge match in a pit of mud. The Republicans make TV spots out of mug shots while the Democrats deny the morals charges. Vice and vice versa.

Democrat and Republican candidates alike are accused of cheating on exams, cheating on the draft, cheating on the wife, cheating on the mistress, cheating on the taxes, cheating on the campaign funds, cheating on everyone but themselves. Who's got time to get an issue in edgewise. And often it is the candidate who seems "most likely to succeed," in the election or in the position, who is brought low by that Achilles sound-byte.

Even the most brilliant of us err occasionally. But one night at the No Tell Motel doesn't mean I wouldn't trust the guy with our nuclear arsenal. Perfect public servants should be a little imperfect, i.e. human. Surely there must be a better way to choose our leaders, a way to give ideas equal time to gossip, a way to give the most talented people a chance to do the job.

I suggest a new political party: The Guilty Party. The Guilty Party is based on the novel concepts of repentance and forgiveness. It might seem shocking at first, but eventually even hard-core Christians might come to accept it.

What do we want from our leaders? Innocence? Naiveté? Timidity? Inexperience? I'd rather have leaders who have learned from their mistakes. Leaders with experience—good and bad.

With The Guilty Party you have experience, plus the freedom to tell the truth about it. The idea is simple. To join The Guilty Party, you simply have to admit your guilt. Confess. Get it off your chest and move on. Our slogan is "Live and learn." Our motto was created by Steve Martin: "Well, excu-use me!"

Our candidates will be men and women who have learned by trial and error and aren't afraid to admit it. They may have screwed around on their wives and husbands, dodged the draft, cheated on exams, smoked grass, snorted coke, consorted with hookers. The important thing is that they've learned from it.

These are the years of the Woodstock Presidents. How can we possibly assemble the best leaders available if we disqualify someone for inhaling?

I inhaled. Over and over again. I held it in as long as I could. And I lived to tell about it. In our party Bill Clinton could admit everything and get on with it. In our party "stonewall" means a famous gay bar in New

York. In our party Warren Beatty is
highly qualified. In our party Gary Hart
is a rising star.

If we want real leadership as we enter
the millennium, we're going to have to ex-
pand our talent pool. That's what The Guilty
Party is all about. It's about bringing people
back into the system. It's about opening the
field to all who are truly qualified, whether
they are from civil service, the private sector,
twelve step programs or the witness protec-
tion programs.

Members of The Guilty Party will be
qualified for the job. We will deal with the
drug problem because we have had to deal
with them, or even dealt them, in the past.
America is the world's largest incarcerator of
its citizens. The Guilty Party will be able
to deal with prison reform because we've been
there. The Guilty Party will be able to deal
with the crisis of the family because we've
been separated, divorced and remarried.

The Guilty Party is perfect because it is
imperfect by definition. It is a recovering
party. It is a codependent party. Maybe we'll
even write a Declaration of Codependence.
The strength of The Guilty Party is that it is
powerless over power. The Guilty Party lives
one issue at a time. The motto of The Guilty
Party is "Now I know better."

The Guilty Party doesn't lie. The Guilty
Party doesn't make promises it can't keep.
The Guilty Party isn't afraid of anything,
even making a mistake.

Interview magazine, 2000

Todd Eberle

HOLY WAR? HOLY SHIT.

They say there are no atheists on the battlefield, son. But I finally figured out that's because the atheists are back in Paris, sitting in cafes sipping champagne with foxy models, wanton actresses and sultry assistant curators. Atheists have too much to lose. Atheists can't afford a war. It takes belief to fight a war. Atheists can barely scrape together enough belief to get out of bed in the morning.

You can only go to war when you know that God is on your side. The atheist has too little belief. He asks too many questions. Even if there is a God, how do I know he's on my side? He could really be on the other side. Or God could be on both sides? Why not? He's God isn't he?

There are no agnostics on the battlefield, son.

The agnostics are back in Boston, marching in Birkenstock sandals against your cause. They have the courage of their unconvictions.

There are no Christian Scientists on the battle-
field either, son. Have you ever heard a wounded
soldier screaming, Librarian, Librarian. Nope.
The battlefield is for believers, son.

Christians, Jews, and Muslims and anybody else
like the Kurds who gets in their way. The battle-
field is a place for the true believers, as well as
the heretics, heathen, pagans, infidels, sinners,
satans, assassins, terrorists, holy avengers of God,
messengers of the almighty, angelic extermi-
nators, flaming swords of God, angels of divine
retribut-ion and death, knights of the temple
and other various bad ass, butt-kicking mother-
fuckers dealing in the big payback, that's who
the battlefield is for.

Kill 'em all. Let God sort 'em out. Death from above.

Israel smote by missiles horribly named scud.
Children die of fear in misused gas masks.
There is fear of anthrax in the house of Judah.
Meanwhile betwixt the Tigris and Euphrates the
cradle of civilization is rocked by Tomahawks
from our nuke subs and blasted from above by
our black electromagnetically invisible batplane.

Saddam opposes the Satanic Whitehouse from
Saddam's luxury nuke proof bunker with pool
and tanning salon. The Assassin of Assassins,
Hassan-e Sabbah says nothing is true, everything
is permitted. CNN's rating jumps to 22.3. Arab
captors slice off the French jet jockey's ear. They
beat the American prisoners and televise their
fraudulent confessions of regret, they cover the
sea with oil and set it ablaze.

Holy war. Holy war. Holy mackerel. Holy war.
Holy moly. Holy war. Holy jumpin jehoosophats.
It's the holiest war of all time. Old Testament
meets New Testament meets the Koran in a two
thousand year-old grudge match, no holds barred.
Even more believers want in. It's a holy war for
feminists, for a woman's right to drive a car or a
tank, a holy war for ecologists concerned about
the gulf and global warming, a holy war for mor-
alists concerned about human rights violations.
A holy war for everybody. If I were a religious
man I'd be scared.

Such a cosmic showdown, such a global high
noon is surely an Apocalypse an Armageddon.
The words of the prophet are written on the sub-
way wall. Jihad. Flags are flaming. It's Holy war.
It is written. It is written. Nostradamus predict-
ed it. It is there in Revelations. The creature with
many eyes and horns. And all that stuff. It is
written. All that stuff. It is written.

Don't you just hate it when they say it is written.
Copywriters hate that shit. As a professional
I say that anything that is written can be rewritten.
And anyway it is not written. Let me repeat. It
is not written. The Bible is not written. The Koran
isn't written. The protocols of the elders of Zion
isn't written. Or even the fucking subway walls
ain't written too good any more.

Fuck the prophets. Where are they getting us.
Into the shit. Just say no to prophesy. The proph-
et is dead. Leave him the fuck out of this. And
that goes for Jesus H. Christ and all his saints
too. And that goes for all of Israel's prophets too,

unless you're counting people like Lenny Bruce.
Mohammed, forget about it.

There is no more prophet.

There is only profit today.
Profit. The bottom line.

There are no more prophets.

There is only more profit.

It is not written. It probably
never was written and even
if it was it sure isn't now.
And even if it was it would
be spelled wrong now and
the words would make no
sense. We have found the
meaning is lost. The lan-
guage is dead.

There is no prophesy—
only lame lies, stale rumors,
pulp fiction, cons old as
the lower hills.

There are no saints here,
only sinners.

There are no sins here,
only omissions.

Omission is our holy mission.

We have no mission. No one

returned from the last mission.
They went ahead and there
was no ahead ahead.

Our father is not in heaven.
He is down to earth.

And there is no heaven
except on earth, as it is now.

And there is no hell, except
on earth, as it is now.

Where the living outnumber
the dead.

Where there are no dead
only the dying.

Where there are no angels
except those created tempo-
rarily when two people
make love.

Where there is no devil
worth the trademark.

Where there is no apoca-
lypse now or ever. There is
no end, and no beginning
that you or I will ever get to

see—just endless middle.
The middle.

I came in in the middle. I left
in the middle.

How did it end?

There are no words to
describe some things.

There are no things for some
words to describe.

There is no beginning of
the end.

There is no secret word.

There is no God.

There are no soothsayers.
No sooth is good sooth.

Don't believe the hype. It is not
written. It is not written.
It is oral and it changes all the
time. So don't count on it.
Don't bank on it. Don't bet the
farm on it or buy the farm on it.

The only secret is there is
no secret.

The only truth is that it's
a lie.

There is no holy war. There
is no apocalypse. There is
no revelation. There is no
final trumpet. The only trum-
pet relevant to this is Dizzy
and Miles.

There is no prophesy there
are only vibrations and the
beat and the epiphany of
being where it's at. Exactly
where it's at.

If in the beginning was the
word, what was the word?
What's was the word. The
bird is the word. The bird,
the bird, the bird is the word.

Go Bird go.

Paper Magazine, 1997

A DEMOCRAT BY ANY OTHER NAME

There are those who say that it will be impossible for the Democratic candidates to lose this election given the record of the incumbent Republican Administration. And, of course, there are those who claim that it will be impossible for the Democratic candidates to win the election because Michael Dukakis has the oratorical gifts of a Silicon Valley sales rep, or because his running mate is named Lloyd. (It is a highly regarded theory that Walter Mondale lost the last election because of his nickname, Fritz.)

But win or lose, these are not the crucial problems confronting the Democratic Party today. The Democratic Party's major problem is the name of the party itself. Democrat is just a bad name. It's a cacophonous word. It sounds ugly. It has what metaphysicians call "bad vibes," and until this name is changed, the Democrats will never win another Presidency.

For one thing Democrat has the extremely unpleasant sounding syllable "crat" in it. And almost without exception "crat" words have a negative connotation. Autocrat. Plutocrat. Aristocrat. And "demo" words are not much better. Demoralized. Demonic. Demoted. Demolition. Demonstration. Not a happy group of words.

Then consider Republican. The word almost rolls off the tongue. It doesn't sound like other words. Except publican, and although in ancient Rome that meant tax collector, today it has the happier meaning of bartender.

Republican evokes stirring phrases like "and to the Republican for which it stands" and the "Battle Hymn of

the Republican." It makes one think of Abraham Lincoln, who was the first modern Republican President. I say modern Republican because prior to 1854 the Republicans were known as the Democrats and the Democrats were known as the Republicans.

Exactly why this bizarre name exchange took place is something of a mystery today, but it seems that perhaps the Republicans were the first to realize the burden of the name Democrat, and that's why they gave it up in 1854, when the modern Republican Party was organized from a coalition of Democrats, Know-Nothings, Barnburners, and Abolitionists (names even more un-commercial than Democrat). Meanwhile, the Democratic Party emerged from the Whig Party, previously known as the Democratic-Republican Party, which was before that the Anti-Federalist Party. I think.

The Anti-Federalists, later known as the Democratic Party and finally as the Republican Party, had come into being, oddly enough, to oppose the Federalist-conceived Constitution on the grounds that it gave the Federal gov-ernment too much power. Famous Anti-Federalists include slave owner Patrick Henry, who said, "Give me liberty or give me death," and George Clinton of New York (no rela-tion to George Clinton of Funkadelic).

In 1834, however, the Anti-Federalist Party became known as the Whigs because the name was easier to fit into the headlines of the New York Post. In 1836 the Whigs were bolstered by the absorption of the Anti-Masonic Party, the first third party in the U.S., which ran John Quincy Adams for President in 1832 on the first written party platform in U.S. history. The main planks of the Anti-Masonic Party platform had to do with outlawing secret societies, such as the Masons, the Shriners, Eastern Star, the Knights of Columbus, the Jaycees, Rotary, the Elks, the Moose, the Lions, Skull and Bones (of which George Bush is a member), Phi Beta Kappa (of which Michael Dukakis is a member), the Water Buffaloes, the Mystic Knights of the Sea, and the Raccoon Lodge.

In 1854, of course, the Whigs gave up the ghost as its members joined the Democrats or the Republicans or the Confederacy, and hardly a Whig has been sighted since. There have been numerous efforts to come up with new political parties with snappier names. In the 1880s there were the Mugwumps—whose name means "big chief" in

the Algonquin tongue (no relation to Robert Benchley or
Dorothy Parker)—a faction composed of liberal Republicans
who supported Democrat Grover Cleveland. The Mug-
wumps soon fizzled, although the name was briefly revived
in the 1960s by a group including Cass Elliot—which later
became The Mamas and the Papas.

In 1874 the Greenback Party was founded to elect
Peter Cooper as President. The party favored issuing
more currency and adopting the eight-hour workday. In
1884 it merged either with the Anti-Monopoly Party or
with the Cooper Union art school, which later graduated
Alex Katz, Lee Krasner, R.B. Kitaj, and George Segal,
among others. Then in 1884 the Anti-Monopoly Party
became the People's Party, probably due to pressure from
the Parker Brothers, who would not allow the party to
"pass go or to collect $200."

In modern times there have been several third party
candidates who have made a respectable showing at the
polls, but none has championed a significant party, with
the possible exception of Lyndon LaRouche's U.S. Labor
Party, which runs regularly on the platform that Queen
Elizabeth and Teddy Kennedy head up the world's drug
trade in association with International Communism, launder-
ing their money through Macy's department store (hence
the red star on its facade).

No, there is only one party with a genuinely good
name today, and that is the Republican Party. Not only
is it a party with a euphonious, noble-sounding moniker,
it also has a terrific nickname: "The Grand Old Party,"
a.k.a. G.O.P. The Democratic Party doesn't even have
a nickname and hasn't had one since Tammany Hall
(no relation to Fawn).

And despite Nixon, despite Meese, despite Water-
gate, Iranscam, and the Iran-Contra affair, the Republicans
maintain a superior image because their mascot is superior
to that of the Democrats. Everyone likes an elephant more
than a jackass.

It is obvious that the Democrats are in a strong
position to win this election. They have a nice-looking
candidate named Mike. They have the potential to deliver
the first Jewish First Lady. And the outgoing Republican
Administration, of which George Bush was a key figure,
has run up an unparalleled debt and may turn out to be
one of the most corruption-riddled regimes in modern

history. But unless the Democrats can come up with a new name for their party, their future and the future of the two-party system looks bleak.

I've been racking my brain, but still I feel that I have yet to come up with something that sounds quite as good as Republican. However, I have thought of several dozen names that are better than the existing liberal faction handle. To name a few: the Anti-Matter Party, the Fiber Party, or perhaps the Fit for Life Party. The Flubber Party. The Ventrilocrats (contains "crats" but is harmonically balanced by a happy syllable). The Oprahs. The Tupperware Party. The Anti-Whig Party (formerly Hair Club for Men). The Party Line.

These aren't all that bad, if I say so myself, but I'll admit that they seem to lack the mass appeal that is so crucial when it comes to naming a winning party. Something cute like Tory, Whig, or Wobbly would be nice, and perhaps Steven Spielberg could come up with something as cute as Gremlins or Wookies, but a little more on the up and up.

I think that a Wheel of Fortune Party could be very big, if Merv were to license it, but he might demand a spot on the ticket for such an arrangement. I think he'd be a mmmarvelous Secretary of State, though, and I could see Pat Sajak in the U.N. and Vanna doing the Department of Interiors. But I guess it's a long shot.

At any rate I'm sure that they'll never win again with a name like Democrat, so let's all put our thinking caps on, O.K.? The future of Democracy, for lack of a better word, may hang in the balance.

Interview magazine, 1988

I have trouble remembering which one is Eric and which one is Uday.

Tweet, 19 November 2016

THE DARK HORSE

If you ask me (and I dare you), there's only one Democratic presidential candidate who can win, and that's Mikhail (we'll call him Mike from now on) Gorbachev. The week after Mike Gorbachev made his American network premiere in an interview with Tom Brokaw live from Moscow (he finished third in the time slot, after *Kate and Allie* and *Ultimate Stuntman: A Tribute to Dar Robinson*), there was an equal prime-timely talk between President Reagan and Dan Rather. During the course of their chat, Dan mentioned that the president's positive rating from the American people was only four percentage points higher than the rating those same sample Americans gave Soviet CEO Mike Gorbachev. Gorbachev is only four percent less popular than Reagan! And that's way more popular than Bush, Jackson, Haig, Dukakis or even Governor Cuomo.

Immediately I started thinking that Mike just might be the man for the Democratic nomination. He's popular, he's smart, he's good on TV and chances are he doesn't screw around. He's cool. He has $9,000 worth of new Italian clothes and a wife who can do it all. He is also not an ordained minister and he's not a millionaire. He doesn't have to worry about rumors that he's connected with the Mafia. He's concerned about The Family. He looks like an American businessman, not a Hollywood actor. And, as an extra bonus, he's already the head of the second or so most powerful nation on earth.

If Mike becomes president of the United States, I think there's a good chance that we could once again become the greatest business power on earth. If he's elected president, the USA/USSR coalition will make short work of the Japanese and the EEC too. And if he's elected it will be because Gorbachev just has a better business image than Ronald Reagan or any of the Democratic, or for that matter Republican, candidates. He's the man who can get American industry moving again. He looks like he wants to cut a deal. He's not afraid to bid on a tough job and he looks like he's willing to roll up his sleeves and get as dirty as the union steward will allow. In short, he seems like an executive and not just a high-powered spokesmodel.

If the United States and the Soviet Union were mere corporations, as well as they should be, there would be no problem with having one man at the helm of both companies. We don't care if Bobby Knight is president and/or chairman of Sheraton Lehman and Beatrice at the same time.

Especially if it will bring down our long-distance charges, get us overnight delivery, help us move more units and get us the check on time and maybe a thank you once in a while.

Russia is the greatest market in the world. These people are desperate for our fashion know-how and our brand-name culture. And to them the workmanship of our cars is a step up! More than anyone, they want what we got and they're willing to work for it.

The Russians can become our success story of tomorrow, our future West Germans and Japanese—once our greatest enemies, later our best friends, clients and business partners. But before we let the Russians get out of control, like the Germans and Japanese did, let's make an official merger with them. Isn't electing Gorbachev president better than recognizing the emperor of Japan for life? Besides, as Jon Hassell said, any guy with a map of Thailand on his head has got to make a good president.

Gorbachev could run as either a Democrat or a Republican. He would seem to be more of a Democrat than a Republican, but the Republicans have had a much better record with bald candidates.

Finding a running mate for Gorbachev won't be easy. He'll need someone who can literally interpret him to the American people. We will need someone with a special knack for communication. How does Gorbachev/Donahue sound? Or Gorbachev/Winfrey? It's something to think

about as our domestic field of candidates grows slimmer and slimmer.

When we can't find an American-made part that works, what do we do? We import it. Let's go for our first imported president. We won't have to worry about nuclear war anymore, because we'd just be nuking ourselves. And just think how great it would be to have two states called Georgia.

Interview magazine, 1989

SYMPATHY FOR THE TALIBAN
A MODEST PROPOSAL FOR TIMES SQUARE

Probably, if given the opportunity, I would
beat Osama Bin Laden to death with the
Manhattan Business-to-Business Yellow
Pages without giving it a second thought.
I don't like all this fundamentalist poop.
I don't like fundamentalist Muslims. I don't
like fundamentalist Christians. I don't like
fundamentalist Jews. I can't even stand
atheists who talk about it too much.

And I'm no flag waver, but I don't like
it when somebody tries to destroy one of our
beautiful U.S. Navy destroyers. Remember
the Lusitania! But something odd happened
to me when I saw the photos of the giant,
thousand-year-old Buddha statues recently
destroyed by Taliban militants in Afghani-
stan, despite the pleas and warnings of just
about everyone in the world. Something
weird clicked in my head. Somehow I
thought, "Well maybe they were right.
Sort of."

Maybe the fact that the before and after
photos were published during Oscar week
had something to do with it, but suddenly I
felt like iconoclasm is not without its points.
The Taliban insurgents, those quaint Islamic
fundamentalists now more or less running
the show in the neighborhood of the Khyber
Pass, are good old-fashioned iconoclasts.
They believe in blasting the bejesus out of
anything made in the likeness of man, citing
the Koran as all the proof they need of the
pressing necessity to do so. They just hate
representational art. If it were a Pollock or a

Larry Poons, they probably would have just left it up there on the canyon wall, but no, it was clearly a likeness of Siddhartha Gautama, the Buddha, and so it had to go. If it had been a giant stone likeness of Sammy Davis Jr., Robert Urich, or Val Kilmer, or a giant stone Madonna video, they would have done the same thing, so it has nothing to do with wiping out the religious competition. Well, maybe Val Kilmer was a bad example, make it Dabney Coleman instead. It's all about idolatry: missing out on real life while caught up in image generated fantasy.

I think that in a very extreme way they are making a point that is well taken. It certainly would have been more appropriate if they had trained their artillery on, say, Disneyworld, the headquarters of *InStyle* magazine, the Jerry Springer show, Julian Schnabel's studio, or every copy of the film Titanic, but the rural zealots struck the only targets they had in range, the big old stone Buddhas. I suspect they were trying to point out that the world is too caught up in the worship of images, be it the Buddha or Brad Pitt, and, if you'll permit me some leeway in interpretation, there are better things to do with your time than wank with *Penthouse*.

This is not a point of view unheard of in the Western tradition. Canon 36 of the Synod of Elvira (305A.D.) prohibited images in Christian churches because the superstitions involving them often resembled good old fashioned idolatry, with the crucifix and saints subbing for the golden calf. The movement picked up steam in the Eastern Empire and ruled for hundreds of years until the seventh ecumenical council at Nicaea in 787, convened by Empress Irene, declared that images should be venerated, not worshipped, and permitted in churches. Still iconoclasm prevailed until the ascendancy of the Emperor Michael III, "Michael the Drunkard" (839-867) whose debauched cronies may

have included representational artists. The
upside of the iconoclast interlude was a fine
heritage of semi-abstract art that may be
admired in the churches of the Orthodox
Eastern Church.

Certainly, the Taliban's benighted view
of the role of women (seen veiled and not
heard or working) is lamentable and retro-
grade, but perhaps even the most odious of
regimes may occasionally, accidentally, verge
on having a point. Western culture is idol-
atrous in the extreme. We worship images:
famous faces, logos, trademarks, computer
retouched photos of surgically enhanced
mammaries, and high-end consumer goods.
And this is bad. I wouldn't mind terribly if the
Taliban blew up the Michelin Man and the
Pillsbury Dough Boy. I wouldn't mind if they
managed to destroy every existing copy of
the new Britney Spears Pepsi campaign and
annihilated every billboard visible on every
interstate highway in the United States. In
fact, maybe Mr. Ashcroft has a little down-
home Talibanism in him somewhere. And
I also doubt that the Buddha minded being
blown up, symbolically attaining nirvana,
which means, literally, being blown out.

Stop the presses! I have just learned
of the following dispatch from Mawlavi
Enayatullah Baligh, Deputy Minister Islamic
State of Afghanistan: "To prevent idolatry:
To be broadcasted by the public information
resources that in vehicles, shops, rooms,
hotels, and any other places pictures/portraits
should be abolished. The monitors should
tear up all pictures in the above places. This
matter should be announced to all transport
representatives. The vehicle will be stopped
if any idol is found in the vehicles." Yes, no
more Naomi Campbell in the lockers of
Kabul. No more Kate Moss for Gucci.
Could this be the end of billboards in art?
Could this be the end of Rhea and Giselle,
marinated in motor oil, snuggling for Dior on

the sides of buses wherever the Taliban Jihad is feared? What are the global imprecations?

I would certainly prefer it if we went abstract in our outdoor art. Let's bring the grandeur back to Manhattan. I mean I don't mind people looking at Nan Goldins or Robert Mapplethorpes or Michelangelos in the privacy of their own museum, but the great outdoors should, perhaps, be treated more abstractly. Imagine Times Square billboards covered in Brice Mardens, Mark Rothkos, Mike Goldbergs and Joan Mitchells. I'd miss Alex Katz, but I think after a few years, once the hideously lurid iconography of commerce was gone, Alex and Jim Rosenquist and their kind would be back in business. Because, if I remember correctly, when Mike the Drunk eased up on the bohemian crowd, the paintings they made were certainly more spiritually motivated than the hunky, humpy, buff sacred statuary that got everybody riled up in the first place.

Arena Homme +, Fall 2001

Sarah Charlesworth

LIFTING THE VEIL

I remember going to London in the 1970s
and going to visit Duggie Fields in Earl's
Court and turning a corner and coming
across an Arab woman, covered in black
head to toe and wearing a strange gold metal
mask. It looked a bit like the beak of a hawk
or owl and she scared the shit out of me. It
was as if a hawk headed Egyptian god had
come down to eat me. Yikes!

I had no idea where she was from but
I knew I didn't want to go there. I found
it utterly threatening and sinister. Today
I believe that she was probably a tribal
Arab woman from one of the Persian Gulf
monarchies like Qatar and was wearing
what is called a batoola. And I think that the
fact that the mask was gold means that she
was high society.

I know I'm not supposed to but I still get
a creeped out feeling when I see a veiled
woman in a western city like London or New
York. I know they are doing it for religious
reasons, but somehow withholding one's
identity in such a way strikes me as aggressive
and threatening. Maybe it goes back to
watching cowboy movies as a kid, where the
bandits holding up the stagecoach usually
had bandanas pulled up over their faces, but
I still tend to associate masking with robbery
and terrorism. Women in burkas are even
scarier than nuns, and nuns scared the hell
out of me as kid. I didn't think they had
hair! One day I caught a glimpse of hair
uncovered by the wimple and I realized
that nuns were women in disguise.

If a woman wants to go around in a
babushka, that doesn't bother me. But
I don't think society should force women
to cover their hair. Hair is beautiful. If
there is a God, blondes are one of his better
inventions. But the all-male mullahs
of the Iranian Islamic revolution decided
that the Prophet wanted women's hair
covered. Supposedly the Prophet indicated
this intention in the Koran, dictating
that women shouldn't "display their beauty
or ornaments except to their husbands,
fathers, husband's fathers, sons, husband's
sons, brothers, brother's sons, sister's sons,
or their slaves. Also their male servants free
of physical needs," which I take to mean
those whose testicles have been removed for
one reason or another. Maybe it's me, but
shouldn't the Prophet have done something
about slavery and castration first, instead
of worrying about visible ponytails?

And so the mullahs made women
showing their hair punishable by 100 lashes
and six months in the slammer. But the
brave beauties of Tehran are fighting back,
inching their Hermes and Chanel scarves
farther and farther back, trying to hold the

line against the past. And that's exactly what's going on here. The future is fighting against the past, which is waging war to make a comeback.

Supposedly the mask and the veil are intended to protect women from the lustful gazes of men, but trust me gals, if you were unveiled the rest of your get-up would be enough of a turn-off for many of us. I don't go for looks that I associate with the Blessed Virgin or Sister Imelda, who used to whack my knuckles with a ruler. On the other hand, I must admit that I find modest women sexy. I find a girl in a skirt at the knee, a twin set and pearls much sexier than one with a midriff and butt cleavage short shorts. But a society where men are grossly unfamiliar with female anatomy and charms is one that programs them for alienation, perversion and fanaticism. In fact I believe that the veil actually produces the opposite of the supposedly intended effect in the societies where they are worn. As long as women are veiled then men will have an unhealthy curiosity regarding them, and awkward manner with them and a very low threshold of arousal in their presence. The countries where women are most likely to be groped by strangers are the countries where they are veiled. In New York, where young women go around half naked in season, such behavior is rare.

But that's not my only problem with the veil. I also resent it, because in the national security state that we have today, allowing Muslim women to wear full body burkas is giving them rights that we ourselves no longer have. When we travel we have to partially strip at the airport, remove shoes, jackets, hats and sunglasses. Now they want to x-ray us through our clothes. My community board district in Manhattan alone has 364 police surveillance cameras. So, in our maximum-security state, should

we allow certain people to go around with hidden identities because an invisible and very possibly fictional authority ordered it?

"What did the culprits look like?"

"Well, they were black shadows from top to bottom. They had no faces."

I wonder what would happen to me if I went around Manhattan in a veil. Right now I have to show my driver's license to get into a business appointment in just about any office building in Midtown. We're surveillance crazy. My community board district in Manhattan alone has 364 police surveillance cameras on the street. So why should people be able to go around masked? I find it disturbing even on Halloween.

President Nicolas Sarkozy of France has the courage to stand up to a cult determined to erase our civilization, along with its modernism, and return us to medieval ways by supporting a ban on full body veils. He said, "The problem of the burka is not a religious problem, it's a problem of liberty and women's dignity. It's not a religious symbol, but a sign of subservience and debasement. I want to say solemnly; the burka is not welcome in France. In our country, we can't accept women prisoners behind a screen, cut off from all social life, deprived of all identity. That's not our idea of freedom."

I was dismayed that the supposed paragon of American rationality, the *New York Times* was offended by Sarkozy's position, insisting that people must be free to choose to wear or not to wear full body veils, a position that seems an absurd exercise in bend-over-backwards liberalism. I believe that if we permit full body veils to be worn in public, we are allowing individuals, by right of their religion, to behave in a way that subverts the public interest.

What if I went around in a burka? Would they let me in a bank? Drive a car? Would they buzz me into Fred Leighton's estate jewelry

POLITICS

store. Would 605 Third Avenue let me up
to see my lawyer? If everyone wore a veil in
the West we'd be set back a thousand years.
Which is, I suppose, the whole point. I would
prefer to be set back 2500 years to ancient
Greece where common sense was respected.

The creepiest thing about the *New
York Times* defending burkas is that they
are worn by adherents to the very same
groups responsible for acts that caused the
government's invasion of our privacy in
the first place. Burkas are Taliban couture,
you know, the Taliban, the guys who drove
airliners into the World Trade Center,
murdering thousands of innocents while
saying their prayers. I wonder how the
Times would react to a mass adoption of ski
masks in Manhattan. Imagine them worn
by men in our banks and airports. Imagine
masked men knocking on your doors.
Imagine the Klu Klux Klan kit as business
wear. I believe that in a civil society that's
drifting toward a national security state,
we can reasonably expect people, for the
greater good, to voluntarily refrain from
hiding their identities, with the possible
exception of Halloween.

And while some degree of multi-
culturalism is good, especially for tourism,
(look at the Amish people, kids!) I don't
think we are required to encourage groups
that seek to efface the individual in defer-
ence to an abstract totalitarian conformity,
and who seek to bring about their anach-
ronistic code through a combination of
obscurantist readings of ancient texts and
brutal intimidation. The Taliban enforced
the burka in Afghanistan saying that "the
face of a woman is a source of corruption."
I say the face of a woman is a source of
inspiration, comfort and joy.

And so, brethren and sistren, I'd like
to close this sermonette with a couple
of quotes from the Right Reverend H.L.

179

Mencken: "We must respect the other fellow's religion, but only in the sense and to the extent that we respect his theory that his wife is beautiful and his children smart."

And from 1925: "The way to deal with superstition is not to be polite to it, but to tackle it with all arms, and so rout it, cripple it, and make it forever infamous and ridiculous... True enough, even a superstitious man has certain inalienable rights. He has a right to harbor and indulge his imbecilities as long as he pleases, provided only he does not try to inflict them upon other men by force. He has a right to argue for them as eloquently as he can, in season and out of season. He has a right to teach them to his children. But certainly he has no right to be protected against the free criticism of those who do not hold them. He has no right to demand that they be treated as sacred. He has no right to preach them without challenge."

So hey, lady, take off your hat.

10 Magazine, 2010

Kate Simon

THE RIGHT TO BEAR CUDGELS

It's easy to get mixed up by what's going on with high school kids today. I mean, back in my day we used to blow up the school once in a while, but it never involved more than a single cherry bomb and a single toilet. I do remember one more organized terrorist effort. When Nixon was elected president, students were planning an action called Flush for Freedom.

The idea was that the first time Mr. Nixon, in his inaugural address, uttered the word freedom, we were all to flush our toilets immediately. Theoretically this would blow out plumbing

systems all over the United States, or at least those on many campuses with ROTC programs. Frankly I missed my flush, I think, because having taken LSD, I noticed that the inauguration telecast was being sponsored by Sinclair Oil, whose symbol, a *Brontosaurus*, symbolized extinction, and suddenly I had become convinced that Nixon was to be the very last president. This threw off my timing and I missed the flush on the word freedom, which might, perhaps, have been the straw that broke the water system's back, at least on my campus in Washington, D.C. This stunt, by the way, was, I believe, inspired by an actual student prank that had been organized many years before at the U.S. Military Academy.

But, I digress. Let's get back to these nutty kamikaze nerds, such as the self-styled Trench Coat Mafia, who have recently been threating our high schools in this unstable mid-millennium shift.

Now this side over here says that it's the extraordinary access to firearms in our society that's causing this mayhem. This side over there says, no, our right to bear arms is guaranteed by the United States Constitution and, if anything, these teens are being destabilized by a deadly combination of violent Hollywood films, violent video games and pharmaceutical anti-depressants. No, says the other side. Freedom of speech is guaranteed by the United States Constitution.

Clearly there's a deadlock here that may threaten the Constitution while plans for more copycat apocalyptic revenges of the nerds are coming to light every day. What's a mother to do? I mean

we love our constitution. But now areas of it are getting gray. The tasteless and worthless Jenny Jones loses a $25 million suit pressed by a man who claims he was driven to kill by being embarrassed on her show. The Supreme Court is allowing a lawsuit to be heard against Oliver Stone and the producers of *Natural Born Killers*, who are being held responsible for inspiring a young couple to go on a killing spree. People are just being driven to do things at an unprecedented rate.

I think it's the fault of the tobacco companies. Ever since we discovered that they drove people to kill themselves against their will by smoking, there has been an extraordinary epidemic of powerlessness. I guess the surge in 12-step programs and law school matriculations have also contributed to the notion of powerlessness. It is only a matter of time before alcoholics are suing the liquor companies for cirrhosis, and the obese, or avoirdupoisly challenged, sue Land O'Lakes because butter is addictive.

I was taught in Catholic School that we all have free will, but the state is a separate thing, and the government seems to be moving to a position where we don't have free will, we are all Manchurian Candidates and Pavlov dogs, controlled by hidden persuaders. I have never been driven to smoke by advertising, although the Marlboro man may have made me a latent homosexual, nor have I been driven to violence by Oliver Stone movies. But I do think that adults should monitor what their children are watching, and that no children under thir-

teen would be very interested in "Kids" or
"Happiness" anyway.

But I do think I have a solution to this "Right to
Bear Arms" problem. Now I don't think that
there's a soul out there, or not more than a million
anyway, who interpret this section of the Bill
of Rights to mean the right to bear any kind of
arms whatsoever. Citizens are definitely not
allowed to bear nuclear arms and surface to air
missiles and landmines are definitely out; so
certain restrictions are implicit to this right. Since
the Bill of Rights was adopted in 1790, it may
be that only weapons extant in that year (not the
actual weapons but the technology) should
be covered since we can't expect our forefathers
to be science fiction thinkers.

I know that the NRA believes we need automatic
weapons to down game but that's wacko, I
can down a deer with nothing more than my
BMW, and I know that part of the NRA believes
we need automatic weapons to ensure that we
can overthrow the government if it becomes
necessary, but that's wacko, as the military will
always have superior firepower to any insurg-
ent group of freedom fighters. The fact is that
the right to bear arms does not mean "all arms."
If it does, I personally would like to station a
cruise missile in my garage in Bridgehampton,
as it is, I shall make do with my battering ram
and catapult. But I think for the purposes intend-
ed by the Founding Fathers, late 18th century
technology is more than sufficient. You have to
draw the line somewhere. We are not permit-
ted to own ballistic missiles, nuclear warheads,

landmines, machine guns, bazookas or mortars.
And it's a good thing mortars are outlawed,
at least for the spec house developers in my
neighborhood. So since we have to draw the line
somewhere, I suggest we draw it at about 1812.
I think every citizen should be permitted to carry
a muzzleloader, a sword, a battle axe, quarter-
staff, pike, spear or mace (not mace), and no pikes
or spears in the subway please. I think cudgels,
dirks, longbows, machetes, bolos, dudgeons, pon-
iards, halberds, tomahawks, javelins, spontoons
and poleaxes should be available to civilians, and
if you wish to walk down 42nd Street carrying a
bastinado, a bludgeon, knobstick, loaded cane,
nightstick, shillelagh, stave, truncheon, harpoon
or South Seas war club, I give you my blessing.
Come at me and you'll be at risk from my flick
cane and knobkerrie and I am confident that such
traditional arms should be more than enough to
provide adequate self-defense for even the small-
est and meekest of us. Uzis are not necessary.
They are, as we say in the urban strategy business,
overkill, and if they came into widespread use
they could result in what the Rand Institute
called megadeaths.

But if the Trench Coat Mafia boys had been carry-
ing flintlocks there's no doubt that they would have
been overpowered after getting off the first shot,
the first shots would probably not have been fatal,
and today those boys would be in reform school,
unless, of course, they had managed to fall on their
swords, Roman-style, before capture.

I have my Grandfather's old Naval Academy
sword lying around the house, and let me tell you,

I wouldn't be afraid to use it on an intruder if threatened or on myself if disgraced. On the other hand, I don't have to worry about it going off accidentally. It's in a very handsome scabbard on a beautiful gold buckled belt and it looks quite good with tailored clothing. Yes, I support the right to bear arms, but only weapons that are Grandfathered.

GQ.com, 2012

Trump is already calling them "my generals." The Fürher waited until he got his job.

Tweet, 7 September 2016

LIGHT TO RIFE

My pal James told me I should write some-
thing about abortion. It was around the time
of the pro-choice march on Washington,
and all of us guys were wondering what our
role in this was. Of course, ostensibly the
issue will be decided by the men's club called
the Supreme Court, but inevitably it will be
decided by women. They will choose
to choose or choose not to choose. We men
can only root from the sidelines.

James said, "Women should be allowed
to murder whomever they want." I knew
what he meant. I think he means ladies
should be allowed to murder whomever they
want. Women do very little of the killing
in this world, and when they do it they are
considerably more discriminating than men.
They seem more likely to kill out of necessity
than out of boredom, madness, or greed.

"The Romans were allowed to murder their sons," James continued. I knew what he meant. In tribal days, the family was not so limited by the state. If there wasn't enough food to go around, abortion was encouraged. It was for the good of the whole tribe, including the unborn. If there was enough food but more help was needed, fertility was encouraged, through the intercession of the moon and by an increase in tribal cocktail parties and hayrides.

It's funny that the same political forces that are loudest on the subject of family are the ones least likely to allow families to make their own choices, the ones that create powerful economic constraints, such as welfare regulations, which destroy the families of the poorest classes.

I said to James, "In the old classical days the Bacchae [women gone ritually wild] used to run through the woods naked, and when they saw a man they tore the dude limb from limb. You could make a lot of arguments for that kind of thing today." There sure are a lot of unresolved tensions in our society, and a good women's run through the woods (Central Park, for example) once a year might be just the thing to defuse tensions. We could call it Sadie Hawkins day. A day of feminist "wilding."

Taboos are just rules that exist for creating a workable balance. And it's just not working. We need to lose some old taboos and choose some new ones.

It just seems more natural for the mother to choose whether or not to give birth to a baby. Because if she doesn't want the kid and doesn't get rid of it now, you know she will sooner or later—physically, mentally, or spiritually. And then it'll be somebody else's problem too.

James said, "Did you ever notice that the people who are 'pro-life' are the same ones who believe in capital punishment?"

Yes, I've noticed, and they tend to believe in pharmaco-agribusiness, nuke power, and the bomb. And chances are they're the ones who go around calling people bastards.

I think most right-to-lifers figure you only go around once. I know Catholics believe that. And they believe that those unborn, unbaptized babes wind up in a gray kind of sub-world called limbo, where they don't do the limbo rock.

Right-to-lifers tend to believe in heaven. A survey published in Newsweek said that 77 percent of Americans believe in heaven and 76 percent believe they have a good or excellent chance of getting there. You know heaven —that's that extraterrestrial dimension where we all go when we've nuked the planet into Christian submission. What is heaven like? Well, the survey revealed that 74 percent of Americans believe that there will be humor there, and 32 percent believe that they will be the same age in heaven as when they died (sounds like *Cocoon*).

I tend to think of heaven as a plot against life on Earth. Hey, with heaven, who needs the ozone layer? Who needs life? Well, I for one would rather come back as a Labrador retriever than be shipped off to some flesh-less, joke-filled Tampa-St. Pete in the ether. I think life is stronger than death.

But I think that the right-to-lifers are the people who don't give life enough credit —they assume that you can't just start over. I think you can. And I say to any fetuses vicariously reading this, "If at first you don't succeed, try, try again."

When I was a child I had a recurring dream, a nightmare, which was totally abstract. There were no images at all, just color and sound and feeling. Visually it was a Mark Rothko-Barnett Newman type of thing involving various shades of red from dark to bright. Acoustically it was about rhythms and noise—unformed, unartic-

ulated sounds becoming louder and more
unpleasant. The feeling was fear. I don't want
to go. I'm not going. I'm definitely not going.
No way, José. Then, Whoops, uh oh, uh oh,
I'm out of there.

Eventually I figured it out. It was a vivid
recollection of the final countdown before
my personal splashdown. I remembered my
birth. I was fully conscious in the womb.
I knew what was going down and I wanted
no part of it. Of course, when you gotta go
you gotta go, but try telling that to a fetus.
They're natural know-it-alls. I was a uterine
wallflower. I just didn't want to go.

Most people scoff at the idea of remem-
bering one's birth. But it's not the kind of
thing you fantasize about. I really believe
that when we're in the womb we know a lot
more than we let on. But I think that for the
most part womb-life is a lot like sleeping.
Sometimes you're out like a light, sometimes
you dream, sometimes you wake up. But
when you start to wake up, you're out of there.
Call me sentimental, but I think I've been
around a few times.

The Tibetan Book of the Dead is all about
life between lives. A lot of it has to do with
what leads up to an individual's acquiring a
body. According to the book, the pre-fetal
person has to make a lot of choices: who their
parents will be, where they will be born.
But this process is nothing like getting into
a good college; it's not like selecting from a
catalogue. It's described as "dreaming back"
to life. And the book gives various signs that
indicate the nature of possible life choices.
The basic idea is to avoid entering a womb.
But if you gotta go you gotta go, and instruc-
tions are provided for that eventuality:

If Karmic forces cause you to enter
a womb, follow these teachings to select a
womb door. Listen carefully. Do not enter
the first womb which presents itself. If evil
spirits force you to enter, break their spell by

meditating... Whatever you see, realize that it may not be what it seems, so take your time and choose carefully... Enter the womb only after you carefully consider your choice of birth. Do so with love and faith, thus transforming the womb into a holy temple. As you enter, meditate on the Compassionate One, your favorite, and the other deities... Listen carefully to avoid error: even if a womb seems good, it may not be so. And if it seems bad, do not reject it too quickly, for it may be good. Know yourself. Accept yourself. Be one with yourself. Follow the white light of the pleasure-seeking gods or the yellow light of the human world. Enter if you can the continent of the great temples of gold, with their beautiful gardens. Be one with these special teachings and Buddhahood can be achieved.

Women have the right to choose. But so do incoming fetuses. No matter what the pro-life atheists think, those proto-babes chose to drop in here and now. Sometimes they luck out. Sometimes the mission is aborted and it's back to the drawing board. But that's life. And for all of them bound for this wild world, I say, "Hey, for all you do, this Buddha's for you."

Interview magazine, 1989

THE FACTS ON THE BOMB

When you've been in this business as long as I have (we're talking lite-years), you begin to wish that the fact checkers lived in. I think that the right fact checker for me—a caring, non-ageist fact checker who enjoys long walks on the beach, college basketball, fugu, *The Addams Family*, etc., just hasn't come along yet. But if I found such a person, a helpmate rather than an adversary, I assume that I wouldn't have to spend most of my time trying to support the claims I have made, and I might have a chance at leading a reasonably happy and normal life.

I have thought of carrying around a tape recorder with me all the time, like Andy Warhol, but I know that if I did I would have a lot of problems keeping it in tapes and batteries, and it would also be a serious drain because I'd have to spend half my time listening to the other half. And during playback, things would inevitably happen, so if I didn't record the playback time too I'd be screwed, and even if I did, when would I listen to that?

Of course, I could become a fiction writer, but it would probably be the same thing all over again, and I would spend my days being queried by fact checkers making sure that there were no facts in what I produced and that any similarities to real persons and events were purely coincidental.

I have started taping most of what I watch on television for my own fact-checking purposes—because the phone always rings during the last two minutes of the game or when you're just about to find out who-dunnit. But even this taping is inconvenient, and once you start forgetting to label those tapes you might as well drop the whole process.

Anyway, for weeks I have been trying to check up on something I heard, with no luck at all. Maybe you heard it. I was casually listening to the TV news while doing something else—maybe cleaning out the U-grooves in my Ping irons—and I swear I heard something like: "President Bush stated today that nuclear weapons are not weapons at all." It happened so fast, and I just happened to catch it, so I can't be sure whether it was President Bush or perhaps someone highly placed in the Defense Department. It's possible that it was John Tower. It could have been Dan Quayle. It might even have been Ron or Nancy. But I swear I heard that some very important person had said that nuclear weapons are not weapons at all.

This struck a responsive chord with me (maybe A Major), because I have long suspected that nuclear weapons are not weapons at all, for what seem to me obvious reasons. Such as the fact that nuclear weapons are clearly unusable. For one thing, using them would end all life on Earth, and then where would we be? I mean, setting off even a few multimegaton missiles is bound to be worse for the environment than burning down the whole Amazon rainforest for hamburgers. And that's something we think may seriously destroy the ozone, the veggies, and us, in that order.

Besides, who are we going to use these nukes on? The Russians? They're our new friends. They don't want to be Commies anymore; they just want nouvelle cuisine bistros, designer clothes, and NBA basketball. Let's face it: the world has gotten very close together.

If they're not weapons, then what are these thousands of nuclear explosives? Maybe they're for blasting to harmless bits giant asteroids on a collision course with Earth. An asteroid came within half a million miles of us last March, and scientists estimated that if it had collided with the Earth it would have made a crater the size of the District of Columbia, although they could not predict if it would have hit the District of Columbia. And there are plenty of larger asteroids out there, such as Hermes, which had a close pass with the Earth in 1937.

Ezra Pound once suggested that a space program could be a way to replace war as our means of deficit spending. Perhaps the manufacture and maintenance (and almost infinitely long-term waste maintenance) of nuclear weaponry is simply a grand scheme to create debt.

The vast nuke arsenal could be an ignition system. When the hydrogen bomb was first tested in 1952, it was exploded in the Pacific Ocean at Bikini atoll. A minority of the scientists who worked on the project protested exploding the bomb in the ocean, because they believed it was possible that it might create a hydrogen reaction in the water, setting the oceans on fire. And there is a substantial minority of physicists today who believe that such an ignition might occur with today's exponentially more powerful hydrogen weapons. Maybe the Earth just wants to be a star and we are her agent.

But there are many other possibilities. Could they be gigantic pest-control devices—a sort of cosmic Raid? Perhaps they are stogies of the gods, or tranquilizers for behemoth macho entities. What else could they be? Battery packs for intergalactic travelers? Food for something very big which will show up soon? The Martian equivalent of Desenex or Micatin, for eliminating irritating forms of life analogous to athlete's foot, such as ourselves? Satan's microwave popcorn? Saturnian air conditioners? Venusian Ty-D-Bol? Maybe the bombs are even some new form of intelligent life that, thousands of years ago, we were DNA-programmed to assemble. But weapons? No way that we could be that stupid. Where are those fact checkers when you really need them?

Interview magazine, 1989

Gaza is about the size of Queens. Imagine if you couldn't leave Queens.

Tweet, 20 July 2014

THE MUSICAL CHAIR

> [Houston's] hostage negotiating team
> has made music—and sometimes more
> ordinary noise—one of its secret weapons.
> During standoffs over the past three
> years, everything from soothing gospel
> tunes to rousing martial airs have blared
> from the team's state-of-the-art mobile
> command post.
> —*The Wall Street Journal*, August 3, 1989

Prison is just not working. They're right
back on the street in a matter of months, and
they have ever bigger muscles than they did
before they went in. But what can you do? It's
incredibly expensive to lock them up, and
you can't kill 'em.

Obviously the answer is to change the
criminal. We can educate them, we can teach
them a trade, but it's not easy to reach the
hearts and minds of hardened criminals, and
that's why I think our penal systems could
take a page from the manual of the Hostage
Negotiation Team of the Houston police
force and start using music as a way of effec-
tively altering the behavior of wrongdoers.

Simply by playing "Stars and Stripes
Forever" at a rousing volume, the Houston

heat was able to disarm a drunken and suicidal teenager who was holding his mother hostage. If that's what you can do for one youth in crisis with a few minutes of amplified Sousa, imagine the effect a real marching band might have on most prisons. Let's make sure that every prison in America has enough brass, reed and percussion instruments, not to mention batons and shako hats, to form a proper marching band. Perhaps these felons simply need to learn to march to a different drummer.

Rather than send criminals into the maddening sensory deprivation of solitary confinement, rather than abdicate our responsibilities and send them to the electric chair or lethal injection gurney, let's send them to the musical chair. Let's forcibly subject them to sit in comfortable recliners and absorbing constant musical reinforcement of proper societal values. Like "Feelings." "Volare." "Nice 'n' Easy." "Happy Talk." "Blowin' in the Wind." "I Am Woman." "I Got It Bad and That Ain't Good." "On the Sunny Side of the Street." "Unchained Melody." "Alone Again (Naturally)."

It's been shown that playing Beach Boys music in mental wards often calms violent patients. Let's see what a little Sergio Mendes might do for Sing Sing. Let's send Lawrence Welk to Attica. If he comes back alive, we'll know it's working.

Beat, 1989

Freedom Tower just doesn't sound right. Freedom Parking Lot, now that sounds good.

Tweet, 19 May 2014

MEANWHILE BACK AT THE RANCHO

The morning after I got back to New York, the headline of the *New York Post* was SPLIT, in type befitting, say, "Moscow Nuked," with the explanation "Trouble in paradise as Donald Trump walks out on Ivana." Down at the bottom of the front page in a one-by-one-inch box there was more news: "Mandela Free—Violence Erupts in South Africa. He says he's ready to die for democracy: Page 3." Now, such a page layout might lead one to believe that there's something very wrong with the priorities of the press. But what if the sex life of Donald Trump is what people in New York are really interested in? In a democratic society is it the duty of the press to determine what's really important, or is it the job of the press to dutifully serve the actual interests and appetites of the people? Well, maybe it's both. That's why we have a choice of news in this country.

If you're not all that interested in Donald Trump's private life and headlines like "Marla boasts to her pals about Donald: BEST SEX I'VE EVER HAD," well, you can always read the *New York Times*, where the news is more fit to print. And if you read the Times you might even discover

other reasons for what the news media choose to cover.
A few days later the *New York Post*'s top story was "Ivana to
Donald at secret sit-down: GIMME THE PLAZA... the
jet and $150 million, too," while the *New York Times*' front
page reported "Drug Bosses Give up Laboratories on Eve
of Bush Visit to Colombia." And that story was full of clues
as to why certain stories get the big play.

> The traffickers, who have been waging a war of press
> releases with the Government for the last month, said
> in a statement to news organizations that they were
> giving up the laboratory complex as yet another sign
> of their desire to quit the cocaine business and live
> in peace with their illicit fortunes... The traffickers,
> who United States officials suspect are being advised
> by professional public relations counselors, revealed
> the laboratory complex near the border with Panama
> to a group of more than 20 Colombian journalists
> who were secretly gathered and taken to the site.
> —*The New York Times*, February 15, 1990

Aha! Press agents! P.R.! That's the secret. Perhaps it's not
that the public is a bunch of sickos; maybe it's just that deal
artist Donald Trump has better publicists than Nelson
Mandela. Why, if Nelson Mandela had had Bobby Zarem
waiting for him outside those prison gates, he might have
stood a chance of bumping Donald and Ivana off the front
pages. If the ANC had Ogilvy & Mather public relations
working for them, they might have been able to delay the
South African hero's release for a day or two until the
Trumpfest leveled off. If Nelson Mandela were friends
with Cindy Adams...Well, no, that's not true.
 Is it a coincidence that the day that Trump began
his week as sex headliner he was on the cover of *Playboy*
magazine cavorting with a Bunny? Donald Trump is a
conspiracy. He's trumped-up, living proof that money
makes your dick hard.
 One week after the Trump split was announced,
the *New York Daily News* headline was "TRUMP JOINS
THE PARTY—He wings to Florida for Ivana's birthday
bash." On page two in a story on Trump's syrupy squeeze
Marla Maples, her agent, calling her "the Marilyn Monroe
of the '90s," told the media, "You will not see her in an ad
for No Excuses jeans... She was reading for every agent in

Hollywood before this happened, and she will be doing it again. They'll be seeing her for the wrong reasons, but her talent will carry her through." On page four of the same issue of the Daily News was a story titled "In Sex, Dull Is Called Better." On page five the top story was "Baby Found in Trash Can."

In a *Wall Street Journal* story on Colombian-drug-lord efforts to break into Colombian high society, a Colombian businessman-socialite said of the blow cartel honchos, "They are vulgar, tacky, outlandish, like the Vanderbilts at the turn of the century. Throughout Western history there has been a connection between evil and bad taste."

The man who said that declined to give his name. Hell hath no fury like bad taste.

If Marla Maples is the Marilyn Monroe of the '90s, does that make Donald Trump the Jack Kennedy of the '90s? It looks that way to me. Rather than hurting Trump's political chances, Marla makes them. I think this sex-symbol campaign of his is really just the foreplay to a full-scale run at the presidency. America doesn't want it all the time. But when America really wants it, like back at the dawn of the '60s, America wants a stud president, a potentate.

I may be mistaken, but I can't see Quayle fucking around when there's golf to be played. My bet is that Don Trump is the next candidate for America's ritually cyclic priapic president. Want to lay me odds?

Interview magazine, 1990

Music

I once told Bono that
"I Will Follow" was sending
the wrong message.

Tweet, 6 May 2015

WAKE UP WIGGERS OR YOU'RE ALL THROUGH

Over the years I've been a puppet, a pauper, a pirate, a poet, a pawn and a king. That's life, in the high occupancy lane. And because of my appearance, behavior and/or milieu I've also been judged a preppy, a hippie, a biker, a punk, new wave (how dreadful!) and a drug addict and, occasionally, the man, i.e. the establishment. Alternative is a hard row to hoe. A lot of name calling going on, but there are no means by which this can be avoided.

I am not your average youth culture cat, being that I am relatively ancient. I get junk mail from the American Association of Retired Persons asking me to sign up for senior citizen shit. They're starting to look at me at the movie box-office trying to figure out if they should let me in half price.

I remember when Lenny Bruce was alive. I remember buying new Coltrane albums. I saw Hendrix and Janis. I bought a ticket for Woodstock. (Dummy!) So I go way back. And yet I consider myself relatively unscathed by the ravages of time. Like James Brown I'm still on the scene, like a sex machine. And on some level, I still relate deeply to youth. I don't look at many women my own age. My wife is a youth. I still hate the government and I support legalizing all that stuff that's illegal.

I'm the old guy you see at Other Music buying Gnarls Barkley and The Boredoms and I'm the old guy you see at Supreme, where the skateboarders shop, buying jeans and jackets. (Well, I'm one of them. Larry Clark is another. I'm the one in the baseball jacket that says "I hate to advocate drugs, alcohol, violence or insanity to anyone, but

they've always worked for me.") But no, I don't think I'm young, and no, I'm not putting anything on. No fake, as the Rastas say. I've been heavily invested in youth culture for forty years. And I also mostly don't care about alternative music. I'm not expecting much from it. I listen to Bill Evans, Miles Davis, Thelonious Monk etc. so I'm not a trendy. My interest in hip hop sort of petered out with Public Enemy, although it still bubbles under. I have a lot of bohemian ties, numerous three-piece suits and almost the least bling-oriented Mercedes Benz. (A station wagon, but with the V-8.) If you see a black Benzo driven by a white guy with gray hair blasting "Fuck the Police," that could be me.

It's not really that I'm interested in youth, but I find myself allied with them out of mutual hatred of their parents. I think lots of artists, writers and prison inmates probably feel the same way. We hate the man, even though we resemble the man, therefore, by the enemy of my enemy is my friend principle, we are somehow allied with youth. Look at Sonic Youth. They're almost as old as me.

Now this is all a sort of preamble to something that's interested me for a long time. A few weeks ago I was walking up Lafayette Street past Supreme and I looked in the window as usual to see if anything in the store caught my eye. There are a bunch of other "street fashion" boutiques on this block, Brooklyn Industries, Stackhouse, Double Five Soul, and Recon is up on the next block, so this is the strip for board-culture b-boy fashion. I'm ambling along the sidewalk having a look in the stores and I hear a loud talker overtaking me from the rear. It's that kind of loud talk that signals a mobile phoner. But this one was different. His was the most rad Ebonics I'd heard in years. It was Black English but deep enough to subtitle, a real ghetto patois. The urban equivalent of Gullah or Geechee. "Yo, I be shoppin' fuh kicks nigga and all I be seein' is dis corny-ass designa shit...I ain't on 'at...I be headin' ova ta Modell's ta see if dey got some dope kicks..."

Theoretically this hard speech should have been emanating from some member of the Fifty Cent entourage or at least a gun toting crack dealer from the deep projects recently released from prison, but, yo, something was wrong. There were two many NPM—"niggas per minute"—and the sheer absence of adverbs, the lack of subjunctive, the high quotient of simple progressive (he buyin'), the intensified continuatives (I be mad chillin'), the dropped copulas

and the multiple negations: this language was too much. In other words, the cat be frontin' on an ill identity level. He white.

I turned and, yes, it was a white man, a young white man dressed in shorts, sneakers and t-shirt. Nothing special to look at really. Kind of a plain look. No Ali G. here. But that was the point of what he was broadcasting into his phone. He was not interested in "street fashion" because it was not street enough. I think he was suggesting that Supreme and Recon and Clientele and 255 (the limited-edition Nike shop) and Nom de Guerre and Stussy and Union were all too fashioney and not hardcore street. He wanted the dope projects shit. You see "street fashion" has turned into big business, and youth have taken sneakers and t-shirts and turned them into a fashion codex as ruthlessly and absurdly driven by exclusivity and arbitrary, hollow one-upmanship as the straight fashion world with its designer cults and conspicuous consumption signifiers. Every few months I see a queue of young men, a few hundred maybe, camped out in front of Supreme or Recon to spend the entire night waiting for the new limited-edition sneakers. It's a mixed race bunch, blacks, whites and maybe a more than average number of Japanese. It seems that some of these guys are not themselves fashion desperados but entrepreneurs who can re-sell those limited-edition trainers on eBay to the real fashion desperado in Japan for several times what they paid for them.

Ah, whither authenticity? I wondered to myself, with a melancholy air. I also wondered if this young Caucasian would have continued in this verbal vein if I had resembled Mike Tyson. How does this dude, whose every other word was "nigger", respond the presence of actual blacks? I would never know the answer to this, but I knew that I found such blatant wangsterism troubling.

I understand where this is coming from. White middle-class youth need someone to look up to and sometimes maybe The White Stripes and Sonic Youth aren't enough. There is a craving for authenticity and realness that isn't easily satisfied by what you see on MTV. Middle class youth have always been inspired by life and death struggles and they don't have many to call their own. The beats are gone. And the hippies on schedule 1 narcotics are dead. And the Weathermen blew themselves up. So what's a motherfucker to do?

In 1957 Norman Mailer published an essay entitled "The White Negro" in *Dissent* magazine. In it he wrote: "A totalitarian society makes enormous demands on the courage of men, and a partially totalitarian society makes even greater demands for the general anxiety is greater. Indeed, if one is to be a man, almost any kind of unconventional action often takes disproportionate courage. So it is no accident that the source of Hip is the Negro for he has been living on the margin between totalitarianism and democracy for two centuries."

Mailer saw jazz as the immediate hipster connection to the Negro. The Beat Generation lifted language from the blacks via jazz. A later generation of hipsters had the same relation with rhythm and blues and the blues. The Rolling Stones were the perfect manifestation of Mailer's White Negro. They took the music of Slim Harpo, Don Covay and Chuck Berry and translated it, through every fiber of their art schooled Anglo-Saxon being into something quite new. Other musicians created similarly strange hybrids, such as Led Zeppelin with their Celtic Twilight Howling Wolf Aleister Crowley fusion or the Yardbirds with their radioactive Sonny Boy Williamson. It was rock and roll and we liked it. It did everything culture is supposed to do, it gave us the tools to mutate in the cause of evolution.

And it wasn't a one-way street. Jazz itself was a fusion of European and African music. And in fact jazz was a less satisfactory model for the emerging hipster, which Mailer saw as a new class of self-conscious psychopaths. Jazz was too sophisticated, too eloquent and articulate. The rocker liked about blacks what his parents feared in them. He liked their rejection of middle class fashion with stylized pimp wear (while the cool jazz men wore suits.) And so hip hop presented an even more irresistible aspiration for bored white youth: the gangster, a violent antisocial without ideology acting entirely for his own gratification. Hip hop was armed and extremely dangerous, anti-idealistic, anti-intellectual and anti-social. And so it was seen as bad, i.e. good.

In a way the gangsta rap can be seen as a confluence of audiences, attracted to the ultra-masculine pose without content, which diverted attention from progressive hip hop as embodied by Public Enemy, De La Soul, the Jungle Brothers, Disposable Heroes etc... But then funny things happened and characters like Jay Z, Puffy Combs and OutKast emerged who clouded the picture with their blatant

refined taste and upward mobility, with their bespoke suits and fine wines. P. Diddy be sittin' wit Anna Wintour. What's a wigger to do?

Give up, dude. The process has passed you by. There is a place in hip hop for whitey, as the Beastie Boys proved with their 24-track irony, and as Eminem proved with his excoriating self-analysis and his gift for all-inclusive satire, but you're never going to be a Crip and you're never gonna be a Blood and instant gratification can't last. Even Marky Mark gave up the Funky Bunch and turned his b-boy entourage into a hep show about keepin' it at least somewhat real. I dug Everlast and the House of Pain but when the cat gave up his Guinness and became a Muslim with beats I felt bad for him. He could be the John Walker Lindh of art. You've got to flow from within, like Bob Marley or Kurt Cobain or Lenny Bruce or Frank Sinatra, that's the only way to keep it real. That's life. Get yourself a pair of limited edition kicks and kick back and feel fashion flow toward a better future.

10 Magazine, Fall 2006

KURT COBAIN:
HERE'S LOOKING AT YOU, KID

Music is like religion without rules. It can take you to a
higher place but demands nothing in return. A hit song is
an epiphany. It stops you in your tracks, freezes you in
space and carries you into time that's moving along but
also standing still.

When you hear some music that's really new it
shakes you; it totally focuses you in the moment. I remember
exactly where I was when I first head "You Really Got Me"
and "Have You Seen Your Mother, Baby," "Like a Rolling
Stone," "Papa's Got a Brand New Bag," "Foxy Lady," "I
Am the Walrus," and "Standing in the Shadows." In a car
outside a 15-cent hamburger joint in Cleveland, driving
along the lake in an Impala convertible, sitting outside a
Puerto Rican church, having a beer in a bar in George-
town, watching the ceiling go psychedelic in D.C. Music
stops time. But it also lives in time. Three minutes that
will live forever. Songs that change you like that sound
wrong the first time and so right the next time. They stick
in your head, rewiring your brain as they reprise.

That used to happen to me a lot and then it hadn't
happened to me in a while. Then in 1991 I found myself
driving through the Southwest, headed for San Francisco.
A real road trip. This was pre-iPod. It was either the radio
or cassettes for sounds and I hadn't brought any cassettes.
I wanted to listen to the sounds pandemic to the places I
was driving through. I-40 is the descendent of Route 66 and
if you plan to motor west, as an interstate it's the next best

thing to the old highway that's the best. (If you want to see
the great motels and diners you actually have to hit the exits
to explore the remnants of 66 itself.) Anyway, I was cruising
between Albuquerque and Gallup on I-40 when I first heard
this rock song that woke me the fuck up. It's a legendary
landscape of mountains and mesas and suddenly this thing
came out of the radio. E, A, G, C! A riff hadn't grabbed me
like that for years, but in the spin of things I hadn't gotten
the name of the song. Then I heard it again and again. Still
hadn't gotten the title but by the time I got to Flagstaff, Ari-
zona I had to know what it was and I had to have it. I stopped
at a hip looking record store and I went inside.

I'm forty and I tell the kid behind the counter.
"Listen, I keep hearing this song on the radio and I want
to get the album." I then proceeded to hum and partially
sing "Smells Like Teen Spirit." "Nirvana, dude," said
the kid. I walked out of there with a cassette tape of
Nirvana's *Nevermind* that got me to San Francisco and that
I still have.

Nirvana reaffirmed my belief in whatever it is that
we have known as rock. I thought it was dead, but it was
obviously back stronger than ever. It was heavy, infectious
and powerful, while at the same time clever, nuanced and
poetic—it seemed like rage transformed by irony and riled
up fuzztone into something anthemic and triumphant. As I
drove toward the sunset, the cars I passed or the few that
passed me must have wondered who that crazy dude with
the gray hair was, dancing behind the wheel. That music
energized me. It was great to hear very electric guitars
doing something interesting for a change. It was spiritual
driving music. I was going west, young man.

Nirvana was sort of third generation punk. For me
it was punk because it was about being really positively
negative. It was utterly removed from the way you were
supposed to think and feel and thus perfectly expressive
of how the cultural aliens feel all the time. Nirvana wasn't
glam, wasn't hair, wasn't metal, and above all wasn't luxury.
It was about resistance to bad systems, big time resistance
in the mega-Ohm range. You couldn't picture the songs
being used to sell cars and pickup trucks. It was a total hors
de commerce headspace.

Nirvana was also called alternative, but incorrectly
because by that time alternative really meant mainstream.
That's what Debbie Harry said, anyway. They were also

called grunge, a word which meant you were a band from Seattle and also apparently had something to do with Kate Moss and teenage British fashion photographers. Grunge came from grungy, which is defined as "begrimed," a fabulous word meaning really dirty. Its etymology is speculative: perhaps a conflation of grubby and dingy. In Nirvana's case grunge wasn't about the Kurt Cobain aesthetic, which was sort of about comfy, androgynous, don't give a fuck for propriety rebellion, although his sweaters and come-as-you-are hair might be described as grungy, as much as it was about the dirty sound. Grunge was the fuzztone and feedback and vocals pushing the envelope of coherence, moving from quiet clarity to raw voiced berserker rage. La di da y'all. Rebel music. Fuck you and incidentally fuck me too music.

What was Kurt Cobain rebelling against? What have you got? It wasn't segregation or the Vietnam War. It was America itself. It was rebellion against the way a man was supposed to be a man. It was about gender roles. It was about "family values." All Apologies: "Married, married, married, buried." It was about the celebrity system. Kurt Cobain wasn't just rebelling against the sensibilities of the past. He was rebelling against a future where hip hop would extol felonies and catalog luxury goods while pop would consist mostly of "songs by naked girls."

My friend John Lurie, who is a great musician in that great yet vague realm known as jazz, is a big Kurt Cobain fan. One day after Cobain died he came up in conversation and John explained how they had meant to meet in Rome but then Cobain had overdosed, apparently on champagne and Rohypnol (prescribed to Courtney Love) at the Hotel Excelsior and the meeting never came off. Sounded like another case of Jimi Hendrix and Gil Evans. A month later, he was dead. John said that nobody in rock wrote such long and complex melodies or employed such nuanced tonalities.

Maybe melodies can take a lot out of you, not to mention lyrics that are taken directly from one's chest cavity, as K.C.'s were. Burnout is real when millions connect to you, like you're a battery guaranteed to charge them up. Cobain came to dread his stage persona as something he had to live up to but derived no joy from.

"Just because you're paranoid doesn't mean they're not after you," he said. Obviously Kurt Cobain was trying to free himself from his demons, but it's more difficult

when they are on salary. It may be that he was just trying to change his life but ended it instead. It's a mystery.

—

Okay, let's go to the photographs....

In these pictures we see late Kurt Cobain. There's more outside of him than there used to be. He was that unlucky 27 — so the patina was on the inside. But here he's disappearing under more and more layers of clothes, clashing patterns, with a man stripped of his skin underneath it all (on the t-shirt). He is winsome, artfully bedraggled, arrayed in artful bumware, a mixed message of thrift store signals. He is, in fashion's version Arte Povera, wearing a hundred bucks worth of denim, argyle, Converse and leopard skin hiding under a vintage aviator's cap and white women's Op-Art sunglasses, somewhat similar to those worn by Keith Richard (also in nailpolish) on the sleeve of "Jumpin' Jack Flash." "With the lights out, it's less dangerous."

He is slumped as if exhausted or about to fall down —but junkies don't fall down—maybe it's just "I have very bad posture." Kurt is knocking back a quart of Evian, unlike Keith and his Jack Daniels. He is lucid, but still the light seems to be flickering. The pose is obvious. His posture is crushed. He's in a slump. He's on the edge of the world we inhabit, peeking into another.

This figure of "anemic royalty" is familiar to the rock fan. He is part of our unnamed religion, based on a pantheon of saints sometimes referred to as the "27 Club."

You can't fire me because I quit
Throw me in the fire and I won't throw a fit

In ancient Greece "pharmakos" referred to a scapegoat, a victim ritually sacrificed to purify the community. The victims were "pharmakoi," and apparently they were well treated before they were sacrificed, and were given a "pharmakon" which is both a medicine and a poison, a spell-giving potion. The Incas offered human sacrifices to the gods, young people who were well fed and kept on a heavy diet of coca and alcohol before they were killed. In some Mesoamerican sacrifice cults, the victims were treated like royalty or gods before they were killed. It seems that's what we do with our sacrifices today. Kurt Cobain's death still haunts us, and whatever one believes,

evokes a sense of mystery. He reminds me of Antonin Artaud's writings on Van Gogh.

"Van Gogh did not die of a state of delirium, properly speaking, but of having been bodily the battlefield of a problem around which the evil spirit of humanity has been struggling since the beginning. The problem of the predominance of flesh over spirit, or of body over flesh, or of spirit over both. And where in this delirium is the place of the human spirit. Van Gogh searched for his throughout his life, with a strange energy and determination, and he did not commit suicide in a fit of madness, in dread of not succeeding on the contrary he had just succeeded, and discovered what he was and who he was, when the collective consciousness of society, to punish him for escaping from its clutches, suicided him."

Kurt was our perfect pharmakon. Not ugly like in old Athens, but an outcast nevertheless. No Arnold Schwarzenegger for sure. He was a poet, a singer in a game with no exit strategy. But no exit is its own strategy.

I would hesitate to interpret any further. It's a very old business. You know what Patti Smith said, "Jesus died for somebody's sins but not mine." But how about Kurt? Not Patti's many sins, but he had a lot of devoted clients. Still I would hesitate to interpret any further. Nothing to be gained there. He speaks for himself still, after all.

Dead rock stars are still working. Jim, Jimi, Janis. From a business point of view they are ideal. Very few management problems. They never get old. Still beautiful. They always look good. They don't renegotiate. Some of them went into this with their eyes wide open, some of them got tricked. Brian Jones fired the handyman and that didn't work out. Generally speaking somebody else gets the last word. It's hard to get the last word when you're gone. All we can do is guess. Hum the tune and guess. "Oh well, whatever, nevermind."

But I remember when I first heard it. A voice out in the desert. I can still hear it. It's in my head now. Hello. Hello. Hello.

Kurt Cobain: the last session, Jesse Frohman, Thames & Hudson, 2014

STUDIO 54

What the Colosseum was to gladiatorial combat, what Yankee Stadium was to baseball, what Jayne Mansfield was to breasts, that's what Studio 54 was to disco. It wasn't the first discotheque, but it was the great, definitive one. History happened there, nightly.

The discotheque phenomenon, clubs where people danced to records, really took off in the sixties, with clubs like Regine's in Paris, the Ad Lib in London and Arthur in New York. Then in the seventies discotheques became discos with the development of clubs created for a gay clientele seriously devoted to dancing.

When I arrived in New York in 1970 the best dance clubs were gay clubs like Tamburlaine, Sanctuary, Stage 45 and The Loft. They played the best R & B, including Motown and the emerging Philly sound. These clubs were far from segregated, however, and the gay boys were amused and delighted that models and jet setters sought to join the party. I remember the black gay boys at Stage 45 being amused

Bob Colacello

Bob Colacello

by the sight of Luchino Visconti and Helmut Berger dancing among them, along with Warhol's chic business agent Fred Hughes and models Donna Jordan and Jane Forth.

Soon everyone hip wanted what the gays had and it happened at Le Jardin, a smart disco opened by John Addison in the down-at-the-heels Diplomat Hotel—it was still mostly gay, but was also frequented by a fashion forward contingent of cool straights, and everyone danced as one to Silver Convention, TSOP, the O'Jays, Marvin Gaye, Eddie Kendricks, the Staples Singers, K.C. and the Sunshine Band, Labelle and Barry White. Boys with boys, girls with girls, and girls with boys, and some people who seemed to be dancing with themselves. I was dancing with Grace Jones. It was wild. One night Patti D'Arbanville's boyfriend Don Johnson, who would later become a star playing a narc, offered me a line of what I thought was cocaine but which turned out to be angel dust. Something new was happening and people noticed. Among them were Steve Rubell and Ian Schrager, two friends who met at Syracuse University and had opened steak houses and a nightclub in Queens.

On April 26th, 1977 they opened Studio 54 in a big old theater on West 54th Street that had recently been a CBS television studio. Rubell and Schrager had it all figured out. They created special lighting that descended from the ceiling at musical peaks. They created a mad scene at the velvet ropes on 54th Street where doormen picked only those who looked right for admission. They also created a secret back entrance on 53rd Street and a VIP room where celebs could retire for drinks when not dancing with the wild bacchant mob on the huge dance floor.

Oddly disco and punk seemed to coincide almost exactly in time, although nobody used either term much back then. And though I doubt you'd ever see Johnny Ramone at Studio 54 or Disco Sally at the Mudd Club, there was a surprising amount of overlap between the downtown punkers and the midtown bumpers. And both crowds were doing "bumps" in the bathrooms at both Studio and the Mudd; there was no such thing as a strict men's room or ladies room. The new thing was the powder room and the revelry everywhere was drug fueled. Coke was everywhere. Part of the décor was an illuminated crescent moon with a nose serviced by a sparkle dusted spoon. Studio also had poppers. Mudd had heroin. But there were no boundaries anywhere. The princess of punk, Debbie Harry, had a big party thrown for her at

Studio 54 by Andy Warhol and the very downtown August
Darnell aka Kid Creole recorded a fun song called *Dario*, the
refrain of which was "Dario, can you get me into Studio...54."

When Steve and Ian decorated the place, which the
regulars called "Studio," they left the balcony alone, so
patrons who met on the dance floor could always go upstairs
and take a theater seat to get better acquainted, or intimate,
or share a toot and they did.

Coke was all over Studio 54 and in the privacy of
the VIP room it went public. Andy Warhol photographed
Halston's assistant Victor Hugo shoveling into nostrils,
although not his own. Andy rubbed it on his gums and
denied it if anyone asked, and he did take up vodka for a
brief fling. Studio was that kind of place. Suddenly it was
a different world. Suddenly the discotheque was a disco, and
it played disco music. The year Studio opened was also
the year of the Bee Gees and Donna Summer and suddenly
it wasn't just R&B, it was a new kind of music. The gays
and the fashion crowd loved the black music played in those
secretive clubs, but how would the masses dance.

In his great history *Black Vinyl, White Powder* record
producer Simon Napier-Bell explains how Germans Peter
Meisel and Giorgio Moroder, influenced by a Bavarian
marching band, created the new four to the bar bass drum
sound that would become disco in order to get arrhythmic
white youth to dance. What made it disco was adding a black
singer, Donna Summer. Suddenly everybody could dance,
especially when the strobe light kicked in and your gyrations
became a series of still photos.

Studio was wild. It was wild getting in. Hundreds
of people mobbed the entrance, half of them yelling that
they knew Steve, or Mark (Fleischman, manager and head
crowd selector). In order to attract attention, people began
renting limos thinking that would get them in, or dress-
ing in outlandish costumes, often minimal, or recruiting
the best-looking people they could find to accompany
them. Inside, the dancefloor was often filled with partially
nude persons, but since the waiters and bartenders were
bare-chested and the atmosphere was utterly orgiastic, it
didn't seem out of place. It was, as the song played nightly
went, "a disco inferno."

At first, I didn't like the place because of the mob
scene out front, but I quickly discovered I could get in
because I tended to have a beauty or two on my arm, like

Bob Colacello

Wendy Whitelaw the makeup artist, and then they memo-
rized me. It wasn't as cool as the integrated gay clubs.
There were a lot of socialites in couture hopping around
like Stevie Nicks, but I couldn't hate the place. There were
enough gay boys and weirdos to make it interesting. And
there was the ruling class, which consisted of Andy's crowd
and Halston's crowd and Calvin Klein and the like. The
celebs were just as drugged as anyone, in fact more so, and
I was always amazed when Steve Rubell asked me if I had
any coke. I didn't, but I thought "If he doesn't who does?"

Although Studio was a wild party nightly, the special
party nights were over-the-top newsmakers. At a birthday
party for Bianca Jagger, a naked black couple dusted with
glitter led a white horse on to the dancefloor and Bianca
hopped on it, while across the room her hubby Mick danced
with Mikhail Baryshnikov. The club was such a huge success
that when Steve Rubell bragged in the press that only the
Mafia made more money, the Feds raided the place in
December, 1978 and again a year later and they charged
Rubell and Schrager with tax evasion. They went to jail in
February 1980 and served 11 months. The club closed, and
coke and money were found inside the ceiling and walls.

Studio reopened in 1981 under the ownership of
Mark Fleishman. And eventually Studio 54 would hire
Danceteria's Rudolf to make the place more "new wave" and
live acts were booked like Soft Cell and Human League.
I found myself going there maybe more. There were more
downtown kids and fewer boring socialites—the kind of
people who used to go to Studio every night. But then the
spectacular theme club Area opened downtown in '83 and
then Palladium, created by none other than Steve and Ian,
featuring art by Basquiat, Haring and Scharf. The scene
shifted downtown, more or less permanently.

Today all those nights at Studio have sort of rolled
into one. It wasn't really my scene, but I was part of it. I was
more of a voyeur there, happily watching celebrities flash
their tits, watching a famous singer turn her purses upside
down to see if any coke had spilled out, watching Andy get
tipsy and Truman get drunk and flail across the dance floor
with Bob Colacello. There was plenty of excitement, like
the night the bouncers threw my friend Ricky Clifton out,
forgetting to open the glass doors first.

One night I do remember was the night that Studio
re-opened after Steve and Ian sold it and they got their

liquor license back. It was raining, and mobs descended on the place. I showed up at the VIP entrance in the back and got in and the place was unusually festive and fun. I stayed for a while, then headed down to my haunt, the Mudd Club. The next day I was at the Power Station recording studio with my friend Nile Rodgers, the guitar player from Chic, when news coverage of the mob scene at Studio the night before came on TV. They kept showing the aging movie star Mamie van Doren standing in the rain trying to get in and coming back and asking her if she still thought she would get in. Then the newsperson said, "And Studio 54 was fined $5000 by the Fire Department for blocking an egress."

Nile laughed and said "Wow! Five thousand dollars for blocking a negress! It must have been Diana Ross!"

Vanity Fair Italia, 2007

Kate Simon

JOHN ROTTEN LYDON IN A FEW WORDS

Stupid

Okay, just thinking about him, I got a powerful yen to listen to John Lydon's music and as the vinyl's all out at the country house where it often covers up the vocals of misfiring roosters, I walked over to the immense Tower Records, where they have big stacks of the new William Shatner album (produced by Ben Folds and featuring Joe Jackson!, Adrian Belew!! and Henry Rollins!!!) and I started thinking that irony has reached some horrible critical mass, a black hole state where everything is sucked in and nothing escapes, and somehow I managed to reach the P area of the pop section in the back of the store where I was amazed to discover not one Public Image Ltd. Recording. Not one! No John Lydon!

Surely there's been some mistake. I look for PIL? Zilch. There *is* a modest stack of "Never Mind the Bollocks" *Sex Pistols* CDs, but there is no evidence that John 'Johnny Rotten' Lydon existed after 1977, when few people existed more magnificently.

This is stupid. I check with a clerk who has never heard of Lydon, Rotten or PIL and after much spelling I'm told that there should be one copy of Public Image Ltd. by Public Image Ltd. in the "P section." Unlike the jazz department the pop area doesn't have miscellaneous Ps, and there is no rack divider between the Public Address System and the Pub Wankers—or some groups to that effect—leaving me feeling I'm not only in the wrong store, I may bed on the wrong planet. This place is too stupid.

Smart

Well, fortunately right across the street is the compact Other Music where I managed to pick up PIL's 1979 "Second Edition" which came out shortly after "Metal Box," the revolutionary 3 LP set that came out in something that looked like a 16mm film can after the demise of the Sex Pistols, and introduced the world to a deeper, groovier Rotten. This is when we discovered in depth that Mr. Rotten was far deeper than the front man for that magnificently caustic vaudeville that was the Sex Pistols: he was a musician and he was a poet (perhaps better not to call him that to his face) whose lyrical scope hadn't even tried out the zoom feature.

Teaming with bassist Jah Wobble, and the barbed wire guitarist Keith Levene, he formed a collective that had two other members Jeanette Lee (video) and Dave Crowe (business,) realizing that everything is beautiful in its own way. They weren't going to be just another band, another act, they were going to be an art corporation holding its own in a corporate world.

Where the Sex Pistols were music hall meets theater of cruelty, Public Image Limited was a temporal laminate of trance/dance groove inspired by Lee Perry dub, belly dancing licks, mosque minaret muezzins, dance hall toasters, voodoo-loa-invoking beats and BBC prosaic narration. Sometimes it sounds like two records being played at the same time, melodies fighting it out, and PIL was doing that before Prince. It was not rock and roll, to say the least, and failed to appeal to the more punterly element of Pistols fans but it was leading the way to smarter, deeper music.

I listened and there it was again, that magnificent acid bath of narrative wed to a deep, life-enhancing dub-art music.

Suitable

The first time I saw Johnny Rotten was at a party at
Andrew Logan's Alternative Tower of London, New
Year's Eve 1977. He was pierced and safety pinned and
ripped and torn and strapped and stenciled on. He
looked like a voodoo scarecrow. The Sex Pistols were
there and The Clash were there and toward mid-
night there was sudden screaming and shouting and I
glimpsed the man in full wrestlemania with Vivienne
Westwood, today Britain's leading fashion designer,
then ditto but also the partner, in business and/or
pleasure, of Mr. Rotten's manager Malcom McLaren.
They were angry at one another and had firm grips
upon the other's hairdos and they careened with great
force, sending the entire bar and many bottles of fine
liquor to the floor where some but not many survived.

The first time I actually met Johnny Rotten was at
Bowlmor Lanes on University Place where young new
wave bowlers bowled late into the night. I was bowling
that night, probably closing in on 200. Mr. Rotten/
Lydon was observing, having a cocktail and I remember
being surprised by his neat appearance, his handsome
Glen plaid suit, and his genuinely charming, engaging
demeanor. He was actually earnest, in a cool kind of
way. I could tell he was a big person, not the sort to be
trapped by the trappings of posture and public relativi-
ty. And he looked really good in his suit. It was a good
move, since by this point the police were wearing safety
pins and the stockbrokers bondage trousers. I remem-
ber thinking what a gentleman he was, not to mention
an engaging and provocative conversationalist.

One sensed then that Johnny Rotten Lydon was
no tool of fashionistas, no matter how refined, but was
a human line marking the end of fashion and the
beginning of serious style. I remember him as a Pistol,
snarling to a room of pogoing-like-pistons punks:

"Your future dream is a shopping scheme...cause I
wannabe anarchy."

Wrong

It's funny how quickly history gets it wrong and then it
gets even wronger and wrongerer. Spike Lee's "Sum-
mer of Sam" depicts New York in the summer of 1977,
that long, hot summer when Son of Sam, a mystery

serial killer was gunning down amorous young couples.
As we know now Son of Sam turned out to be David
Berkowitz, a wacko postal worker who was killing at
the behest of Satan, who spoke through a dog.

One of the Bronxites whose lives are the focus of
the film is Richie, a budding punk played by Adrien
Brody. Richie lives on the mainland, but likes to spend
a lot of his time in the isle of Manhattan, hanging
around places like C.B.G.B.s. He wears his hair done
up in multiple spikes, with a Roger Daltrey style Union
Jack t-shirt and bondage pants, or he wears a seven-inch
platinum blonde mohawk and a metal studded collar.
And when we see C.B.s in full swing, that's the scene—
DayGlo leather freaks pogoing toward apocalypse.

That's not how punk happened, although I guess you
had to be there to know that. The punk scene in New
York in '77 wasn't even called punk. Nobody called
themselves a punk. Punk magazine was a fanzine started
by cartoonist John Holmstrom and some Ramones fans
and Lou Reed idolaters.

Punk, as it is popularly regarded in the popular
imagination and in the narrative we call history, was
created in England. To stretch a metaphor, it's almost
like what happened when Christianity was created
in Rome based on ideas and events that happened in
Palestine. The seed of the music came from the New
World, Iggy Pop, The Velvet Underground, the New
York Dolls and the Ramones. But punk style came from
across the sea.

The English kids seized on the musical emergency
and made it their own. The ringleaders seemed to be
a bunch called the Sex Pistols. They wore unspeakable
outfits and their fans spat on them as a form of appre-
ciation. The lead singer had a pop art name, Johnny
Rotten, and he had hair the color of flame.

He started punk. Somebody else might have dreamed
it, but he incarnated it. He was the savage avatar of
Celtic druid roots come back for revenge. He was the
first real punk, and he remains the best punk ever—
tan, fit, ethical. Back then he fronted a group that actually
threatened the monarchy. The Sex Pistols were the
most threatening, most deviant, most aggravating man-
ifestation of pop art ever. They made the Rolling Stones
seem like the Bay City Rollers.

Some see the Sex Pistols as the creation of the notorious impresario Malcolm McLaren. McLaren, who was looking for trouble on a high level, had briefly managed the New York Dolls, correctly sensing their global importance. He had tried to make them the next big thing. Part of his plan was to put them in red vinyl clothes and have them perform in front of a communist red flag. They put on one show that way in New York but it failed to launch them as the next big threat, so the Dolls went back to their usual Dead End Kidz Drag and Malcolm went off to England to form a band with a mind of his own.

Malcolm was running a fashion shop called Sex, and later Seditionaries, with his partner Vivienne Westwood, and he assembled the Sex Pistols after auditioning kids who hung around the shop. Luckily one of those kids was John Lydon who became Johnny Rotten. Now I'll grant you that *Sid and Nancy* is an entertaining movie in some ways, especially as a Gary Oldman vehicle, but it sure fails to capture the absurd grandeur of the Sex Pistols and its most impish, pixilated, anarchic, articulate and sane member.

Punk was a guaranteed flash in the pan, and yet somewhere in there were dark roots under DayGlo, roots that went deep into a brain where cultural foment was bubbling like witches brew. PIL was a culturally ambitious musicals strategy, something that would extend the ephemeral time signature of punk into future dubs—an art vaccine ready to mutate into whatever form was necessary to function as an anti-body to corporate death culture.

Wankerer

Punk, as a style, was a far cry from previous alternative or bohemian subcultures. Hippie style was based on a sort of retrospective idealism, harking back to pre-industrial ideals—the noble savage, the puritan, the homesteader. Punk was negative fashion. Your ugly is our beautiful.

Punk was tribal. It was like war paint or juju masks, designed to frighten or intimidate the uninitiated. Shock value. Related to outlaw bikers wearing swastikas and stuff. As such it had the shelf life of a flash bulb. Punk, in its opulent British version, was also related to the deep inherent tribalism of the British isle. Remember, the

islanders were painting themselves blue and going into battle naked when the Romans had flush toilets. There's a great Anglo tradition of tinkers, chimney sweeps, pearly people and others with great tribal style and that comes out in punk too. The tartan and the kilt fit right in.

Rotten was always a superb stylist who understood that fashion was a race against time with no finish line, so he was constantly innovating, slinging together castoffs, mistakes and remnants and language-oriented garb to create a pace-setting synthesis that announced from across the street that he was rebelling. Against what? What have you got?

John Lydon aka Johnny Rotten has never been on the International Best Dressed List. He's never even been on Mr. Blackwell's Worst Dressed List like Debbie Harry who made it to #5 in 1979. And yet his importance to personal style is almost beyond measure. He's up there with the Duke of Windsor. Yeah, that's it. He's the anti-Duke of Windsor. He looks as good as Mountbatten after the yacht went up. He's living proof that true style is an expression of character, and character is what he's all about, in its various senses.

Now

Not long ago, John Lydon was a guest star on the reality TV show "I'm a Celebrity... Get Me Out of Here!," a version of "Survivor" in the Outback featuring "celebrities" instead of "real people." Celebrities like Melissa Rivers and Robin Leach and Maria Conchita Alonzo.... But Johnny has always taken the piss out of celebrity. Got famous acting barbarian on chat shows.

He says: "I'm not a celebrity, I'm just a human being."

But it's perfect, John Lydon doing that show, because he's an antibody to the whole mechanism. I mean, Jesus would have done "I'm a Celebrity... Get Me Out of Here!," And wherever he is, like JC, John Rotten Lydon gives powerful testimony through his presence, words and even posture that he is human and being. Working at being. And there's not enough of that kind of conscious being going on around here, and certainly not enough humanity, if humanity still deserves that word as a quality.

Not a rich man, Mr. Lydon donated his pay for

"I'm a Celebrity... Get Me Out of Here!" to The World Society for the Protection of Animals.

Prescience

Right now is a great time to have a listen to PIL's "Flowers of Romance," (1981). Go out and buy it if you haven't got it, and I bet you haven't and listen to it. It's Lydon as muezzin, blending the call to prayer mode with a sort of Gaelic banshee keening, dealing with East vs. West paradigms.

> "Alla. Alla. Doom sits in gloom in his room. Destroy the Infidel. In a mosque. In a ghost. Is a sword. Is a Saracen. Alla. Joan of Arc was a sorcerer. The trilogy of the desert song. Scriptures in the tower of Babble. Alla. Only ending is easy. Burn. Burn. Burn. In the tower. Only ending is easy."

If we had listened to PIL as much as Madonna, the Taliban might never have happened. Our society just isn't good on the self-criticism. All this vulgarity isn't even luxury.

Which reminds me the other day I put this beautiful Buddha in the dining room out there in the country overlooking the pond across which the roosters were crowing, and my wife said: "Buddhas are so passé now."

I was a little shocked but the more I thought about it, the more I realized that she was right. Just walk through ABC Carpet and Home and there are all these Buddhas and Lakshmis, deserted by their clients who have, perhaps, become Asian Muslims, or else were looted from the starving by White Decorators and I thought about the Buddha Bars and all the Gautamas sitting in honkey dining rooms and imagined a bunch of Taliban standing there in Bamiyan, Afghanistan looking at the giant Buddhas carved into the Cliffside, and imagined them saying: "Buddhas are so passé now."

You don't need a Buddha in your dining room. You can get a Johnny Lydon poster on the Internet that will work too.

Face

Just look at his face. The history of my people is in that face. The face of a man, a real man.

"...People like to roll over and are constantly trying to get you to roll over because they've rolled over. And as you get on you realize that happening around you, because it's easy to just settle in and hang on your laurels, but what laurels? I didn't do it for that, I've got a need to just fucking do something, and all the more fun if it irritates the universe, that's an achievement in itself..."

"...Music isn't just there to make you happy, it's to make you feel everything possible, including suicidal, which in its own weird way can be helpful."

Communist?

"I've never worked with anyone on any other level but equal shares. Now Mr. Rotten could quite easily grab the lot, but I don't because I treat people with respect."

Standing

"What is punk? It's do-it-yourself isn't it? And guess what? We're still doing it ourselves. If there's any flags to wave, I honestly don't see anyone out there doing it. They're all so super-starred and structured, and video orientated, it's really negative. They're all sucked up into the shitsdom."
—John Lydon

Lydon still makes music the old fashion way, from scratch, right out of the bean-to-bean and into the air. He does it as an amateur—i.e. a lover. He makes the sounds he wants to and needs to hear, not what anyone is expecting or prepaying for.

"...if you focus is all on 'note perfect' you've lost it. It's unemotional and its dribble. It's like Japanese Jazz, everything in the right place, but so what? ...You get the best sounds of instruments that are fucked, broken saxophones and two stringed violins. The emphasis in all music seems to be on instruments and it shouldn't be, it should be on the voice. I think I approach it in a truer Gaelic tradition, you know, where bag-pipey drones fit the voice and not the other way around."

Tubular

Rotten TV was planned as seven episodes for VH1. Unfortunately Mr. Rotten, the host, fell out with the network after three. Tragedy, but hope lingers. On the first

he was thrown off Roseanne Barr's talk show.... Then
there was a famous appearance on Judge Judy, where
he was sued by a former drummer. He won the case
but was found "out of order." At the trial's conclusion
Lydon summed up: "Now I can get on with my life.
We're going after the real killers." Someday, perhaps,
Rotten TV will return transforming the medium to
extra-large.

Iraq

John Lydon's current plan is to take the band to Iraq.
Play for the troops? Nah. Play for everybody there.
Anybody want to bet that he won't?

The odds would seem to be against him, heavily.
But that's where his experience lies.

"Smile in the face of adversity. Just 'cus you're
paranoid doesn't mean they're not out to get you."

V Man, 2005

Hooman Majd

HARDCORE

The *Village Voice* recently featured a cover story on "slam dancing" in New York's "hardcore" rock clubs. I always get a kick out of intellectual apologies for anti-intellectual behavior—they are the high point of liberal journalism but this was more kicks than usual.

I don't think much about hardcore anything and I don't think too much of hardcore punk rock and slam dancing. I've never considered slam dancing myself any more than I ever contemplated pogoing. The pogo was a briefly popular, milder ancestor of slamming; the British punk rock dance, it was a craze here for several weeks. It was pretty good as a metaphor (*File* magazine saw it as an analog of the pistons in an engine) but as a dance I thought it was stupid and rude. During the pogo period, about five years ago, I was watching a band at Hurrah's when I was rather violently pogoed into, spilling my drink all over me. I had been jostled by pogoers before and had been tempted to retaliate for their encroachment; this time I felt entirely justified. On his next pass I gave the unknown bobbin a solid shove, sort of a downfield block, and he was propelled a considerable distance across the dance floor. When he turned toward me I saw that it was Jim Fouratt, soon to be manager of the place. Jim had always been very polite and kind to me and I felt guilty about the shove but more than that I felt that the pogo was really an anti-dance, intended to repel and annoy rather than attract and charm. I'm sure Jim hadn't seen it that way, but I never saw him pogo after that.

Anyway, slam dancing seems to me to be a more aggressive version of that same sort of organized annoyance. Since slam dancers tend to keep to their own clubs I've had no reason to think about it. But seeing it lauded by the liberals did get to me and I do find that scene interesting now— now that it's getting the interpretation that it seems to be a cry for. Remember when kids just cried out for attention?

So I got all the way through that blab blab rhetoric and there weren't too many surprises, just the usual sociological bravos for an honest young malady in search of pathology. I was sort of relieved that they'd found each other once again. Here's another case of a para-lumpen youth movement, so pure and in touch with its subconscious that its every aggressively meaningless convention is preggers with symbolic eloquence just waiting to be delivered by concerned structural analysts.

You know the shtick: revolt against decadent bourgeois manners, against sexual stereotypes, against capitalist drugs, blah, blah, blah.

What the pop anthropologist found particularly interesting about this case though is that these youth in their latest anti-fashion fashions are on to a new form of relating physically. Angst in their pants and a need to dance, etc. Tribal blah, revolt against the conventions of revolt blah—the usual. What separates this from the pogo and earlier noble savagery, the *Voice* noted, is the all-male nature of slam dancing. This is not for sexist reasons but for the practical reason that it's really hard-hitting, and for the even more marvelously reasoned reason that slam dancing is, *au fond*, a really new and revolutionary and symbolically fascinating form of male bonding.

For my non-psych major readers: I believe that male bonding means forming sociologically meaningful relationships between males. (Nothing whatever to do with *bondage*.) We all know what a sticky problem this bonding is for us American males, that's why we're all either queer or wife beaters. But now there's hope, a new way of getting close to your peers without being queers, of having a positive, co-operative touching experience without being the complications of Eros, of providing an outlet for that old male aggression without channeling it into real violence or even the dreaded bane of American life: competition. Here, noted our reporter, is a healthy alternative to sports. Slam dancing, she said, *is healthier than sports!*

You may have noticed that the *Village Voice* does not have a sports page. Sports are too controversial for liberals. Many liberals like sports but there are so many sticky issues just under the surface that sports are a can of worms that they keep in the closet. It's far less risky politically to admit to a penchant for fist fucking than to own up to watching Monday Night Football.

But sports being unhealthy compared to a bunch of drunken shaved headed geeks bashing one another randomly to the sounds of distorama simpleton rock—well that seems to require some serious explanation.

I certainly agree that going to war is going too far for the purpose of male bonding. Sports seem to be a far superior source of it, if we really need it. I guess the supposition is that sports don't really defuse that old war lust, they only temporarily sublimate it, maybe strengthen it. The fatal flaw of sports, according to this argument, seems to be that they combine male bonding with an atmosphere of fierce competition. Slam dancing is a superior solution because in it that aggression that results from males in proximity is discharged in the collisions, grapples and crushes of this contact "dance" without the dreaded competitive context. Slam dancers don't compete, they co-operate in not crippling one another.

As you might have guessed I remain unconvinced. I still think sports are healthy and slam dancing still seems rather sadly ill. It is male bonding to be sure, uniting males in the shared experience of stupidity, in the common pursuit of an extremist identity through the laziest *épater le bourgeois* tactics, in the desperate cry for some meaning through wacko interpretations such as the one in the *Voice*. I really think that these kids, if they have no taste or ability for sports, would be more healthfully engaging in old time activities such as beer chugging and circle jerks.

East Village Eye, 1983

ARE YOU READY FOR THE COUNTRY

I live in the country. Part-time. I have a house in Northwestern Connecticut. It's the country alright, 22 acres, a lot of it woods. Tomatoes, strawberries, fennel, rosemary, basil, and stuff growing out back. Mint juleps growing out front. Had a big bear run through the backyard last year, found six wild turkeys on the back porch one day, and we've got hawks, buzzards, flying squirrels, deer, bobcats, snakes, turtles, salamanders, and insects that look right out of science fiction. I thought I saw *Mothra* one night.

I've got a shotgun but I might not have any shells. And one night I did see a mountain lion running down the road. The state pretends they aren't here because then they'd have a habitat or something, but this is wild in the country, baby. Don't leave the dog out. But it's also farm country. There are cows grazing right across the street. My neighbors raise cattle and geese and the chief executive

of our town has a farm stand up the road where lately he's got organic potatoes, onions, garlic, zucchini, raspberries, and various exotic forms of salad. The corn and heirloom tomatoes aren't far off. Hey, I know urbanity is my beat, but I'm more country than you'd think. I've got a pair of overalls!

I used to have a house in Long Island, a house built by a farmer in what was once a farm town, but today almost all the old fields are filled with a bumper crop of spec McMansions. I've heard that some of these enormous "cribs" are now going to seed after several years of sitting vacant. It doesn't break my heart. When I first lived out there we'd actually say, "Are you going to the country this weekend?" Later that changed to, "are you going to the beach?" Really it should have been, "Are you going to the distant suburbs?" I couldn't bring myself to say, "The Hamptons." It made me depressed. But now I can say, "Are you going to the country?" and really mean it.

I've been spending a lot of time in the country lately, and suddenly I had a craving for country music. As a longtime New Yorker, it might seem funny listening to country music, and I find most of that Nashville stuff horrible, but I have had a weakness for country for a long time. They do it right in Texas. Some people call it outlaw country. I call it urbane country music. I think I picked up the habit in Chicago. I used to go to an Irish pub called O'Rourke's and they had a lot of Waylon Jennings and Willie Nelson on the jukebox. I just fell in love with their voices and their poetics. How many nights did I stick in a quarter and pick

"Good Hearted Woman"? She's a good-hearted woman in love with a good timin' man. And it was in O'Rourke's over a pint of Guinness that I learned the lyrics of "Luckenbach, Texas" by heart.

City people love country music; and it's big in Irish bars because Irish people love country music, too. Ireland is a country with a lot of country. It's really green, and they like American country music because it comes from Irish music, especially bluegrass; but they also relate to the poetry of country music, and such themes as drinking, infidelity, betrayal, heartache, all the good stuff. The fact is that a lot of what we call country music is just as much city music, and the truth is most of those country cats love the city. One of the most spectacular apartments I've been to in New York is Jimmy Buffett's penthouse. It's so high up you feel like you're in a plane. And the time I met one of my favorites, Jerry Jeff Walker, it was in the very fancy apartment of Dan Jenkins, one of our greatest country-and-western novelists. (Was that on Park Avenue?)

I love that outlaw country—Waylon Jennings, Willie Nelson, Johnny Cash, Kris Kristofferson, Merle Haggard. Hey, I had "Okie From Muskogee" stuck in my head for three days. Merle was just funnin' us, fellas. I'm sure he smoked marijuana in Muskogee. And of course, you cannot beat Hank Williams. If you have never really listened to Hank Williams, you have never heard the greatest white blues ever. Eric Clapton doing Freddy King is fine with me, but Hank Williams is the real deal. I suggest that you immediately go to iTunes and grab on to "Ramblin' Man," a song that gives me

the chills every time I hear it. It's the razor's edge
of a high, lonesome sound that has as much soul
as anything called soul music.

When we think of poetry in American music we
think of Bob Dylan and Leonard Cohen (I know he's
Canadian, I mean North American music) and Tom
Waits, etc., or of the great tunesmiths of Tin Pan
Alley like Cole Porter, Jerome Kern, Johnny Mercer,
or Irving Berlin; but some of the greatest poetry
in American music comes from the country tra-
dition. Waylon Jennings's "Drinkin' and Dreamin'"
is the great lyric poem of the disappointed
American blue-collar man of the rust belt:

*All I got is a job I don't like...and a woman that
don't understand...so tonight at the bar I'll get
in my car and take off from the promised land...
drinkin' and dreamin' knowing well I can't go...I'll
never see Texas, L.A. or old Mexico...but here at
this table I'm able to leave it behind...drink till I'm
dreaming a thousand miles out of my mind.*

Or the beautifully simple irony of the refrain of
Waylon's "I've Always Been Crazy:" I've always
been crazy but it's kept me from goin' insane. Or
the powerful poignancy of Johnny Cash's "Jim
I Wore a Tie Today," as he sings to a deceased
friend at his funeral, Jim, I wore a tie today...the
first one I ever wore and you'd have said I looked
like a dummy out of a dry goods store.

Anyway, here's a little playlist of what I consider
essential "country music," without which you
haven't been exposed to the full spectrum of
American culture.

Hank Williams: "Your Cheatin' Heart"; "You Win Again"; "Why Don't You Love Me Like You Used to Do? "; "Move It On Over"; "I'm So Lonesome I Could Cry"; "Honky Tonkin'"; "Hey Good Lookin'"; "Honky Tonk Blues"; "Cold Cold Heart".

Waylon Jennings: "Luckenbach, Texas"; "Good Hearted Woman"; "The Wurlitzer Prize"; "This Time; Lucille"; "Rainy Day Woman"; "I Ain't Livin' Long Like This"; "I've Always Been Crazy"; "Drinkin' and Dreamin'".

Willie Nelson: "Crazy, Good Times"; "Always On My Mind", "On the Road Again", "Blue Eyes Cryin' In the Rain", "Mammas Don't Let Your Babies Grow Up to be Cowboys"; "Hello Walls; Cowboys Are Frequently Secretly Fond of Each Other".

Johnny Cash: "Ring of Fire"; "The Man in Black"; "Hurt; I Walk the Line"; "Solitary Man"; "Rusty Cage"; "One"; "Folsom Prison Blues";

"Sunday Mornin' Comin' Down"; "The Beast in Me"; "Delia's Gone"; "Thirteen"; "Jim, I Wore a Tie Today".

Merle Haggard: "The Bottle Let Me Down"; "I Think I'll Just Stay Here and Drink"; "Mama Tried"; "Things Aren't Funny Anymore"; "The Fightin' Side of Me"; "If We Make It Through December"; "Living with the Shades Pulled Down"; "Big City".

Merle Haggard & Willy Nelson: "Pancho & Lefty," "Reasons to Quit" and "No Reason to Quit".

Jerry Jeff Walker: "Mr. Bojangles"; "L.A.Freeway"; "Pissin' in the Wind".

Kris Kristofferson: "Sunday Mornin' Comin' Down"; "Help Me Make It Through the Night"; "The Silver-Tongued Devil and I"; "The Best of All Possible Worlds"; "For the Good Times".

David Allan Coe: "Take This Job and Shove It".
Billy Swan: "I Can Help".

Ray Price & Willie Nelson: "I Fall to Pieces".

Ray Price: "For the Good Times"; "Heartaches by the Number"; "I Can't Go Home Like this"; "Release Me"; "Weary Blues".

Billy Joe Shaver: "Old Chunk of Coal".

Tammy Wynette: "Stand By Your Man"; "D-I-V-O-R-C-E"; "Til' I Can Make It on My Own".

Listening to classic country music is good for you. It takes your mind off your troubles because it reassures you that somebody's got it worse, and it definitely distracts you from the contemplation of fashion, gossip, and luxury goods. And country music, at its best, carries with it a sort of immunity to the cultural ideas of "alternative" and "progressive" that have infected other genres with market driven modernism. I don't need to know who the next Amy Winehouse is as long as we've got Tammy Wynette. Which reminds me of the time I interviewed the great Tammy Wynette. I think it was at the Plaza Hotel. She fit right in at the Plaza. She was as cool a customer and as a hot a woman as I've ever met. Sexy. If you don't believe me, ask Burt Reynolds. I came so close to asking her out, even though she was five years older than me.

Ironically, I don't think that an American can be truly urbane without appreciating the musical tradition of this country, from rhythm and blues to bluegrass, jazz, and country. The pinnacle of urbanity in country music is probably somewhere in the neighborhood of one of my favorite acquaintances, Ned Sublette, a cowboy musician

who came of age in the New York New Wave Scene, but who wrote "Cowboys are Frequently Secretly Fond of Each Other," which became a hit for Willie Nelson and was written long before Brokeback Mountain. Ned is not only a country cat but he's a black belt in salsa, and his extraordinary album Cowboy Rhumba brilliantly reveals the secret powerful connection between country and the Caribbean, just as Gangstagrass (written about here recently) shows the alarming magnetism between hip-hop and bluegrass.

Anyway, on Friday I'll be packing up for the country.

GQ.com, 2009

Lynn Goldsmith

HEAVEN AND HELL

In the search for heaven there is breathing, eye contact,
touch, words that cause puzzlement and enlightenment.
There is dancing and clapping and the playing of horns.
Rhythm and pitch are precise in the transporter room.

A soul is a straight line. When two souls touch
the angle makes an angel. Choirs of angels sing in collec-
tive improvisation and the chandeliers of heaven sway and
the crystal flutes of champagne ring in time. Heaven's bar
has crystal in a variety of tunings, so the table tops reso-
nate when the soloists leap in.

In the lounge of heaven the piano of Bill Evans
can be heard in the late afternoon around cocktail time. Bill
slumps over the piano surrounded by vases of red and white
poppies. He plays: "Peace Piece," "What Are You Doing the
Rest of Your Life," "Stella by Starlight," "If You Could See
Me Now," "Turn Out the Stars," God phones in a request
for "Israel."

Sometimes after dinner Ellington takes over the platinum filigreed piano and although he likes to try out new material he'll always oblige with "In a Sentimental Mood," "Caravan," or "Mood Indigo." If Duke is with a woman he'll send Billy Strayhorn to fill in and the crowd is just as happy, although Billy flatly refuses to play "Take the A Train" unless the full orchestra is on the stand and that only happens on Sundays.

In heaven there is a photo next to the hat check room where Rita Hayworth takes your hat. In the photo, Jesus, wearing a beret and goatee, is seated in the classic Last Supper pose with Duke Ellington, Count Basie, Billy Eckstein, Charlie Parker, Dizzy Gillespie, Thelonious Monk, Louis Armstrong, John Coltrane, Lester Young, Bud Powell, Dexter Gordon, and Miles Davis.

When Miles Davis arrived at the pearly gates (which are actually mother of pearl) he found himself in front of St. Peter.

"Nice robe," said Miles. "I used to have one like that from Issey Miyake."

St. Peter just nodded as he filled out the forms. From the pink and golden mist behind Peter Miles heard the sound of a solo piano.

"Oh wow, man," said Miles. "I can't believe it."

"Can't believe what," said St. Peter.

"I thought I died first," said Miles. "You mean to tell me that Keith Jarrett is up here in heaven."

"Oh no," replied St. Peter smiling, "that's God playing. He just thinks he's Keith Jarrett."

——

Miles was surprised to find that *Kind of Blue* was his most popular album in the Kingdom of Heaven. Coltrane would kid Miles that it was because he was in the band then. Coltrane had started drinking again, but only wine with dinner.

Outside Duke's place there was always a crowd of angels gathered. Some came to listen to the sound of the piano issuing from the drawing room but some were also admitted. Musician friends who dropped by often found the Duke seated at the piano in an indigo velvet dressing gown with a transparently clad angel sitting on his lap. The rumors of rampant chastity here had proved a false alarm.

In fact no one had imagined the degree of freedom enjoyed here. Rahsaan Roland Kirk had become a film maker and Art Pepper and Stan Getz owned a pharmacy with a lunch counter. The musicians had their own neighborhood but other types lived there as well. Kerouac had a duplex across the street from Yardbird's Barbecue and Lenny Bruce lived in a penthouse across from the Five Spot and could often be spotted sharing a stick of tea in the park with Cab Calloway or Gil Evans.

—

When Miles Davis died he found himself in an elevator going down. When the door opened the Devil himself was there to greet him.

"Hello Miles, we've been expecting you," said one Prince of Darkness to the other.

"Cool," said Miles.

"A lot of your friends are here. Wait till you check out the band."

"Nice cape," said Miles, "I used to have one like that from Jean-Paul Gaultier."

Miles followed the handsome Devil down a Persian carpeted corridor that lead into a vast ballroom and there they were on the bandstand. Philly Joe Jones on drums, Charlie Christian and Jimi Hendrix on guitar, Mingus on bass, Monk and Bud Powell on piano, Louis Armstrong, Chet Baker and Fats Navarro on trumpets, Coltrane, Ben Webster and Lester Young on tenor, Bird, Johnny Hodges and Art Pepper on alto, Harry Carney on baritone, Jack Teagarden on trombone.

"I haven't seen a band like this since Minton's," said Miles. "But I don't get it, man. I thought this was hell."

Allow me to introduce the leader, said the Devil.

Miles heard a familiar voice with a heavy Eastern European accent. "How about a little champagne, music boys?" and out from behind the curtain, baton in hand, stepped Lawrence Welk.

Suddenly Miles felt a sudden terrible burning, as if he were walking on a bed of hot coals. So this was hell!

Miles awoke soaked in sweat to find himself seated in his plush leather chair, Charlie Parker grinning maniacally on the floor, with a pack of matches, giving Miles a hot foot through his custom-made alligator shoes.

Paper Magazine, 1998

The thing about Jim Morrison was that he never even considered being embarrassed.

Tweet, 15 March 2014

CHET

Chet Baker was the coolest. He was the coolest player in cool jazz. When he was young he was the handsomest white man in jazz. In the '50s his picture on the jacket sold lots of records. He looked like an angel. He blew a horn like one and he sang like one, too. Listen to "Angel Eyes" or "Deep in a Dream." Twenty years later he looked like what fallen angels must look like. He looked like he had fed on his own flesh and blood. That's the cost of life in lotus land.

Chet died at the age of 59. He fell out of his second-floor hotel room window in Amsterdam. Maybe he nodded out the window and dreamed himself down to the street. Maybe he woke up on the way down, saw the pavement rising and decided to go back to sleep. Or maybe he just flew out that window, and as he realized his wings were working, he dropped his tired old blues and headed for Birdland in the sky.

Interview magazine, 1988

Advertising

It's kind of cool that Mont Blanc
has a fragrance, but shouldn't it
be black and permanent?

Tweet, 23 August 2012

SELLING SPACE

> Barry A. Smith, general counsel to the International
> Consolidated Trading Company, said it had received
> an agreement from Glavkosmos, the Soviet space
> agency, allowing it to broker space on the outside of a
> space capsule scheduled to ferry two astronauts to the
> Mir space station in late August. Mr. Smith said he
> was negotiating with seven companies to place their
> logotypes, slogans or trademarks on a 21-foot-by-10-
> foot surface on the outside of the Soviet rocket. He
> said he had also received permission from the Soviet
> Government for a crew of five Americans to film the
> launching, enabling his clients to use the footage in
> television commercials.
> —*The New York Times*, July 17, 1989

I'm telling you, they're hungry and they're going to beat
us at our own game, those wily Russkies. After all those
years of being denied the fruits of free enterprise, they're
going after them with a vengeance now. They're putting
advertising where no advertising has ever gone before—in
space. They're going to put marketing in orbit, logos on
the moon!

Meanwhile, back on planet Earth, in the good ole
USA, we're struggling. We're just now finally getting some
of our satellites in orbit after a near-total breakdown of

our space program, during which the space shuttle was grounded by disaster. We're finally back in space again, but the cost is staggering. It's hard to maintain both a presence in outer space and a viable system of nuclear overkill. With costs like this, it's amazing that anything else gets done.

On September 19th, Northrop ran an ad for the B-2 stealth bomber on the op-ed page of the *New York Times*. It consisted of a photo of the spooky plane, which resembles the Batman logo more than anything else, along with some copy written by "B-2 Chief Test Pilot":

"The B-2 is more like a fighter. It's very compact and it moves in unity. We've seen a very close correlation of the design objectives and the actual performance: in the structural arena, in the engine-inlet, and particularly in the flight controls."

This ad, like any good ad, made me want to run right out and buy one. (Especially that part about "it moves in unity"—why, that's poetry!) But I quickly came down to earth and realized that I couldn't buy a B-2. By the time the first B-2 got off the ground, the plane had cost taxpayers more than $8 billion. And even if I had that kind of dough, I doubt they'd sell me one. No, this is a different kind of advertising. It's intended, apparently, to make us feel better about the tax money that has already been spent on this weapon and the tax money that will be spent on it in the future, if there is one. It's intended, apparently, to make us see this plane as *art*—that other stupefyingly expensive commodity.

Unfortunately, this ad did not address many of the questions I still have about the B-2. Such as: Is this a first-strike strategic bomber, designed for sneaking up on the Reds or the Shiites or whomever when they're not looking? Or is this radar-evading, nuke-bearing vehicle intended for use after New York, Los Angeles, and all of the other art-and-entertainment capitals of the United States have already been incinerated?

All I get from this ad is that the B-2 bomber is a success from an aesthetic point of view. That really doesn't make me feel any better about all the money we're spending on this and other exotic new weapons systems. And I'm particularly put off by this sort because the national debt is getting pretty darn close to three trillion bucks, and I have a sickening feeling that we're probably paying MasterCard interest rates on it.

We're always hearing about the Russians' tremendous strategic strength and the sophistication of their space program. Lately they've been a lot better at getting satellites up there than we have. But their national debt is nothing like ours. And do you know how much those production model B-2 Bat Bombers are going to cost? The current quote, with no overruns, no markup—we're talking estimated wholesale price—is about $530 million each. And what good is just one? We need 132 of them to be up to code as far as our nuclear umbrella is concerned. This stealth thing is really going to cost us. Forget heating the pool this year. We've got to pull together as a nation to be ready for the freaky kind of war that will be fought in the '90s.

Of course, we little guys might not understand the rationale for such a bank-breaking project, but let's remember that when it comes to national defense, information is distributed on a "need to know" basis. And our leaders all seem to feel it's very important that we have this strange new machine that radar can't see, this Dracula-shaped plane that can deliver advanced warheads to the Soviet Union before that country is able to respond with nuclear weapons or even before it is able to turn capitalist and splinter off into a common market of small, harmless republics.

But how can we afford it when we owe so much already? (Almost three trillion!) I was mulling this over in my wine the other day when there it was, right in front of my face—the answer! Arnold Palmer!

So far this year Arnold ranks thirty-second in prize money on the Senior Professional Golfers Association tour. He has won $97,295. Better than your average household income, but peanuts compared with the $9 million he earned this year wearing corporate logos and doing corporate endorsements. Arnie was out there playing golf for himself, but also for Hertz Rent-A-Car, Sears, Paine Webber, Pennzoil, Lanier, Johnston & Murphy Shoe Co., Lofts, GTE, Rolex, ProGroup, *Ladies' Home Journal,* and about thirty international licensees.

Jack Nicklaus is still a draw, though the last time we looked he was ranked No. 123 on the PGA tour, with winnings of $96,595. But Jack was far from hurting in 1989, since he made $7 million by being a personable, articulate billboard for MacGregor Golf Company, Lincoln-Mercury, Nabisco, Uniden, Warnaco, Bostonian Shoe Company, Manville, Hart Schaffner & Marx, Optique du

Monde, Pine Hosiery Mills, Asahi Chemical, ABC-TV
Sports, and the Great Golf Resorts of the World.

These guys are great golfers. But they're hardly at
the peak of their games. Still, they have tremendous earn-
ing power thanks to their logo-bearing abilities. And these
guys are nothing compared with the space-shuttle program
(think of how many people watched the *Challenger* blow
up again and again). Think about how the whole world is
watching the Strategic Air Command. It's quite a deter-
rent now. But if the B-2 were on regular TV commercials,
reminding the world of our nuclear arsenal (and maybe
bearing a few corporate logos), imagine the purchasing
power it could influence.

Then you think about Batman, not the greatest
movie ever made, but something that generated $100 mil-
lion in licensing revenues. Think of what something really
state-of-the-art could do in the world of commerce. What
if we licensed the stealth bomber? Or the space shuttles?
First of all, you'd sell the exteriors for logos. Imagine the
space shuttle with a big "Budweiser" all over it. Why not?

Imagine what Coors could do with the stealth.
I can see the spot now. It's a sunny day at the beach; a boy
and girl cavort in the surf. They kiss. Drink beer. Music:
"It's the right beer now!" Cut to stealth bomber streaking
over the desert at low altitude. Cut to pilot in cockpit.
Voiceover: "But definitely not now." Coors would probably
pay enough for a whole bomber. Or at least a whole bomb.

And that's just the beginning. I can see the stealth
bomber of the future—appliquéd with dozens of logos
on that flat-black, nonmetallic skin: Bardol, Mobil, Ping,
Marlboro, Pizza Hut, Cheetos. Not only could the entire
surface of the plane be sold without compromising its
radar-eluding capacity; the entire shape of the plane
could be licensed, much as the Batman logo was licensed.
Imagine how much defense revenue could be generated by
stealth T-shirts and caps, stealth sneakers (invisible hang
time!), stealth medallions, stealth lunch boxes, stealth sun-
glasses. The sky is no limit.

Let's face it. Now the biggest strategic gap between
us and the Russians is not in missiles or warheads. The
biggest gap is ideological. How are we going to fund the
rocket's red glare in the next decade? If the Russians fund
their missiles through free enterprise and advertising
while we do it through taxes and secrecy, well, what are

we fighting to protect here? We may have already lost World War III. Have we given any thought to surrendering to the new capitalist leadership, Moscow's Madison Avenue?

It's really unnecessary. We just have to keep our thinking as fresh as theirs. We have to look at each technological breakthrough as a marketing opportunity. Think of the chances for funding we missed back in the '70s when we sent the *Voyager* probe heading out to the outer limits of our solar system and beyond. We sent along pictures of men and women and our solar system and a record that plays Chuck Berry, among other items designed to show extraterrestrials our way of life. But by licensing Voyager we probably could have underwritten the whole trip. We could have sent a message of Peace on Earth and "Have it your way at Burger King."

Let's get hip and open up NASA and the Defense Department to the marketing techniques that made this country great. It could be a first step in reversing the deficit spending that's killing our collective future. It could be a way of showing that government, even its notoriously wasteful branches, can turn a profit. And you American media planners out there, if the Russians come to you offering ad space on their next space flight or strategic weapon, stop and think—think about our future, about our national debt! Just say nyet!

Interview magazine, 1989

What does it mean to be a
Man? The best thing is to be
a gentleman. I'm really gentle
and really a man. Some guys
think cursing is manly. I think
it's manly to say "yes mam." And
I feel I have a mission in life. I
don't know exactly what it is yet,
but I know it's out there. And
part of it's to be a good man,
a gentle man.

Contradiction for Men , Calvin Klein, 1999

THE ART OF ADVERTISING

Art school is the place you go to learn how to
be a creative director, even if you don't know
that yet.

You start out wanting to be a painter, a
sculptor, an installation artist (an installer?)
or performance artist (non-entertaining
performer), and so you start out learning to
be an artist—drawing, painting, and reading
theory—and then one day you find yourself
drawing storyboards for a hipster beer.

It's just a temporary thing, or so you tell
yourself. You could drive a taxi or wait tables
and make art in your spare time, but of
course that is exhausting and dispiriting if not
demeaning, compared to the big-time artists
whose lives you read about. Where's the loft?
Who's your dealer? Where's your summer-
house? Somehow, you may find you don't feel
like painting in a room with a bathtub in it
after a day sucking carbon monoxide as a bike
messenger or taxi driver.

Many would-be painters, art school
students discouraged by the cost of living
and cowed by the daunting stairway to the
top, then seduced by the salaries at hipster ad
agencies, derail their fine-arts careers, opting
for a creative-director slot with benefits.
Creative director is the contemporary name
for what used to be called art director. The
title changed over recent decades because
art director proved too small a title for what
had become the dominant job in magazines
and advertising. Art director began referring

to the subordinates who size photos and push type around. The creative director is a visual genius collaborating with fashion photographers (who prefer to be known as artists) and fighting it out with the corporate editors and writers for creative control.

I went to art school, then double majored in literature and philosophy, and then went to graduate school; if anyone asked, I identified myself as a writer, not a motorcycle messenger, bartender, or temporary typist, or however I was making ends meet. As writing and editing were not very lucrative, I did continually engage in various forms of employment of the sort Marx termed alienated or estranged labor. Most of my artist friends were in the same boat, scraping the barrel bottoms to survive and in the hope of eventual artistic salvation. At least we could say we were an artist or, even worse, a poet. We could fail nobly, even in style. But we were headed upstream.

I could have been an artist, but somehow I had convinced myself that my drawing skills were inadequate. How did I not realize that I could have had a thriving art career without skills beyond ordering neon tubes or hiring assistants who could draw or paint better than I could. Ideas were more than enough. But the truth is I would have been embarrassed. I had an unshakeable belief in skill, talent even! I would stick with writing because I had the skills and could type ninety words a minute.

One day, my mother, who lived in an affluent Florida retirement community, had an idea. Why don't you get a nice creative job, she said with a sad yet hopeful lilt. I laughed because I knew exactly what she was thinking about. She was replaying the Hollywood movies in her head, mostly comedies that took place in the world of Madison Avenue, where living wages were to be had selling the world what it did not need, stoking the fires of conspicuous consumption in the hearts of the ambitious.

Typically, the creative executive was
played by Rock Hudson or James Garner,
and his sidekicks were Tony Randall or Jack
Lemmon. Their world was the world we
know today as *Mad Men*, except without the
tragic and existential aspects. The creative
executives enjoyed much of *La Vie de Bohème*,
hobnobbing with photographers and models,
frequenting jazz clubs, possibly smoking an
occasional jazz cigarette. They were free
of many of the constraints of conventional
business life and even enjoyed the company
of actual artists. And there was some truth to
this character. A friend's father was a creative
director at BBDO and he sat in on drums
with Dave Brubeck now and then. He got us
into Birdland.

My mother felt that if only I could
channel all that creativity into something
productive and lucrative, like advertising, my
problems would be over. I might even meet
a nice girl like Doris Day or Kim Novak
and commute from Connecticut to Madison
Avenue on the bar car. My mother, who
never had a job other than homemaker, had
witnessed the influence that artists, poets,
and bohemians had on me, she bemoaned the
curse of artistic ambition, but she knew that
there were alternatives, even for the seriously
afflicted, beatnik-bedazzled youth. I could
spout Rimbaud and swill Pernod on the 5:40
to Greenwich and I'd be okay.

Something creative! Like advertising!
In the Mid-Sixties a sort of crossover moment
occurred when Pop Art baffled America by
making fine art that looked like commercial
art. The world popped a pill and the world
looked different. Andy Warhol, the most suc-
cessful commercial artist of his time, famous
for drawing shoe advertisements, making the
leap to fine-art painting Campbell's Soup
cans and Brillo boxes. Mel Ramos painted
Coca-Cola and Lucky Strikes. Roy Lichten-
stein made comic book panels into museum

pieces. Jasper Johns, who had decorated the display windows for Bonwit Teller with his partner Robert Rauschenberg, sculpted Ballantine Ale cans. Pop Art's license to steal worked both ways with admen creating work that seemed like art. Stan Freberg created advertising that topped in popularity the television and radio it supported. His famous campaigns for Chun King, Jeno's Pizza Rolls, and Contadina Tomato Paste didn't take the back seat to any of the TV programming they supported.

How do you sell a lawn mower? Pit it against a sheep. How do you sell Chinese food? Stan Freberg thought, why not sell it like a car? Here's one of his radio spots:

> *Announcing the 1966 Chun King. Sleek, arrogant, a different breed of Chow Mein. You see it instantly in its bold new bean sprouts, its crisp aggressive water chestnuts. Talk about extras! You want bucket bamboo shoots? Power onions? You've got it Mister in the 1966 Chun King Chow Mein! Outside too you notice the revolutionary styling of its round cans right away! Wrap-around labels! More pick up in the two cans taped together. That's standard equipment on this baby! Look at the way she handles. The bottom can ... independent vegetable suspension. And in the top can ... where the action is ... over twenty-seven cubic inches of succulent Chun King sauce, loaded with high performance chicken. Step up to the tuned Chow Mein—the 1966 Chow Mein. (Noodles optional.)*

Pop Art had conquered the world. The acid-rock band Jefferson Airplane made a spot for white Levis. The Yardbirds sold Great Shakes. The Stones sold Rice Krispies! And made a movie with Godard.

Could it be that the firewall was gone between art and commerce?

Tom Waits has profitably hung on to his purity, suing those who would even sound like him, but in the seventies, long before Iggy Pop sold "Lust for Life" to a cruise line, he heard the Stooges on an ad for Detroit Dragway and felt validated. "I was so thrilled," said Iggy, "I felt like I was somebody. I felt like I was in the society."

I never acted on my mother's suggestion that I find a nice creative job, like in advertising, but then the job came to me anyway. An art-director friend called and said she was making a TV commercial for Barneys New York and she needed some words. Would I do it?

I didn't hesitate for a second. Why not? What is the difference between art and advertising?

Quality? Clearly not. The only difference I could come up with for sure was the logo. I was an adman from that day forward, and somehow it gave me the resources to do what I thought was art—with a logo.

I had always been interested in the neutral zone, the DMZ of art and commerce, and now I was working there. It was a place where I could push the limits, mainly because I was so unfamiliar with the limits. Like Iggy, I didn't feel like a sellout, I felt empowered. If you're going to be a bad boy, be bad: like Bob Dylan talking to the computer in the IBM ad. Don't tell me he wasn't savoring the transgression of the whole thing.

Decades later, I'm still accepting commissions. You can't improve the discourse without improving the language, and you can't improve the language by sticking to the hoity-toity of it. You've got to get down and dirty with it. Stan Freberg, who refused to advertise tobacco or be sponsored by it, made a hot-dog commercial where a man lights the wiener as if it were a cigar. Then he bites into it. He talks about cutting down and then he

pulls a pack of frankfurters from his suit jacket
and says, "I'm down to a pack a day."

Freberg's work is the model for great
advertising because it goes against all ex-
pectations. It transcends categorization. It
uses commerce as a vehicle for art. That's
how you really succeed in advertising, really
trying or not.

I have had many of my TV spots
satirized. Brad Pitt talking to himself for
Chanel. Both *Saturday Night Live* and *Beavis
and Butt-head* paid homage to the contro-
versial cK One series. Remember that one?
It looked like casting for a porn movie.
There's actually nothing obscene about it,
except perhaps the carpeting and the wood
paneling. It's just young people tearing their
T-shirts and fending off the suggestive
innuendo of an off-screen dirty old man
interviewing them. Remember? Bill Clinton
asked the Justice Department to investigate
that campaign. He said he wouldn't want his
daughter (then fifteen) to see the spots we
had done.

Calvin Klein made the most of the
publicity by "withdrawing" the ads, which
he called "misunderstood." Truth be told,
the media budget had already been spent, and
the whole affair disappeared from the news
rather quickly—especially when Monica
Lewinsky began to confess her affair with
the President, which began at the same
time, when she was a twenty-one-year-old
White House intern. Perhaps Mr. Clinton
found the ads more arousing than most.

"Like Art" was the title of my *Artforum*
column that ran from 1985 to 1990, but
it was also my philosophy of advertising.
Advertising was like art, and more and more
art was like advertising. Ideally, the only
difference would be the logo. Advertising
could take up the former causes of art—
philosophy, beauty, mystery, empire. We
were clearly living in a time of extremist

hypocrisy where various forms of creative work descried one another. Price-gouging painters looked down on lowly craftsmen and entertainment journeymen. Millionaire rock stars adopted a quasi-communist stance, emphasizing the anti-commercial aspect of their work.

When my advertising "practice" took off, I was soon offered a column in the *New York Observer*, writing about advertising. It was their idea. Why not? The *Observer* had a good audience. I had an agent deal with the details and they didn't meet her fairly ambitious ask, so it didn't happen. But soon afterward, I was written about by the *Observer*, scolded for working both sides of the fence, editing a magazine while continuing my career as a creative director.

I can honestly say that I never felt I was put in an awkward position by this supposed conflict of interest, but also I can say that if I was guilty of working both sides, so was every fashion editor, creative director, photographer, and stylist in the business. There are no ethics in fashion. There are no ethics in magazines. There are no ethics in advertising.

Anyway, advertising has always been on and in my mind. I wish I was the Dos Equis "Most Interesting Man in the World." I actually relate to Geico's Neanderthal. But more than that, I can't help but feel like my ads are better than Barbara Kruger's. Although hers are art and mine, well they are just ads. They have a logo. But I think art has logos now, too, so maybe there is no difference. A Koons or a Hirst work doesn't have a logo like Audi or Mercedes, but it might as well. Since the Warhol Factory, the artist's studio has adopted more and more features of a leading manufacturer. The visionary Ashley Bickerton put the Bickerton logo on his early works, which were logos adorned like a NASCAR racer and some of which featured an LED tracking the work's estimated net

worth. If I could, I would put my own logo on my work, but if it's beautiful and witty and stars Charlize Theron stomping on her jewelry, well the Dior logo doesn't bug me at all.

The fusion of advertising and art is adding another dimension to culture. I think it has something to do with the Citizens United Supreme Court decision. Corporations, which began as legal persons, are now mutating into actual persons, with opinions and personalities. I found a de facto manifesto for the emerging corporate personality in an ad.

I still don't know what SAP HANA is but they have infiltrated my consciousness with a TV spot—a montage of techno-landscapes over which that authoritative Oxonian Brit voice speaks like God over a stirring crescendo of strings:

Can a business have a mind? A subconscious? A knack for predicting the future? Reflexes faster than the speed of thought? Can a business have a spirit? Can a business have a soul? Can a business be...alive?

If I have to be a business in order to be fully alive, so be it. Glenn O'Brien... try some today.

Like Art, Karma, 2017

Fame, Fashion and Living

Essentially fashion is a control system based on making ugly people feel beautiful, boring people interesting, powerless people relevant.

Tweet, 26 August 2014

AREYOU A CELEBRITY?
DO YOU LOOK JUST LIKE ONE?

Are you a celebrity? Have you ever been a celebrity? What
are your chances of becoming one? You may be surprised.

How many celebrities do you know?

Personally? Well, yeah, you might know some per-
sonally, especially if you belong to the celebrity club. But
then how many celebrities do you know about? How many
famous people can you name? Take your time, our culture
may hang in the balance.

Think of all the rock stars, actors, models, fashion
designers, film directors, comedians, politicians, lottery
winners, television personalities and talking heads, clergy,
terrorists, chefs, wrestlers, deejays, sucker emcees, prize
fighters, gurus, football players, coaches, figure skaters,
hairdressers, corporate raiders, gangsters, dog trainers,
astrologers, bobsledders, magicians, golfers, restaurateurs,
writers, editors, serial killers...

This is a good exercise. You might want to keep
a pencil and paper in the loo and it'll give you something
to do...because never before have there been so many
fabulous celebrities. They have changed the way we live,
the way we think, they have reached out and touched our
hearts! Study them and you may turn out to be a celebrity
too. That's how young Patti Smith did it. She became a
groupie so big she was a star in her own right.

Celebrities have given us something to live for,
because with more superstars than ever before, they've
opened up the door and maybe you too can be world

Richard Prince

famous. You don't have to wait until death anymore. Immortality is here now. Just boot up the system. It's a new game.

Because if God is dead, or even out to lunch, then maybe celebrity is all that we have left to worship. Old William Blake wrote that "science is the history of dead religions." Mysteries aren't so mysterious anymore. Physicists say that we are on the verge of a unified theory that explains everything. We're messing around with DNA, becoming the Creator. But we still have needs.

The gods may not be hanging around Mt. Olympus anymore, the Blessed Virgin is making fewer and fewer public appearances, the Saints just aren't working those miracles like they used to. But people still have needs for what the gods did, the lessons they taught, the archetypes they reinforced. So if the B.V.M. isn't answering your Hails, or appearing in a cloud anywhere nearby, there's always a chance that you'll get to meet Madonna. You take what you can get. Maybe if she lays her hands on you, you'll be healed. Anyway, it probably won't hurt.

—

I asked a young friend, a few years out of the university but with no apparent career direction, if he had any idea what he wanted to be, what he wanted to do. After some head scratching he said, "Well, I think I'd like to be a famous writer or a famous artist." I could be dreaming, but it seemed like when my generation was coming up we left the "famous" out. Maybe we were just being modest, but maybe we attached a greater value to the work itself and less value to the awards ceremony. But now celebrity is where it's at. It's not what you did to get there; it's being there in the digital limelight. It's the club with all access, and there are a million ways to get in.

—

Is it better to be Joan of Arc or Milla Jovovich? Joan of Arc was a celebrity, and a saint. And today, in our secular age, celebrities perform many of the ancient functions of saints and demigods. Celebrity as victim: JFK, RFK, Marilyn Monroe, Elvis. The martyrdom of the saints is echoed in the modern phenomenon of the stalker, as in the case of John Lennon. Or acts are done in the name of the saint, as in the case of the Jodie Foster inspired assassination attempt on Ronald Reagan by John Hinckley.

—

Now how many celebrities did your parents know? What about your grandparents? Go back through the genera-tions. Sooner or later, and not much later, you're going to get to a generation not so far back there where celebrity was rare indeed, because the medium of celebrity was word of mouth only.

"The King, yeah, I saw him once! And there's the queen of course and the royal family, I heard of at least a half a dozen of them. And the Bishop, I've seen him five or six times."

Unless you're a religious fundamentalist you acknowledge that the human race has existed for millions of years. History begins with our earliest records, and that spans only about eight to ten millennia. And the beginning of history marks the beginning of celebrity. Gilgamesh, the Pharaohs, the personalities of the Old Testament. But even civilizations as advanced as Greece and Rome had comparatively low celebrity quotients compared with our era. There are not only more celebrities alive today than ever before, perhaps more alive now than have ever lived, but there are also far, far more per capita. So if you want to be a celebrity, now is the time. Sometimes you don't even have to try. You can become very famous by being shot by the police by accident.

You can become world famous by acts of great stupidity or outrage.

The poet Edward Dorn found this graffito in a toilet at the University of Colorado at Boulder, regarding would be presidential assassin John Hinckley:

"Why is wanting to kill Ronald Reagan and fuck Jodie Foster considered insane? Makes sense to me."

The main reason for this unprecedented popula-tion of celebrities is the vacuum of the media. It's a sort of hydraulic principle. The number of media outlets have created a great suction. The media sucks. We have so many more celebrity openings that must be filled we don't even get enough celebrity volunteers anymore. We're drafting them.

—

The explosion of the celebrity cult is directly proportional to the exponential explosion in media outlets. In the fifties and sixties the U.S. was served by three television networks, relied upon to provide enough programming, about eigh-teen hours a day, for about two hundred million people.

Forty or so years later the average cable box serves up about 99 channels, many of them global, twenty-four hours a day, meaning about 47 times as many hours of programming. And that's just the tip of the iceberg as satellite will sooner or later bring hundreds of channels. But for now, with 99 or so, we seem to need 47 times more celebrities to fill up those relentless hours.

Of course since there are so many media options, with more cable channels and websites going up every day, the nature of celebrity has changed too. The requirements for celebrity have gotten smaller. Today we have major network celebrities, but we have vast second and third ranks of celebrity, those who are legitimate stars in such venues as the Food Channel, the Surf Channel, the Health Channel, the Sci-Fi Channel, the Pet Channel...

And celebrities aren't just needed for TV. There's a whole Internet out there—naked girls with their own sites, wacko investigative reporters, paranormal researchers, super-groupies. And the whole world of magazines has changed too. Once there were dozens, now there are thousands. Outlaw Biker, Monster Truck, Barely Legal, Traditional Home, Nest, Leg Show, Cigar Aficionado, Spoon...

More celebrities! Show us your closet! Show us your garden! Tell us your intimate secrets! Show us your tits! Your lives are our lives. You make us interesting. Your reality is virtually ours!

Advertising is also hotter than ever as a source of celebrity, especially as the boundaries between art and commerce have blurred, with galleries presenting as art photography that, accompanied by a logo, would be a handbag ad. It has helped create legions of famous designers, models, photographers, hairdressers, cameramen, creative directors and advertising stars. In America everyone still knows Joe Isuzu, gone from the tube for years, and they know Frank Perdue, the chicken magnate who has taught them that it takes a tough man to make a tender chicken. And I've learned many a lesson from Donatella Versace and Ralph has taught me to be a better American: "God save Queens."

Besides the explosion of media venues, the celebrity culture is also fueled by the cult of the new—the cultural byproduct of the triumph of scientific progress and industrial revolution.

The rise of modernism in the arts was a natural complement to industrial progress. The new painting, like the new automobile, was considered inherently better, driving art to undreamed extremes. The same standard of novelty for its own sake also became a part of pop culture, especially pop music.

In both the visual arts and music there was real development, and great works were produced by experimenters, from the abstract expressionists to the pop artists, from the beboppers and free jazz players to artistic pop bands. But at some point the force of change in these arts was no longer any perceived progress or superior cultural vision, but novelty itself.

The idea of progress was replaced by novelty for novelty's sake, and so art and music became analogous to fashion. What distinguished the new from the old was only that it was new, and the content of the art or the music was not progressive in a modernist sense, but in the fashion sense of planned obsolescence.

Robert Johnson's blues is still compelling. Charlie Parker has more fans today than during his lifetime and his music is still startling. But who wants yesterday's pop band? Today's bands are disposable because nobody wants to listen to their older brother's band. They're like last year's jacket with epaulets. You've worn it already, and now it's just an embarrassing reminder of bygone hype and pathetic enthusiasm.

What this means is that the defining quality in culture is now fashion. The formerly famous British writer and painter Wyndham Lewis identified this phenomenon in 1927, in his *Time and Western Man*, where he labelled advertising "the pure expression of the romantic mind."

He wrote: "The world in which Advertisement dwells is a one day world. It is necessarily a plane universe, without depth. Upon this Time lays down discontinuous entities, side by side; each day, each temporal entity complete in itself... In this way the structure of human life is entirely transformed...The average man is invited to slice his life into a series of one-day lives, regulated by the clock of fashion. The human being is no longer the unit. He becomes the containing frame for a generation or sequence of ephemerids, roughly organized into what he calls his 'personality.' Or the highly organized human mind finds its natural organic unity degraded into a worm

like extension composed of segmented, equally distributed, accentless life. Each segment, each fashion day...must be organically self-sufficing. In the world of Advertisement... everything that happens today, or everything that is being advertised here and now, is better, bigger, brighter, more astonishing than has ever existed before."

—

Celebrity culture is turning politics from a profession into a popularity contest. We suspected this when Ronald Reagan, a popular Hollywood leading man, was elected president of the United States. Charlton Heston, hero of "Ben-Hur" and the "Planet of the Apes," is now a major political force in the U.S., helping defend our right to bear automatic weapons. But the reality of the way things might now work began to hit when the state of Minnesota elected professional wrestler Jesse "The Body" Ventura as Governor, and it struck again when developer and self-promoting "billionaire" Donald Trump announced that he was exploring the idea of running for President of the United States and suggested Oprah Winfrey for a running mate. Why not? What is democracy, really, but a popularity contest.

The top show on the American tube these days is "Who Wants to be a Millionaire," but by the time the next election rolls around it could be "Who Wants to be the President?"

In the sixties, it was called "the making of the President." Even then we knew he was a product. But today it's the marketing of the President and we've got a political system that sells candidates the same way it sells used cars.

—

But wait a second. Wasn't Pop Culture—pop art, pop music, pop fashion supposed to set us free from the establishment?

When bands were really big, like when the Beatles were bigger than Jesus and the Rolling Stones were the devil and Hendrix and Clapton were God, there was only pop music. I mean there was Mantovani and Lawrence Welk, but there was one pop music network, where the rockbands and the soul bands all interacted to create our culture.

There is no such thing as popular music anymore— except for the lowest common denominator elevator music (Mariah Carey anyone?) It's not just the cult of novelty, it's the over-formatting of music, where musicians are limited to specific genres by the forces of marketing. I know I'm a

musician, but am I Album-oriented Rock, Alternative, or, God help me, Adult Alternative? And if you don't know what station I'm on, what bin I'm in, how will you ever find me?

MP3.com, the new Internet company that was supposed to save us from the tyranny of the world's three record companies by allowing listeners to download music directly from the bands, eliminating the evil middleman, could be even scarier than what it's supposed to be replacing; it has 273 categories! The Grammys, America's record industry awards, has 93 categories. How do you fit art that's really art into a category?

Power has been categorized out of the music. Remember when the FBI was spying on Lennon and Jim Morrison was in jail for whipping it out while singing revolutionary ditties?

The Revolution has been televised and edited to fit your screen. The Revolution has been demographied and the most advanced methods of marketing have been applied to give us the perfect product. Youth culture is planned obsolescence because time alone will make it obsolete. It might be revived, when fashion hits that retro phase, but youth moves on into the future...either that or we move on into the future and youth stays here in Never-Neverland with Michael Jackson and Bubbles the Chimp (whom, Michael says was targeted with evil ESP by Prince). Either way, culture is a time bomb, set to implode into nothing.

It turns out that youth rebellion and generation gap, especially if we can mark out a dozen or so generations at a time, is the perfect marketing tool, the ultimate capitalist strategy; the perfect means of controlling rebellion is selling it. Every cultural product, like your yoghurt, will be freshness dated. If you're not wearing the new, listening to the new, watching the new, then you'll be old and inherently worthless.

So one of these days, somebody's going to come around to sign you up to be a celebrity. They'll size you up. Tell us a little something about your personality. What are your favorite designer labels, who are your favorite bands, what book are you reading (make one up,) who are your favorite celebrities????

Be smart about it. It's not going to last forever. A star gets a year or two. A superstar might get a five-year run. A megastar might have a career. But there aren't too many megastars these days. And there are millions of little

stars. You might look like a god, feel like a god, but chances are you'll get a few good seasons, so put it in the bank.

—

In the early sixties, popstar professor Marshall McLuhan predicted that the impact of electronic media would be to create a global village that would break up traditional units and reform society along more tribal lines. We have seen the devolution of the Soviet Union, the decline of nationalism in Europe combined with economic unification, and the emergence of what could be called a global culture— or arguably, a global lack of culture.

So say so long to the tribal costume. Hello blue jeans and Tommy t-shirt. Goodbye oral history, hello *Baywatch*.

My lifetime has seen the disappearance of plenty of species of flora and fauna, but almost as disturbing, entire cultures and subcultures: from entire rainforest tribes to the famous Brooklyn accent.

American and British accents are being sucked away by the vacuum of television and radio, destined, perhaps to meet in Mid-Atlantic English, a hybrid of BBC, hip hop, Texas pilot drawl, Silicon Valley, valley girl and 1984 "Newspeak."

Well, for years it was preached "we're all one." And pretty soon it might be true. We'll have different generations, alright. But maybe we'll all dress the same and talk the same and have the same ravenous need for fashion personality containers.

Of course they say the new technology may set us free. Thanks to digitalism and computerism and Internetism we'll be able to make and distribute our own music, our own writing, our own art. The promise is there to make us independent of the lords of distribution. To free us from the evil networks and the culture *cosa nostra*. Wanna download my novel? I'm not convinced. When it comes to real art I still find myself asking the age-old writer's question. "How is it possible to sell that little of anything?"

Religion isn't what it used to be, despite highly visible and active fundamentalist movements. Church attendance is way off. The Catholic Church is having trouble keeping enough priests and nuns. An American priest recently announced his intention to have a sex change—"sexual reassignment" that is, meaning that the first woman priest ever could come in through the back door, so to speak.

Still from *Tea at the Beatrice with Glenn O'Brien*

How did Patti Smith get in that photo with Walt Whitman?

Tweet, 29 March 2014

Andy Warhol died 30 years ago today. I remember thinking "who's opinion will I care about now?"

Tweet, 22 February 2017

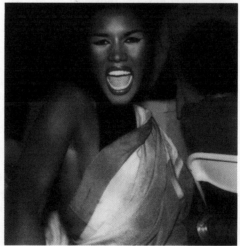

Maripol

So who will save our souls? Will the new pantheon
of Hollywood stars, the gods and goddesses of digital
Olympus do it? Can we pray to Brad and Gwyneth? Can
we find a digital Jesus on the web? Is the Internet itself a
super-brain, a global uber-mind that will enlighten us all?
Will the Internet save our souls? It has certainly made
many a fortune, but does it offer similar enrichment to our
lives? Some hold out the hope that digital technology
and the Internet will free the arts from the stranglehold
of corporate greed that has wrung creativity from music,
film, fine art and publishing.

To the founders of Communism, workers would
free themselves by seizing the means of production. Today,
culture workers can contemplate a similar prospect of lib-
eration in the potential seizure of the means of distribution.

The endless revolt that youth culture continually
rebuilds itself upon, is based in the idea that the arts are
progressive—that interesting music, film, fashion or even
writing, must overthrow the old.

In the late seventies and early eighties punk rock
arose as an "us vs. them" paradigm of revolutionary art.
The record companies were decadent conglomerates run
by fat cats on huge expense accounts that had no connec-
tion with either artist or audience. The powers at major
record companies had lost the ability to scout talent. As
a result hundreds of small record companies were created
by artists themselves and like-minded compatriots to
distribute the music of real musicians. And then these
independents were all absorbed by conglomerates. Today
there are three record companies left. One is owned by
a lightbulb company, another is owned by a liquor distiller.
Today the fat cats have long hair, dress bohemian, take
drugs, and give the appearance of radicalism, but their
lingo is pure marketing, as if the product were aluminum
siding. That's why today the term "alternative music"
means mainstream. The Internet makes it theoretically
possible to distribute music without the services of
a traditional record company. But so far, the monolithic
mega-corporates have yet to suffer. Music fans still like
to browse the record stores. It gives them a chance to
leave the house. But if we're ever to have powerful arts
the distribution power has to devolve to the people,
doesn't it?

—

"Now, at century's end, I find it hard to believe
that I once lived in a time when writers were
world figures because of what they wrote, and
that their ideas were known even to the vast
perennial majority that never reads."
–Gore Vidal, *Palimpsest*

—

One prophet of our current gigapantheon global media
meltdown was Andy Warhol who remarked almost forty
years ago "In the future everyone will be famous for
fifteen minutes." This view informed by the predigested
pop news, the tabloid news and television news, reduced
the complexities of the world into a "bite." In the newsreel
era the man on the street was a media amateur, but as the
electronic media surrounded us, and became our "matrix,"
the average person grew up knowing how to talk on televi-
sion, how to give a sound bite, how to be a celebrity. We're
all ready for our fifteen minutes. We're all experts. Anyone
can have the answer.

I think that in the future everyone will be Andy
Warhol for fifteen minutes. And, at some point in the
future, the future will be fifteen minutes. Our attention
span is almost there already...

Paper Magazine

HOW TO UNDERSTAND FASHION

We're not going to solve this overnight. It took thousands of years to get philosophy right where we want it. Think of the human toll—Socrates poisoned for asking too many questions, world peace shattered by Nietzsche—but finally, thanks in large part to Freud, pharmacology, medical science and the no nonsense approach of deconstruction, from Lacan and Derrida to Kawakubo and Margiela, speculation has been perfected and industrialized, providing answers comprehensive and reliable enough to eliminate the need for questions.

It took even longer to figure out art, in large part because they kept moving the finish line. But finally, thanks to science, and the triumph of industrial design, that too is no longer a problem. In a world of permanent wealth and enlightenment, a globalized aesthetic lifestyle is available to all with the ambition and "sticktoitiveness" to afford it, rendering messy and parochial cultural strife unnecessary. The agony of introspection endured by such valiant pioneers as Vincent Van Gogh and Jackson Pollock has given way to an

objectified system of sociological totemism that is effective, satisfying and affordable. It's no longer called art; it's design. Artists may persist but they've seen the handwriting on the wallpaper. Music, the history of which has been equally agonizing, has now been perfected. The entire gamut of human music is now available to all, thanks to digital technology, and the recycling allowed by digital recording and sampling has obviated the need for originality. The most effective and satisfying rhythms and melodies can now be isolated and employed at will without tedious practice or annoying royalties.

Politics is now stable, thanks to our ability to contain it in a binary system. Now all political issues can be resolved by a simple "yes" or "no," which should ensure that democracy has an infinite half-life. Rather than dealing with an endless menu of choices, the two-party system, by skillfully combining choices through a method developed in the United States Congress, is able to manifest the will of the people with one simple "yes" or "no," solicited as infrequently as every four years.

Culture, generally speaking, is no longer a problem, thanks to techniques developed originally by NASA or by companies involved in agribusiness. If we can put a golf ball on the moon and design a featherless, beakless chicken that reaches full eating weight in 1/3rd the time, we should be able to deal with the productivity loss that once resulted from cultural pursuits. Gradually we are breeding a better employee, but in the meantime by perfecting the transmission of data we need no longer distinguish between "home"

and "office," "work" and "leisure." The aberrations once generated by cultural practice can now be controlled by enhanced lifestyle.

Still, problems remain. Fashion seems to spring from the unconscious mind, which seems to grow ever larger, as work once performed by the conscious mind is now done by computers leaving humans with gigabytes of unused RAM. In fact, some social scientists project that in the future all employment will be in the fashion industry—designer, stylist, model, and buyer being the principal roles, aside, of course, from hair and makeup, which may, by then, fall under the heading of "health care services."

As we have seen, fashion now occupies a role in our lifestyle world (via culture) once occupied by the fine arts. The triumph of minimalism in architecture and design obviates the need for content, since we ourselves are the content. But, being human, we still retain trace impulses of "creativity" and "self-expression." While militant modernists might consider this barbaric, likening it to such vestigial or obsolescent apparati as the appendix or the typewriter, the creative consumer understands that fashion is a deeply enjoyable meditation on our history, as well as an important system of signification within our societal constructs of power, value and meaning. Fashion is also an important "outlet" for role playing, especially among our youth or those in gender assignment transition.

It would also be foolhardy to discount the value of fashion as religious experience. Take the case of

my acquaintance "Fred" (not his real name) who claimed to have a religious experience when he saw Tom Ford in an Italian restaurant. Or the case of "Irene" whose medically verified stigmata have been attributed by some to the clothing designers *Imitation of Christ*. Throughout the twentieth century people were heard to cry "that's divine" when beholding some unexpected item of fashion, and perhaps these utterances were not as hyperbolic as once supposed.

The role of clothing is not only significatory, it is transformative. Its very concept is to render the wearer beautiful. Fashion is certainly not "a religion," but perhaps it would not be wrong to say "fashion is religion," because just as there were many faiths in the world of our birth parents, so there are many visionaries among us today. Are they not like the sadhus and yogis and saints of old—altering their consciousness through potions or staying up for days at a time at the sketchpad. And are not the lovely models that adorn the runways like the vestal virgins that guarded the mysteries of ancient Rome, except, of course, on the pill?

As I write this, fashion week is approaching, and by the time you read this, the world will look different. Hemlines will rise or fall. Bosoms will be exposed or hidden. Green may be the new white. But one thing is certain: fashion will change, and this, neither mankind nor God him or herself, has the power to stop.

Paper Magazine, 2001

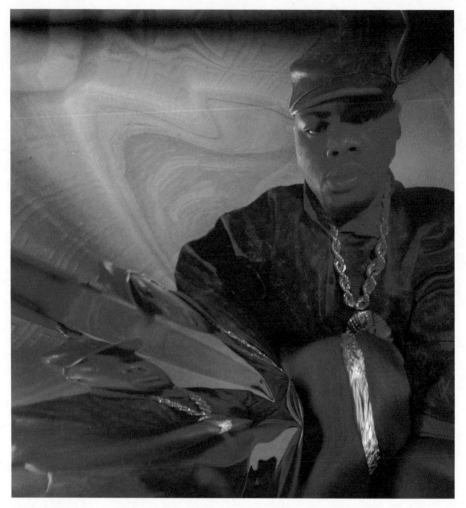

George DuBose

MY MAN DAPPER DAN

He knocked up the world's prestige brands.

 Arguably America's greatest couturier, male division, is Daniel Day aka Dapper Dan, a self-made entrepreneur from Harlem. He made luxury bespoke fashions that are among the most important examples of the art of appropriation. Andy Warhol had Campbell's Soup, Dapper Dan had Louis Vuitton, Gucci, Fendi. He outdid the most luxurious brands at their own game, dressing a hall of fame of notoriety, and making a consciousness of conspicuous

FAME, FASHION AND LIVING

consumption that was exquisitely elitist, arcanely under-
ground and perfectly ironical at the same time. Treated
like a white-collar criminal by those he most benefitted,
in his magical re-imagination of luxury as something
shameless and flamboyant he turned luxury empires around.
Without Dan there was perhaps no Sprouse, no Tom Ford,
no Marc Jacobs, at least not as we know them today.

I guess I first heard of Dapper Dan in 1988 when
he hit the *New York Post* because of an impromptu fight at
his shop between Mike Tyson and Mitch Green, another
heavyweight Tyson had fought in the ring in 1986. Tyson
was the champ by '88 and Green had a beef about money
with promoter Don King and thus Tyson too. I then real-
ized that I had known Dapper Dan's work for a while, he
was the genius cat who made those amazing unauthorized
Louis Vuitton, Gucci and Fendi for a clientele of the
dopest M.C.s and the superflyest gangstas and playas they
consorted with—and whose salon was habituated by such
super-vixens as Naomi Campbell.

Dapper Dan was the man who re-branded the
brands, generously giving them a spontaneous and gratis
chic they might never have otherwise achieved. He
turned the beat around.

When I was growing up clothing labels were on the
inside. There might have been an alligator on your polo
shirt, but that was pretty much the extent of conspicuous
fashion branding. Sneakers, of course, did have some visible
signs—the little blue rubber label on the heel of Keds, the
"Plimsoll" line on the sole of Converse All Stars—but it
took an educated eye to name the brand of a button-down
collar shirt. I could spot the brand by the flare of the collar,
or a locker loop. You could distinguish a Brooks Brothers
blue oxford cloth button-down by the color and the lack
of a breast pocket. We all knew about conspicuous consump-
tion, of course, and chinchilla coats and big diamonds,
but fashion wasn't always about the conspicuous. It was an
initiatory system of signs that took education to master—
you had to know the subtleties to immediately distinguish
the socialite from the middle management drone. It took
a certain sophistication to even recognize a Chanel suit.
It was the pre-logo era.

I remember the genuine fundamental shock I felt
when I first saw the label go public. I was in college, late
sixties, when I saw a Yves Saint-Laurent woman's coat in

the window of an upscale boutique on Wisconsin Avenue in the Georgetown section of Washington, D.C. with a very large monogram on the breast. If it were a little smaller I might have taken it for something made to order for the sort of woman who had initials embroidered on her towels or hankies, but I knew that the rather large YSL was actually the monogram of the designer and somehow I knew we had crossed over into a new era.

We had already crossed over into new territory with the swinging sixties, the hippies and the miniskirt. The philosopher of the electronic media age Marshall McLuhan had declared "Miniskirts are not fashion. They are a return to tribal corporate costume. Apparently the new tribalism was going to revise the entire fashion system by the system of luxury and aspirational branding. With the logos moving to the outside we were entering a new realm of allegiance—with designer creating clothes that conveyed ranks, allegiance and conformity the way military uniforms had for centuries.

In the 1980s the financial boom was accompanied by a fevered yen for designer clothing and extravagant luxury goods and logos took on a new cachet, marking out a new elite. Brands like Chanel, Gucci, Louis Vuitton and Fendi flaunted the affluence of their adherents with trademark leather, while brands like Prada explored new levels of logo-forward design treatments with the brand given billboard prominence on some products. Such luxury leather goods became universal status totems, objects of desire among the wealthy as well as their housekeepers. This fashion mojo inevitably led to a wave of counterfeiting as well as what might pass for "appropriation" of art world standards by hip offshore manufacturers.

While the ladies who lunch sported superbly crafted Gucci handbags, pot dealers on the corner sported Gucci sweatshirts and baseball caps. And Gucci did not make sweatshirts and baseball caps. The street had its own elite, that was entirely aware of haute monde éclat as well as the charm of the outlaw sampling happening in the emerging art of hip hop.

On my first trip to Japan I came back with wonderful artisanal items such as brushes and tea ceremony utensils, but I also had a stash of Hermes scarf pattern bags (which Hermes didn't make), a Gucci sweatshirt and a Louis Vuitton watch and baseball cap (both of which

existed only in the outlaw versions.) They seemed to be much more than knock offs, they were ironic fashion statements. They were luxury in quotation marks. Almost art.

But that was just the beginning of logomania. In 1982, as hip-hop culture was beginning to take off, a man named Daniel Day opened Dapper Dan, a boutique for the funky and fly on 125th Street between Park and Madison. His best customers were the entrepreneurs he had rubbed elbows with as a young man, whom some might call gangsters, or players. Dan originally intended to sell them furs and high-end designer clothing, but he had trouble getting such merchandise for his Harlem emporium, so he decided to provide it by any means necessary.

Dapper Dan became a couturier. He had spent time as a student in Africa, and he found it easy to employ skilled tailors from West Africa. His Harlem atelier was open 24 hours a day to suit the lifestyles of his OG clientele. Dan understood the appeal of luxury and if the big brands weren't going to supply him, he would supply himself and so he began making coats and jackets featuring the logos of luxury accessory brands. He started out buying Louis Vuitton garment bags, leather-printed with the LV logo, cutting them up to use as material for clothing.

When acquiring garment bags became difficult, and he wanted to expand, he learned how to print on leather. Soon he was turning out his own materials. He made bulletproof jackets out of homemade LV and MCM motif leather and outlaw appropriations of Gucci, Versace and Fendi. Dan dressed fighters like Tyson and hip-hop artists like LL Cool J and Eric B and Rakim—whose album covers for *Paid in Full* and *Follow the Leader* were like billboards for his "knockups" of Gucci and Louis Vuitton. Big Daddy Kane, KRS-One, Fat Joe... so many hip-hop legends were dressed by Dapper Dan, but his first and best customers were legends of the underground economy, street entrepreneurs whose high-fashion profile added another dimension to their already urgent security considerations. Thus he learned to incorporate special features like invisible pockets and bulletproof Kevlar panels in his jackets and coats. He allowed customers whose garments had this treatment to test his garments before acceptance. (One shot only.)

When Dapper Dan saw my Perfecto motorcycle jacket he said, "You know this was the original bullet proof vest. In my neighborhood we didn't have no real firearms,

we had zip guns made from TV antennas that fired .22s.
A .22 short wouldn't get through this jacket."

The gangsters didn't just want to wear Dapper Dan
and so he began customizing their rides, from doing
unauthorized luxury-brand Jeep spare tire covers to full
interiors, like a BMW 325 convertible I once spotted in
Sag Harbor with a full MGM interior.

Business was all fabulous for Dapper Dan until
1989 when he was finally shut down by the law. Ironically,
Supreme Court Justice Sonya Sotomayor was a young
prosecutor on the team that raided Dapper Dan's looking
for "counterfeit" Fendi, even though none of Dan's cre-
ations ever resembled something the honored brand would
have produced. One of the items the raiders discovered
was a "Fendi" car roof. They would settle for infringing on
Fendi's trademark.

Today Dapper Dan dresses Floyd Mayweather,
Busta Rhymes, Puffy. He's got serious clientele still. I see
him around town. Handsome, dignified, well spoken,
modest, and transcendentally ultra cool. Mike Tyson told
the *New Yorker* that he always thought Dan was African
because he was so polite: "He conducted himself real dig-
nified. You know, them African guys are dignified and
shit—I thought Dapper Dan was African."

Dapper Dan has an African level of cool. He should
be Dr. Dapper Dan because he knows a lot and has a lot to
teach. As the couturier of the hip-hop world, we could say
that Dan was sampling the same way the musicians were.

Dapper Dan is a true artist in the highest sense.
Supposedly Pharrell said that Dapper Dan was an outsider
artist, but I think he's more than that. If there is a real
contemporary artist in the field of fashion, it's Dapper
Dan. He is a houngan or witch doctor as couturier, and
he infuses the things he makes with magic.

Maxim, 2015

BASEBALL UNIFORMS

One of the wonderful things about baseball is its stability, its constancy. It changes ever so slightly now and then, but basically it's been the same game all this century. A 300 hitter and a 20-game winner are still the same thing. In the big leagues the bats are still made out of wood. The only horrendous innovation is plastic grass—but if you're an American League fan you don't have to see that much of it.

The biggest changes in baseball in the last twenty years, aside from fake grass, are in the uniforms. That's one of the reasons I still love the Yankees. Their uniforms still look like baseball uniforms. White with pinstripes at home and understated gray away. I like any team with a nice traditional uniform: Boston, Detroit, even the Dodgers. But it's funny—even the teams with classic uniforms don't quite look the same. It's subtle, but almost all of today's players wear their pants wrong. The pants are just too low. Too close to the ankle. I really wish that all of the New York Yankees would take a good look at how Toby Harrah wears his pants. That is the correct amount of sock to show. Toby knows because he is, I think, the last active Washington Senator in the major leagues. If there's one thing that looks even worse than six or seven gold chains under a jersey it's pants down around the ankles.

It's all the fault of Charlie O. Finley, former owner of the Kansas City A's. He introduced gold uniforms into a gray and white league as part of a campaign of gimmicks to get people, in the city where the beef is, to go to the

ballpark. First there were the garish gold uniforms, then things like a blowhole in home plate so the umpire wouldn't have to bend over and whisk broom it off, exposing his butt to the TV cameras. Finley's most amusing caper was bringing in his right field fence to the same dimensions as the "home run porch" in Yankee Stadium. Instead of putting seats out there he put grassy hillocks and goats grazing.

I don't like what Finley did to the uniform, but otherwise his efforts were amusing. He was the Jimmy Piersall of owners. If only George Steinbrenner were a little like him and could take out his energies on details rather than the team. Yankee Stadium is very nice as stadiums go, but they could improve it.

For one thing, I wish they'd get rid of the ads. It's bad enough that they have ads on TV during the inning breaks, but to sit in the stadium and be subjected to commercials on the giant "Diamondvision" TV in right field—it's just too much. It's like if Phil Rizzuto did the play by play over the PA. Why pay to be there if the advantages are eroded?

Also I wish Steinbrenner would pay more attention to the hot dogs. They are far too long. Or the buns are far too short. And the only mustard is packets of bright yellow French's. That's un-American. There exists a mustard called Stadium Mustard and why do you think they have stadium mustard? It's for stadiums! Ever try to hold a hot dog and a drink in your lap while tearing open several tough little plastic envelopes of bad mustard?

The first game I attended this season went 16 innings—one more and it would have been called because of the American League 1 a.m. curfew. It was great fun. Whenever things got a little dull a scuffle broke out somewhere which was quickly and seemingly non-brutally handled by security. It was fun watching the dozen or so kids in the upper deck scramble for foul balls. But when you have a five-hour, sixteen inning game going you want to have a decent cup of coffee. Well, at Yankee Stadium the coffee comes out of one of those plastic machines with a little hose that says Hot Coffee on it. You know it's like generic instant; not exactly picked at the peak of ripeness by Juan Valdez. But I must say the hot chocolate is excellent, so if it's extra innings...

East Village Eye, 1984

Fashion is really boring. I can live in last year's clothes. We should transfer all that energy into oratory.

Tweet, 10 February 2014

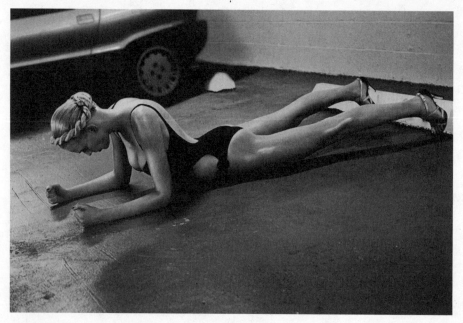

Wayne Maser

FASHION ATE ART

Frank Lloyd Wright said "Fashion exists for com-
mercial purposes only." Wright was a great dresser,
with dramatic capes and scarves and oddball porkpie
hats. He was talking about fashion in the new mod-
ern industrial sense, an increasingly powerful system
of seasonal revolutions and mass molting. Marketing
agents, euphemistically known as designers and
editors, render perfectly good wardrobes instantly
obsolete, ostensibly for the sake of novelty, ulti-
mately for the sake of conformity.

It makes no sense for a person to recycle
cans and bottles if they're afraid to wear last year's
sneakers. Yet somehow fashion remains immune
to political analysis. No one thinks ill of it, despite
its increasing sway. Most people who can name,
say, a dozen "couturiers" probably cannot name ten
important painters or writers. It's no exaggeration
to say that fashion has replaced art in our society.

The art world did itself in. Its modernist sys-
tem, in which progress was all-important, became

exhausted, no longer able to engage the imagi-
nation of the public. It became a self-contained
world divorced from the public at large. The
artist's reliable old tactic of "épater la bourgeoisie"
finally succeeded too well. The bourgeoise found
something better to do. They put on their designer
clothes and went to the movies.

Fashion is much better suited to the rigors of
relentless obsolescence anyway. Nobody cares much
what it means, and you can talk about it endlessly.
Also it's easier to replace one's entire wardrobe than
a large art collection. And in a world that worships
growth, progress and upward mobility there has to
be a system in place that constantly apotheosizes
movement and struggle and continually recreates the
pantheon of relevant personae.

For the last decade or so we've seen fashion
designers lionized by and advertising in the
most important art magazines. We've seen artists
courting designers, jealous of their popularity,
and churning out fashion-based work dependent
on the thinnest of implied critiques. Anyway
who needs Francesco Clemente when you've got
Rei Kawakubo. The average media savvy, pro-
gressive person can afford to own Comme des
Garçons, Helmut Lang and Martin Margiela
but they can't afford Koons, Prince and Polke.

In the democratic media state, for a long
time we have been defined by our ideas, our aes-
thetics, our tastes. It used to be what films we saw,
what books we read, what artists we liked. But
who has time for that now? We needed something
more immediate and we got it: five hundred-dollar
sneakers and two hundred brands of jeans and
celebrity culture.

Fashion is our new profane religion. It
embodies "now" attitudes, and transmits them
across the world, creating a matrix in which
the ancient struggles for production, reproduction
and acquisition can carry on. It's our new system
of secret society.

Today personality is the aggregate of thou-
sands of consumer choices. We've become human
hard drives, programmed with brand choices and

above all fashion. But it's complicated. Our fash-
ions don't always say who we are. They often serve
as camouflage. You have to know the code.

The rise of casual fashion coincided with the
rise of the new super-rich. America, the hope of
the great middle class, has returned to robber baron
standards. The billionaire dresses just like the
guy who picks up his garbage. You have to know
the code.

The only way to act as a revolutionary
force in today's culture is to drop out of the fash-
ion system and become your own designer. The
opposite of fashion is style. Style comes from the
same root word as stylus, a writing instrument,
the stick that we used to make our letters or hiero-
glyphs on wax tablets, or the needle we use to scratch
on our turntables. It's how we make our mark on
the world.

I'm paying attention to fashion lately, mak-
ing sure that I'm not in it. I'm paying even more
attention to what clothing I buy and what I put on
and in what combinations and when and where.

When I get dressed in the morning, I con-
sider the weather, the mood (personal, local and
national) and the opportunities and perils ahead.
I'm also changing more, making more of an
effort to change for the afternoon and sometimes
for the evening. I'm trying to resurrect that
old filmic phrase: "Shall we dress for dinner?"

I'm not entirely clear on how this is working,
but it is. Today, for example, my mauve shirt and
pink sweater and the lack of an American Flag pin
in the lapel of my single breasted peak lapel brown
flannel jacket make it quite clear that I am not a part
of the Coalition of the Willing, but am distinctly
part of the of Elevation of the Chilling.

Paper Magazine, 2005

NOTES ON HIP

I've been asked: "what's hip?"

It's a stupid question. But then again, "stupid" is the new "fresh," the highest of hip compliments, the hip word for hip. Stupid is the new cool and the new hip, so dig it. You want to be hip? Be stupid. It's easy, but it can be an art, too.

To be hip, as long as there has been a hip to stand on, has been to be where it's at, pointed toward where it's all going. Hip is the posture of the futuristic elite, who are living today by tomorrow's standards, ideals and ideas. To be hip is to live in the future. Twenty minutes or more. And to be hip is to possess the attributes of the future as they are perceived from where it's at. That may mean being cool, being radical, being casual, being fresh or, as we are now seeing more and more, being stupid.

Today, the art of being stupid would seem to be where hip is at. Of course here, as in any hip movement, there is going to be a whole spectrum of stupid, and no doubt our readers, already into the basics of stupid, want to know about the esoteric, elegant, exquisite, upscale forms of stupid that constitute the New Stupidity. What's the Stupidest? Who are the Stupid Elite?

Yo! Dig, "What's stupid?" is the question behind all contemporary magazine journalism, not to mention most human behavior. And the answers to this question are not only fictional, they're also a secret. Spilling the beans must be done very gradually and at a very good rate of exchange.

Some things are better left unsaid. Like hip. But out there in the highways and byways people are dying to be hip. And although we may be overpopulated, I'm not into encouraging death by hipness. It's a leading cause of death among the young. That's *faux* hip, phony hip, the wrong idea. That's stupid stupid.

Expecting an answer to "What's hip?" is like Hamlet asking "To be or not to be?" and then, like, York's skull speaks up and says, "Yeah, but like how, man? Like how?"

In pre-Columbian Mexico the cats who had their hearts cut out on top of the pyramids were known as "hipsters." These teen idols were well paid and retained publicists. They were known as "fresh" and "stupid."

Today hip has changed title. It's still a concept of an occult elite. It is primal, primitive and metaphysically unavoidable; if you're not hip yourself, you still have a Hip Twin in a parallel universe, your Bad Self. Hip is all too often the cause of an existential leap of faith from the Brooklyn Bridge that one was just sold.

It's not hip to talk about hip. It's worse than the weather—everybody talking about it and then trying to do something about it, and it's still just the same. If you have to try, you ain't. It's not a matter of choice. The leopard can't change his spots, and the beatnik can't change his goatee.

Hip, like nobility, is inherited, but sometimes it skips a few generations. And you inherit it from yourself. Hip can be acquired, but only by establishing a karmic claim to the estate.

Hip is mysterious. Sometimes it doesn't appear until adulthood, sometimes it disappears altogether soon after its appearance—making the formerly hip person seem in retrospect to have been the victim of himself. The mechanism of hip is like the mechanism of possession, because you can't own it, you can't hang on to it, you can only tune it in and stay tuned. Maybe somebody acting remarkably cool for a short period of time has been temporarily possessed by Eric Dolphy or Fats Waller.

Hip is a noun, a verb and an adjective. Hiply is the adverb. Hip is a joint. When hips get together they do the bump. They do the hip shake. When a hip gets cut off and smoked, it's a ham.

And the hipbone is connected to the thighbone
and the thighbone is connected to the knee bone and
the knee bone is connected to the triumph of the will and
the triumph of the will is connected to the G-spot
and the G-spot is connected to the Communion of Saints.
Et cetera, et cetera. Dig?

Hip is "In the Know," and for that reason hipness
is often identified with Gnosticism, and more recently
with Rastafarianism.

Hip is like a secret society, because you can only
be known to be hip by the hip. Others can be told you are
hip and believe you are hip, but only those who are hip
will know you are hip. Loose lips sink hips.

"I'm in with the in crowd. I go where the in
crowd goes. I'm in with the in crowd. I know what the
in crowd knows."

Publicity for hipness can and usually does work
against hipness because it tends to impute hipness to the
beliefs of others, i.e., the public, when actually hipness is a
form of knowledge possessed by and of oneself, recognized
by others possessed of that knowledge, that is entirely inde-
pendent of the beliefs of the public, even though hipness is
often the matrix of the *faux* hep or bogus hipster.

Hip may be the "white negro" update—the Beastie
Boys are the latest of that and totally stupid. Or hip might
be some dude locked inside listening to Chet Baker and
making a killing in the futures market. All hip is, is a little
island of enlightenment, real, unreal, alleged.

Hip is a majority of one, a minority of millions.
It's a free-form freemasonry established by eye contact,
sportswear, rhythm and jokes.

When you're young you're automatically hip for
hours, weeks or years at a time, but hip is fleeting. It fades,
just like its physical counterpart, "bloom." You can be
young without being hip, but you can't be hip without
being young. You can stay young as long as you're hip.

"When you're in with the in crowd it's easy to find
romance. Everywhere, people stare 'cause we ain't square.
We make every minute count, our share is always the
biggest amount."

To be hip is to be hypnotic or to be hypnotized.
When you're hip you give people the eyeball and they get
the message. When you're hip you're full of suggestions that
people love to follow. Or you'll follow somebody anywhere.

"Other guys imitate us, but the original is still the greatest."

To be hip is to be "Wild Thing": You make everything groovy. When you're hip you don't live on the edge, but you know somebody who does who is just a phone call away.

When you're hip you live in the middle. You eat right, look good and play hardball. When you're hip you're more than Fresh. You're unpicked. When you're picked you're Aboriginal operating on your original DNA programming, shooting the curl of the bioplasmic flow. When you're hip you're so Casual you're Causal.

When you're hip Uncle Sam is looking for a few good you. When you're hip you're Down by the Law of Nature. When you're hip you're Word. Hipness is Word Upmanship. When you're hip you're Fly. You can Birdland all night long: hips that go bump in the night.

When you're hip you're Intense but Chill. When you're hip you're Bad. As in Good Bad But Not Evil. When you're hip you're always wearing shades to protect others from your own brilliance.

Hip is its own reward and its own downfall. Hip can be hip or totally unhip. But when you're hip you don't give a flying buttress for any of that hip chacha-cha. You've got bigger red herrings to sushi. After that let them eat pie in the sky à la mode.

Interview magazine, 1987

CAMPAIGNING

Campaigning in style? Well, actually political style
is a contradiction in terms. Style is individual. Politics
is more about fashion. Fashion is dressing for a group,
observing dress codes to please others. Politicians dress
the way they think their voters want them to. And
when they don't, things often go badly for them. Here
are some tips on how to dress for electoral success.

Dress downscale
A candidate should never look rich, even if (especially
if) he's a billionaire. Senator John Kerry looked a little
too rich when he ran for president with his CEO suits
and artfully patterned ties that looked suspiciously
Ferragamo. That chic canvas country jacket with a cor-
duroy collar should never have strayed out of the horse
barn. And he should have avoided windsurfing in a wet
suit too. And the Livestrong wristband. The hand-
some, charming and rich Mr. Jon Huntsman wore plaid
shirts and checked shirts with suits and tab collars.
His denim jacket had a corduroy collar. I remember
girls talking about guys being too good looking.
That means they think he's gay. Mr. Huntsman just
appeared too good looking to be president.

Don't be fussy
What cost Mr. John Edwards the chance to run as the
Democratic candidate in the 2004 election was his
$400 haircut. I mean the very idea of paying $400 for

a haircut is alien to hard-working Americans, but
his haircut also looked as if it cost $400. And he was
very unfortunately filmed adjusting that master-
piece. When former president Mr. Bill Clinton was
running, he looked as if he paid $4 for his haircut.
Mr. Mitt Romney's hair looks professionally done. His
grey temples look almost too Hollywood to be real.
President Barack Obama's hairstyle, on the other hand,
is smart. It's the same every day. It looks as if it could
have been done on any military base in the world and
it's short enough to obviate any questions of process.
Mr. Paul Ryan has long parted his hair on the center
right, but perhaps attempting to engage the base
he moved the part farther right. At the Republican
National Committee, he even appeared to be going
for broader appeal by abandoning the once prominent
part for a shorter version of the Bieber swirl. I have
always blamed former president Mr. Jimmy Carter's
one-term presidency on an unlucky decision to switch
his part from right to left while in office. The comb-
over is also unwise as it is symbolic of dishonesty; it
was probably as damaging to former New York mayor
Mr. Rudy Giuliani as the photos of him in full blonde
wig drag.

Regularity and consistency is key
The typical politician wears two-button single-breasted
suits, button-down collars as dress shirts and plain
red or blue ties. Don't do fancy ties—they look rich
or, worse, creative. A stripe is fine, but club ties look
elitist and controversial. Don't wear a hat. While Mr.
Herman Cain had a strong moment in the Republican
campaign, that black fedora with the leather braid and
shades suggested he had a "playa" side we didn't know
about, perhaps leading to fatal questions regarding his
amorous inclinations. Hats haven't worked for anyone
since JFK sent them out of fashion a half-century ago.
(The occasional yarmulke is OK.) Also avoid putting
on a construction helmet, or a military helmet. The
latter almost single-handedly knocked Mr. Mike
Dukakis out in 1988. Sweaters are difficult. Senator
John McCain blamed his advisers for putting him
in "gay sweaters" in 2007, in the run-up to his doomed
presidential fight against President Obama. Mr. Rick

Santorum may have been held back by his frumpy sweater vests. It's probably best for politicians to avoid casual clothes as much as possible. They should always look as if they're working. To appear casual, candidates should simply take off their jackets and roll up their sleeves as if they've been working all night.

Avoid Excess

If you are a bigger guy, like Governor Chris Christie of New Jersey, wear dark colors, never take your jacket off and keep your double chin up so that it doesn't completely cover your tie knot. Beards and double breasted jackets make it look as if you have something to hide. If you absolutely must wear jeans, don't wear a relaxed fit—a mistake formerly made by both President Obama and Mr. Romney. Politicians must never look too relaxed. Avoid dad jeans or anything that looks pre-washed. Wear jeans the cowboy way, like Governor Rick Perry or former president George W. Bush, as if you were just out clearing brush: lean, snug and home washed. You must wear an American flag pin. Even President Obama had to after he said he wouldn't be forced to. Get a discreet one that looks as if there's a breeze—even the flag on the airless moon has a bit of a ripple.

GQ.com, 2012

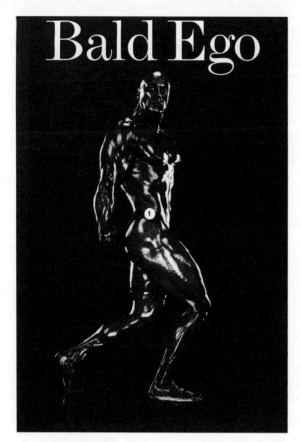

Bald Ego

Jean-Baptiste Mondino

HYPER-MASCULINITY.
WHEN YOU'RE A BOY YOU CAN WEAR A UNIFORM...

Boys like tough stuff. My kid has a Viking helmet with horns on it, a Roman style breastplate, various plastic swords, various camouflage outfits, a Red Army tank commander's helmet, a SWAT team Halloween uniform, cowboy chaps, all kinds of play clothes. I had the same kind of stuff. It's hard to grow up and leave all that fantasy behind. So some guys don't.

I used to ride a Triumph motorcycle and one Halloween when I was in college I decided to dress up like an outlaw biker. It wasn't too hard. I had Jesus length hair and a beard, and the bike had ape hanger 16" handlebars and no mufflers. It wasn't a Harley, true, but it was faster than one and stopped in a distance where on a Harley you might be dead. Anyway, I put on a cutoff Levi's jacket and had 13 embroidered on it—that stands for the 13th letter of the alphabet with which the word marijuana begins—and headed into the night. There was a dance on campus and a bunch of drunken preppy yahoos threatened me but I got away, not being drunk. It would have been awful to get beaten up by a bunch of guys in Harris tweed, wide wale corduroys and tassel loafers, looking tough as I did.

"I, Stymie...Member in good standing of the He-Man Woman Haters Club...do solemnly swear to be a he-man and hate women and not play with them or talk to them unless I have to. And especially: never fall in love. And if I do, may I die slowly and painfully and suffer for hours or until I scream bloody murder."

That was the oath of the He-Man Woman Hater's Club, an organization founded by Spanky of *The Little Rascals* in 1937. The club didn't work out that well because of the charms of the sexy six year-old Darla. I think that the idea behind the club resonated with many little boys, until of course they got older and something happened and suddenly girls, that alien race, began to interest them. But they didn't interest all males. Some men are he-man woman haters their

whole lives. Hate may be too strong a word. Sometimes hate mellows into indifference. But there is a not inconsiderable segment of manhood that has little truck with women. You might call such a fellow a man's man.

A man's man loves men. He may have women friends, but he does not love women. Such men are often misunderstood. It is widely thought that men who dig men want to be womanly. This is a popular fallacy. Often the man who digs men is extra manly. It makes sense. If you want to attract men who like men, why would want to appear feminine. Unless of course you had hopes of attracting a straight guy. I figured this out when, during the course of the Vietnam War, I was a bartender in Washington, D.C. We had a lot of gay Marines come in the bar, and they were tough guys. We also had a rather creepy segment of Pentagon guys, generals and senior officers, who would come in and drink very heavily and try to pick us up. The usual approach started with, "you've got long hair but I bet you're no fairy," and ended with them following you into the toilet. It didn't take long for me to figure out that it's not that simple.

When I was *The Little Rascals* age I actually liked girls a lot, I still do, but also loved the he-man attitude. Flagrant butchness. I don't know if girls understand the appeal. Maybe some do and some don't. I don't know if most guys really understand flagrant if not over the top masculinity but it registers with them somewhere. I don't know if America understands—this territory is bound up in invisible lines.

The traditional paradigm was that men who liked men acted like women. Guys who liked guys were supposed to be sissies. And sometimes they were. But often they most definitely do not. Sometimes they were manlier than most. Our culture was not well equipped for such complexity.

The women in my family had terrible gaydars. My grandmother's ultimate dreamboat was Tyrone Power. Her daughter, my mother, had a big crush on Merv Griffin and she was indignant when I suggested that as a woman she was just not his type. She was resentful when I informed her that Deney Terrio, who was Travolta's dance coach on Saturday Night Fever, had sued Merv, the producer of the disco show Terrio hosted, Dance Fever, for sexual harassment to the tune of $11.3 million. My grandmother liked Liberace. Everybody thought Liberace was a sissy, but my grandmother bristled at any suggestion that Liberace was unlikely to find a wife. Her official position was that he hadn't found the right girl yet. Meanwhile I could tell my grandpa, an old Navy man, thought that Clint Walker, Lee Marvin and Clint Eastwood were real men. He liked the way Clint Walker's muscles looked in that lace-up fringed buckskin shirt.

And I thought it was a shame that my grandma didn't live to see the Village People. She was a Navy veteran and she would have loved "In the Navy" and probably would have had a crush on Randy, the cowboy. But my mom and grandma weren't the only ones who didn't understand what the Village People were talking about. But

if you were actually from the Village or spent any time there (or at the YMCA) you knew where they were coming from.

Every man wants to be a macho macho man
to have the kind of body, always in demand
Jogging in the mornings, go man go
works out in the health spa, muscles glow
You can best believe that, he's a macho man
ready to get down with, anyone he can

When I moved to New York I met a different breed of tough guys from the biker dudes I knew. They were outlaw bikers with no bikes. You'd see them standing on the corner of 53rd and Third in leather jacket, white t-shirts, Levi's and biker boots. They looked like they were waiting for somebody. They were. The Ramones song "53rd and Third" explains.

Standing on the street
53rd and 3rd
I'm trying to turn a trick
53rd and 3rd
You are the one they never pick

I think maybe Dee Dee had been on that corner once or twice. It was the same sort of story that inspired Andy Warhol's *Trash*, with Joe Dallesandro as a married hustler who needs money for a fix.

When I arrived in New York you could walk over to the Hudson River and see men in black leather jackets swarming like bees over the piers and the hood around the piers, around the all-male bars and that popular spot in the Meat District

known as "the Trucks" where empty semis
and trailers provided a place where macho men
could get together in an impromptu kind of
way. Some of these guys looked really tough,
others looked tough at a distance but showed
some soft edges up close, but as a panorama,
it was quite spectacular. Hundreds of thou-
sands of men in motorcycle jackets and boots
and jeans and no motorcycles.

You can tell a macho, he has a funky walk
his western shirts and leather, always look so boss
Funky with his body, he's a king
call him Mister Eagle, dig his chains
You can best believe that, he's a macho man
likes to be the leader, he never dresses grand

Mister Eagle seemed to reference The Eagle's
Nest, which was back in the day, New York's
premiere leather bar located on a grungy corner
at 11th Avenue and 21st Street, across from the
fucked up and abandoned piers and the falling
down elevated West Side Highway, since torn
down. It looked rough and it was in its own sweet
way, with black walls and a pool table. All the
black leather gave a certain resonance to the name,
which happened to bear the same name as
Hitler's Alpine aerie. The place had opened in 1931
as the Eagle Open Kitchen, a longshoreman's
hangout. In 1970, months after the Stonewall riots
forever changed the gay bar scene, and inmates
took over the asylum from the mob, it was turned
into a leather bar.

My friend Stephen Varble, a performance artist,
took me there. You had to wear a motorcycle

jacket to get in, but Steven always carried a
spare just in case. But the only motorcycle near-
by was hanging from the ceiling. The Eagle was
crowded with guys, mostly wearing the famous
Schott jacket and Levi's. In some cases the asses
had been cut out of the Levi's. I was glad mine
hadn't because the local handshake seemed to
involve your ass. But it was a friendly place.

The leather and western guys who hung out
on the waterfront looked tough. By day a
lot of them were book editors, art directors,
or fashion designers, but by night they put
on the leather and went out looking for advent-
ure in all male territory. Lots of famous
hags tried to get into the Eagle but they were
strict. You couldn't even bring in an umbrella,
much less a woman. I liked that they had a
rigorous code and there were places women
couldn't get in. Sometimes you want to be
with the guys. I was honored when the lesbian
bar the Sahara let me in because I was with
Grace Jones, but I understood when I was turned
away at the Cubbyhole even though I was with
Fran Lebowitz. Supposedly a famous social-
ite from a political family got into the Anvil
and wound up part of the impromptu sex
show. Rumors!

The great thing about old New York was that
there was weirdness everywhere. Even if it came
to nothing, one could enjoy being cruised even
if it came to nothing. It's a compliment. I always
liked that atmosphere. I sort of felt like Al Pacino,
the undercover cop in "Cruising." He got off on
being got off on. Nothing wrong with that. Even

the discos had a manly thing going on. You'd see two guys dancing looking like lumberjacks: plaid flannel shirts, boots, jeans, keys on the belt, hankie in the back pocket, Carhart fleece hoodie and the same moustache.

The weirdest bar of all was the Toilet. It was all-male but beyond leather and beyond code. You did see leather boys there, but also guys who looked like they really did drive those trucks and they were really scary. I went there once in the late seventies. You took a freight elevator to the third floor of an industrial building in the meat district and at the door they asked if you wanted to check your clothes. You walked past a long bar decorated with rolls of toilet paper and then, if you dared, past the stage where there was a mattress and a toilet into an increasingly dark labyrinth of rooms. I don't recall there being an actual men's room there. The whole thing was a men's room.

New York's first leather bar was Keller's, which opened in 1956. The Village People were photographed in front of Keller's in an homage to its venerability. Keller's was home to guys from the New York Motorbike Club—one of many postwar gay motorcycle clubs in America. The Spike bar opened down the street from the Eagle's Nest at 120 11th Avenue in 1972, with a similar if not identical clientele to the Eagle's Nest. What good was cruising if there was only one place to go? There was a whole scene and it was visually spectacular. But then sadly it was gone when the epidemic arrived, and it never really came back the way it was.

But it did come back. There will always be a
need to dress up for a dream. The Eagle's Nest
re-emerged as The Eagle in a new location.
It's filled with guys who look like the grandsons
of the characters drawn by Tom of Finland.
Muscles, moustaches and leather. You'll see the
old-fashioned Muir Cap, like the one Marlon
Brando wore in *The Wild One*. The new Eagle
has a dress code that is strictly enforced.

Footwear: Leather or rubber boots
Pants: Leather, rubber, uniform, jeans, S/M, jocks
Torso: leather, rubber, uniform, harnesses, vests,
armbands, collars, wristbands, etc. or nothing
Accessories: braces, caps, belts, tattoos, piercing.

Like David Bowie sang:
When you're a boy
You can wear a uniform
When you're a boy
Other boys check you out...

It's not just what to wear, but what not to wear:
"No cologne, sneakers, sandals, dress shoes, dress
shirts, khakis, suits, shorts (other than leather).
The doorman's decision is final."

I like a place with a dress code. I miss restaurants
requiring jackets and ties and I also like places
where ties are banned. The most amusing code
was that of Jackie 60, the meat district club
operated by Johnny Dynell and Chi Chi Valenti.
"Approved are leather, rubber, PVC, glam drag,
full evening, Victorian and Edwardian, jockstraps,
Gothic drag, cyber-wear, religious garb and
pagan robes, Jackie t-shirts and flannels, military

drag & uniforms, traveler garb (burlap), tattoos, scars & piercings, butch drag for women. Absolutely NO fur coats, NO suits, ties, dress pants or jackets for MEN. No rugby shirts or rugby players. No droop drag and no banjy clichés. And as always no ski wear. Legends know no code."

As a Jackie legend I would show up in suit and tie with impunity, but I recall one evening in the very same shady neighborhood trying to go for a drink at the Anvil with John Waters—we were both wearing jackets and ties—and we were turned away at the door. "I'm sorry gentleman," they said to John Waters (and me) "this is a gay bar." Good for them!

You don't have to have sex with men to want to wear leather and studs and hang out with men and without women. You could just be a heavy metal fan. Think of the arenas filled with guys watching the macho strutting of black leather dressed dudes, what are those fans thinking? Maybe they're not really thinking, just roaring and flipping their Bics at the stage. There's a certain undertone to the whole thing. Rob Halford of Judas Priest has been out for ages, and the German band Accept sang about the Leather boys of London, but mostly that scene is hormonal headbanging. What do you expect?

For thousands of years our ancestors went around in armies, all bound up in leather and metal, fighting for turf, doing a little raping, burning and pillaging. It was a guy thing. If, pre-battle you managed to scare the opponents

by the way you looked, so much the better. You put on your Visigoth shit or stripped naked and painted yourself blue. You just don't lose those instincts overnight. Feeling tough makes you feel like a man.

It's fun to see somebody living the dream. I'm always happy when I run into Peter Marino, the architect. For years he went around in Armani suits, then one day he decided that he was going to dress exactly the way he likes and he put on his boots, leather pants, motorcycle jacket, armbands, wristbands, studded gloves and Muir Cap and he went about his business. It's a good way to show them who's the boss.

Man About Town, 2013

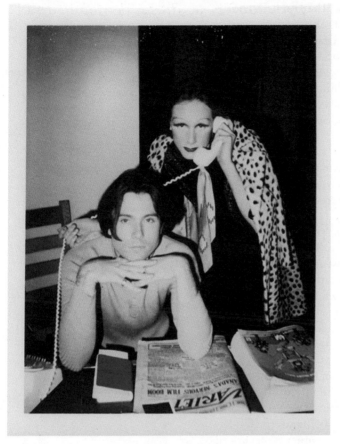

Unknown

I WAS A MALE FAG HAG (OR PICKING UP CHICKS THROUGH DISINTEREST)

You wouldn't believe how often young fellows seek me out, pale, trembling, a pleading look in their downcast eyes, and usually they say to me, "Sir, (or sometimes the rather embarrassing Master), how do we score with today's chicks?"

"Do you mean, my son," I invariably reply, "how do you succeed with today's young women? How do we make the ladies swoon into our well toned arms? How do we get the woman of our dreams to wake us up ringing our doorbell?"

"Yes! Yes! Yes!" they reply in chorus, quite overeagerly, as this is obviously a horrifyingly perplexing problem for these randy young men, jocks and nerds alike, so I continue: "How do you balance the crucial issues of feminism, sensitivity, and trust with the age-old issues of hormonal secretion and seduction?"

"Yeah, that's the ticket," they bellow as one.

"Well, that's complicated," I reply. "How complicated are you willing to get?"

"We'll do anything," they squeal, wriggling.

"Well, then maybe I can help you, boys," I reply gruffly, flopping my wrist in a defiantly limp posture. "All you have to do is to understand the enormous appeal that homosexual men have for today's heterosexual woman. I'm going to teach you how to be gay heterosexuals. Do you know what the word gay means, soldier?" While he's still hemming and hawing I give it to him straight. "It means 'full of or disposed to joy and mirth'! It means light-hearted, exuberantly cheerful, sportive and merry. It means offhand, for God's sake! In the sixteenth century it meant brilliant, attractive, excellent, fine!

"I'm going to teach you how to feign disinterest. I'm going to teach you to simulate good breeding and exquisite manners. Ladies, I'm going to teach you how to be gay in the old sense of the word. I'm going to teach you how to comport yourselves on the verge of the effeminate when necessary. Because, men, when the going gets tough, the tough give each other a big hug."

They faint. I throw a pitcher of cold Belgian beer on them, and when they come to, my story begins. It goes something like this:

I think it started back in elementary school. I was hanging around with

sissies. I hung out with guys too. I played sports. I liked girls. But I had friends who were definitely sissies. We had things in common. We liked to draw. We liked to go shopping with our mothers. When a macho kid called one of my sensitive homeboys a fairy or a fag I felt embarrassed, not just for the nominee but for everyone. We didn't have Apple to teach us back then, but still I liked the "think different" types.

Ernie Kovacs had a great character on his TV show called Percy Dovetonsils, a mincing dandified critic of just about everything. I loved him. I dug Clifton Webb, especially as the evil poison pen artist Waldo Lydecker in "Laura." I didn't know what it was, but I loved dandyism and foppishness. Percy and Waldo began my journey toward getting in touch with my inner outlandishly sensitive side.

I think my mother suspected. I had talent. I spent hours drawing. But something was up. By the time I was a senior in high school I had guilt feelings. I liked Oscar Wilde. Allen Ginsberg was gay. William Burroughs was gay. Jack Kerouac dabbled. What about Rimbaud? What was wrong with me. I wasn't gay. And I was head of the art club!

Things were better in college. My gay friends accepted me for what I was. I was still able to edit the literary magazine and write poetry. Then I moved to New York to go to grad school. I did what any self-respecting heterosexual bohemian would do. I got a job painting needlepoint canvases. I was married. My best friend, gay and out, said that the problems in my marriage could be solved by me getting a boyfriend and my wife getting a girlfriend, but that didn't work. Somehow we got it wrong and she got boyfriends and I got girlfriends. And then my gay friend, my wife and I moved up out of the needlepoint world—we got jobs working at Andy Warhol's

Factory—a move we considered roughly
equivalent to ascent into heaven.

This is where I discovered the terrible
truth. The best place to land the most beau-
tiful women in the world is in the company
of homosexual men. Every night we went
to the best parties, proud members of the
world's greatest and most notorious entou-
rage. Everywhere Andy went we all went.
Usually we would wind up dancing at a
club. The clubs we went to were basically gay
discos but they were integrated in a way
that no longer exists as far as I know. We were
a weird posse of gay and straight guys and
straight girls with wandering tendencies. All
the most beautiful girls loved going to the
boy bars because they had the best music and
they didn't have to worry about overeager
and uncivilized hetero idiots hitting on them
constantly. They only had to worry about
us, the handsome infiltrators, the lavender
pimpernels. But we didn't worry them that
much. They could handle us. And occasion-
ally they liked to.

The clubs were truly great. It was mostly
guys and guys but if you were fabulous you
were welcome. We used to go to a club near
the United Nations called Stage 45 which
was mostly young black boys and the men
who liked them. I remember how amazed
I felt walking in there one night with Andy,
Halston, the great Italian director Luchino
Visconti, four or five girl superstars, two
guys wearing a lot of makeup and Candy
Darling, the world's greatest drag queen.
Warhol, Visconti and Halston eyed the
black boys dancing to "I'll Always Love My
Mama," and I eyed Donna Jordan, Patti
D'Arbanville, and Jane Forth, the models
who hung out with Andy. Donna was a
great beauty and always rude, which I found
unbelievably sexy. I was always plotting to
get Patti but she seemed more interested in
my wife. A few years later Patti was dating

Don Johnson. I ran into them in another gay dance club. Don, who was not yet a Miami Vice cop on TV, offered me a line which I politely accepted. An hour later I was home trying to count to ten. I still don't know how he did that dust. Those were wild times.

Of course, being a good-looking young guy in a club filled with gay men you're going to get attention and we did and we liked it. I have always liked attracting everyone, within reason. (Probably because I have never spent much quality time in jail.) Anyway, I never minded getting hit on or asked if I was a model or was with the Australian Ballet. It was cool. Everybody danced with everybody. I didn't feel threatened by dancing with Helmut Berger. I didn't mind it when the appalled natives of Barbados thought I was holding hands with a boy. It was Grace Jones.

One night I was sitting at a very wild and fun dance club called Tamburlaine and my friend who was the Factory video guy, a handsome guy with long hair and another practicing hetero, started holding my hand. I thought he was drunk. Later I realized he was just trying to pick up Tuesday Weld who was sitting next to us. It was a period of mixed up messages. Another night we went with our wives to a swinging couples club called Captain Kidd's Treasure Room. A couple guys asked the wives to dance. The girls denied knowing us and their dancing partners said, "Yeah, they come in here all the time. They're fags. Why don't you dump them and come to a party with us...in Staten Island."

I think the real beginning of disco happened in those gay men's dance clubs in New York, places like Tamburlaine, Stage 45, Nepenthe, Sanctuary (an old church painted purple), Le Jardin. They played an incredible mix of Motown, Philadelphia International and proto-funk: Marvin

Gaye's "What's Going On," the Spinners, the O'Jays, James Brown, Aretha Franklin. The best dancers gay or straight, male or female, wanted to be there. Everybody was friendly and if you were cool and looked good you could come in. A few years later the scene would change and clubs would keep straights out. I remember showing up at the front door of the Anvil one night with John Waters. We were both wearing suits and ties. John had his little pencil moustache. The doorman looked at us and said, "I'm sorry gentlemen, this is a gay bar." John chuckled for hours.

The greatest womanizer I ever knew was a good pal of mine. He was a hairdresser, which you might consider being a heterosexual in a homosexual profession. He was, at his peak, the most successful hairdresser in New York, financially and heterosexually. Actually, hairdressing is more integrated than most people think. But my friend was the *Shampoo* character come to real life. He loved women and never tired of trying to make a new "friend." I was awed by this guy. To know what it is you really like and then do what it takes to have it. He was surrounded by beautiful models, beautiful rich ladies, beautiful receptionists.

I would go visit him and I'd say, "Hey, that new makeup artist is really gorgeous." His eyes would twinkle. "You like her? She is eighteen," he'd say in his amused French accent, picking up the phone. "Could you please send Wendy into my office." And there she was. He let her stand there for a moment to put her on the spot, then introduced me. It was like shopping for girls. And, like in *Shampoo*, he had the perfect cover. What man would ever suspect his wife of sleeping with her hairdresser? He was a genius. He took his fantasy all the way. Then he gave up hair and womanizing and became an artist.

Today he lives alone in a sparsely furnished small apartment and takes beautiful Zen photos for his own pleasure. Just because Fitzgerald didn't have a second act doesn't mean other American lives don't have them. I saw my friend go from a cad to a Buddha.

Gore Vidal, who once spent a night with Jack Kerouac, the aggro-hetero heartthrob of every bohemian chick of his time, says there's no such thing as a heterosexual or a homosexual. I think that just this once Gore Vidal is wrong. I think there are homosexuals and heterosexuals and just plain sexuals. Sexuality is a broad spectrum, but it has some major wavelengths on it. To have ultra-modern sexuality is to have stealth sexuality. You have those girls sleeping with you before they see it coming.

For me one of the greatest events in modern American History was when the elegant and droll Vidal called the fairly nelly William Buckley a crypto-fascist on the live TV coverage of the 1968 Democratic Convention. The arch, aristocratic facade trembled; Buckley's lunar complexion turned deep mauve and he started sputtering as if his aorta were about to implode. "You...you...you..." he stuttered. "You...fag!"

You fag! It was, apparently, the worst thing the twitchy, tic ridden Buckley could think of. Fag, faggot, such terms of contempt. "It takes one to know one," would have been Pee-wee Herman's reply. Fag doesn't just mean homosexual—it's a constellation of louche, outré qualities. (Pardon my French, boys.)

I called the famous fashion designer Halston a faggot once. He yelled at me for wrinkling a fashion sketch by hubris-packed illustrator Joe Eula. He acted like I had wrinkled a Michelangelo. Wrinkling was too good for it. And he yelled at me like a messenger when in fact I was the brilliant young editor of *Interview*. I lost my composure and called

him an old faggot. When I got back to the
Factory I told Andy Warhol what I'd said. For
a microsecond I thought he looked angry. I'm
sure faggot was a word that had been directed
his way quite a few times. I felt really guilty.
I should have called Halston an asshole. He
was an asshole. Or an old queen. Ditto.

But there's no other way to say it. I have
always liked fags. I would much rather hang
out with a bunch of fags than a bunch of
hockey fans, by a long shot. I would much
rather watch Stephen Fry as Oscar Wilde
than the Stanley Cup Finals. I don't know
why exactly. It might have something to do
with culture, or it might be genetic. My
grandmother adored Liberace and my mother
was crushed when she found out about
Merv. But the thing is I like fags, not just
plain homos. That is, perhaps there was
something acquired in the closet that may
be threatened by liberation. A lot of gay
people aren't very gay anymore. Gay was
always a bad choice of words, but now it's
becoming positively ironic around lesbian
storm troopers and double husband mar-
rieds. I like the culture of the closet—the
subtlety, the refinement, the innuendo.

So many shades of mauve, so many great
words for queer and the many varieties of
the epicene: swish, pansy, she-male, nelly, dirt
farmer, fudge packer, fruitcake, dinge queen,
chicken hawk, manhole inspector, nancy boy,
rent boy, rimadonna, butch, closet queen,
leather boy, midnight cowboy, Mary...

I like the way Andy liked to put it.
"I think he's got a problem."

But one man's problem is another man's
opportunity. Straight women love gay men.
They're always trying to convert them. To
study this phenomenon observe the Seinfeld
episode where Elaine tries to recruit one
over to our team, despite Jerry's warnings
that it's virtually impossible because they
like their team's equipment.

What did women love about Cary Grant (who by most accounts came around to women in his declining years)? He was charming. He was not threatening. He radiated honor and loyalty. And, of course, he knew how to dress.

When you've lived in New York as long as I have (which makes you fairly old) there's one thing that you're used to hearing from women: "Why are all the great single men gay?" Well, this never was true. And it's even less true today, now that a lot of the great single men have become life partners with one another. But the fact is that there are a lot of things that women like about gay men. They have a lot of subject matter in common. Although more and more of my gay friends can name at least three of the New York Knicks (Patrick Ewing and two good looking ones), gay men are not in general obsessed with sports. (Gay women are obsessed with sports.) Gay men, in general, think your breasts are fine just the way God made them. Gay men have no particular reason to lie to women, unless it's to spare their feeling about their new hairdo or what they're wearing.

Maybe I'm a straight fag because I have certain qualities, in addition to a raging hormonal attraction to vixens. There's no way to hide it, I am incredibly well dressed. My wardrobe is enormous. When I emerge, it's a spectacle of subtlety. I have a lot of close personal women friends. We have a lot of things to talk about. I think the new Prada looks like Miu Miu and I think it's a disaster what they've done to *Glamour* magazine. I don't have any secret agendas in their regard. (Either that, or I can wait for them to make the first move.) They can trust me just like one of the girls. I won't steal their boyfriend (although I might diss him now and then. Hint, hint.). I know a lot about fashion. ("Wear the mules, baby, you've got sexy heels.") And in real life I sell billions of dollars worth of fashion,

perfume, and beauty products in my spare
time. I can speak their language because
I wrote it, girlfriend. I can style the bitch.
I can even do her hair and makeup in a
pinch. And this is why I have slept with
the greatest female minds (not to mention
bods) of my generation (and probably yours
too son), whom I met at dawn, stalking
the angry Negro streets looking for a nice
hetero boyfriend. I may have slept with
your mother and your girlfriend, Jim.

Luckily, I'm not a womanizer anymore.
I'm married and brilliantly so. (And I must
say, so far marriage seems almost as attractive
an obstacle to females on the lookout as
apparent inversion!) My wife is a beautiful
heterosexual female fag and together we can
do the dance routine from Saturday Night
Fever or redesign your fall collection. But I
can't help my cloaked hormones, I still like to
watch the girls, the beauties, the miracles of
nature and grooming, and so I'm very happy
to live in fashion land near the border of the
art world. I'm comfy at the fashion shows (if
I'm no farther back than the third row). I still
love my sissy friends, kiss kiss, but the world
is changing. A lot of them can tell you who
starts for the Knicks now. My wife's maid
of honor was her hairdresser (male). And at
my house everybody wears the pants and
brings home bacon.

Hey, I'm just a modern guy. I've had it
in the ear before. I've got a lust for life. So
what can I say. I can box out on the basketball
court, but I can gift wrap too. I golf from the
back tees but I make the risotto in my house.
The divisions of labor, they are a-changing.
I am not what my ancestors had in mind, but
on the reproductive front I am getting the
job done. I am evolution. I am the new man.
Hear me roar: We're here, we're sometimes
mistaken for queer, get used to it.

Paper Magazine, 2001

Make content that cannot be contained.

Tweet, 11 May 2014

BETTER LIVING?
HERE'S HOW TO DO IT.

I don't need no Martha
Stewart nor Deepak Chopra
to tell me how to live my
life, but then again I can semi-
dig where they're coming
from, because living is an
art, and sometimes you need
a guru to point you toward
Mecca or Nirvana or Mount
Olympus or Sherry Lehman.
I've had my share of gurus
in the art of living (Frank
Sinatra, Robert Benchley,
Miles Davis, Fred Hughes,
Keith Sonnier, eg.) but by
now I have attained perfect
mastery myself, and so
I'm passing along a few tips
for your consideration.

It's always better to be over-
dressed than underdressed
for an occasion. It will appear
that you are going some-
where better later.

Drink champagne. If you have
only one thing in the refriger-
ator it should be champagne.
(And then butter.) You'll be
ready to celebrate or seduce
at all times. And if you don't
drink anything else you'll
never get a hangover. And if
it's too expensive then you're
probably drinking too much
anyway. Cut down and make
it bubbles.

Vinyl. Collect 33 1/3 long play-
ing records. They sound good
and the sleeves look great
lying around the pad.
Take that Cohiba label off

that cigar. Unless, of course, you're going to stick it up your ass.

Expensive sheets. Better than furniture, baby. Porthault turned my life around. That high thread count will keep your bed crowded.

On a budget? Forget those $7 bottles of Pellegrino and Evian in restaurants and drink from our excellent New York City supply. It's in your coffee and soup anyway.

Answer the phone "Studio." Everyone will think you're an artist.

Don't give too many people your cell phone number. Get a beeper and screen.

If you order white wine in a restaurant and it's not cold enough, dump the contents of a salt shaker into the ice bucket and mix well.

Read the tabloids before you read the *Times*. It's a more natural transition from the dream state to full wakefulness.

Don't be afraid to ask the dentist for painkillers. There is no nobility in suffering and there are ten thousand dentists in the naked city.

Don't buy stocks, buy good stuff. You can't sit on, drive, wear or flaunt stocks and bonds. Some Japanese bank goes boom and the market crashes. But a '59 Cadillac Eldorado Seville will never go down in value and you can drive it to the bank looking good.

Black tie means you have to wear a tie. Duh.

If you want a good dog, go to the pound. Mutts are the true aristocrats of the canine gene pool, representing the nobility of natural selection.

Artists are the real saints. You can never know enough about Duke Ellington.

Don't lie. Say what you think and smile. Be ruthless and affectionate. Let them think you're being ironic. Speak the truth and beam.

When you eat a big meat sandwich, eat a pickle. It's the antidote.

Make your bed when you get up. It gives you more of a will to live.

Have nice stationery and write thank you notes at every opportunity. Thanks for the gift, for the meal, for the appointment, for the shag, etc...Thank you for letting me be myself again. Flattery may get you somewhere. Gratitude will get you everywhere.

Consume ethically. When it comes to athletic footwear, don't believe the hype. Kathie Lee Gifford took the rap for Nike. Philosophers don't run sweat shops. Buy American. Buy New Balance and Converse.

Take your son to work on "take your daughter to work day."

Don't just read your own horoscope in the paper, read all twelve, that way you'll know who to watch out for.

When travelling always try to carry everything on the plane, saving maybe an hour, maybe your wardrobe. The worst that can happen is you'll have to check it at the gate. Last luggage on, first luggage off.

If you find yourself having too many hangovers but you don't feel ready for AA, try drinking something you don't like. If the vodka goes down too easy, try a nice expensive single malt scotch with a difficult to pronounce name.

Watching network television is decadent. Get up a regular card game at least once a week to expand your interaction with other humans. ER is degeneracy. Contract Bridge is civilization. Have you Scrabbled™ lately? It's a rush.

Get a china pattern and publicize it. This will give your tasteless parents, relatives and friends something to give you for birthdays and holidays that can't fail.

Revenge should be savored.
Revenge should be fun.
Don't get all hot under the
collar and antsy. Just wait
for your moment, even if it
takes a lifetime.

Be beautiful and be loveable.
By any means necessary.
The forces of love, humor and
gorgeousness may appear
ruthless at times, but look at
what we're up against.

Paper Magazine, 1998

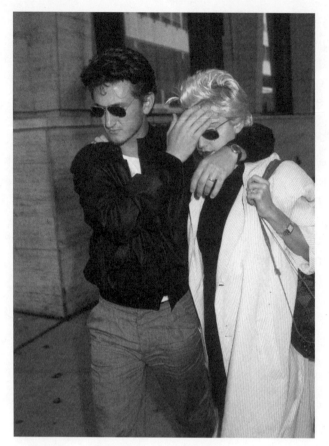

Ron Galella

HOW TO AVOID FAME

Do you want to be followed by paparazzi?
Paparazzi in recklessly driven autos stalking
you to your favorite bistro? Do you want to
have a helicopter hovering over your wedding?
Do you want you and your significant other
referred to with a combination name by the
tabloids? (As in Bennifer, Brangelina, Tom-
kat?) Do you want groupies hiding in your
shrubbery, bursting out and strobing you to
test the resilience of your coronary arteries?

Is the notoriety worth it? Really?

Do you want to worry about your wine glass being stolen so you can be cloned from your DNA? Do you want your wine glass photographed after you get out of rehab? Do you want every ugly detail of your horrendous divorce recounted in the tabloids and commented on by Cindy Adams and Andrea Peyser? Do you want every unintentional kiss of the wrong person or slip on a banana peel or medication reported in Page Six, or worse, if there is worse?

Are you sure?

Do you want your sexual preferences questioned on South Park? Do you want that casual one-night stand to be attempting conception? Do you want pictures in the paper of you screaming at your kids? Do you want the price of everything jacked up? Do you want everyone in every restaurant staring at you and the spinach in your teeth? Do you want to be followed into the bathroom by autograph seekers? Do you want that fourteen percent tip in the newspaper? Do you want to be a plus fifteen instead of one? I thought not.

Fame makes a few things better. But it makes most things far, far worse. Like your chances of being approved by the co-op board, getting those expensive or illicit items through customs, getting a real stock tip, having a dinner with a person who is not actually your spouse, getting your kids into particularly discreet schools or yourself into a low-key country club, being discovered using controversial prescriptions or even the ones everyone else takes like Viagra or Valium, making a slip of the pencil on your income tax? Death. Any rudeness or unkindness is magnified tenfold. Every sub-par gratuity or grumpy retort is national news. Lies that are told about you will tend to be given credence, simply because it makes good copy in the newspaper. But above all, most of the people

who read about you and are jealous of your
beauty, your talent and your good fortune
will all be rooting for your utter ruin: your
impoverishment, physical debilitation,
incarceration and most likely, your painful,
ignominious death and utter oblivion to
future generations.

I know it would be easy to give in and
become a household name, but don't. Find
a nice comfy niche in the lower ranks of
notoriety and stay there. I have.

Rule number one is: Avoid having your
name in the newspaper. At the beginning
of the age of publicity it was said that ladies
and gentleman had their names in the news-
paper three times: once when they were born,
once when they were married, and once
when they died. Of course in the information
age this is impractical and one should make
allowances for at least two or three marriages
and the appropriate number of divorces.
And we can make allowances for one or
two indictments.

How do you avoid the newspaper?
Never respond to requests for quotations or
comments, even though you are eminently
qualified to do so and have something
intelligent to say while others around you are
blithering. "No comment!" is pretentious,
and worse likely to be noted. Simply become
incoherent: "Well I suppose that given the
circumstances...I mean...anyway you look
at it...there are bound to be...well... that all
depends...who can say really..."

The best defense against fame is to act as
a famous person would never act. Insanity is
no safety net, as celebrity often behave irratio-
nally. Humility will throw celebrity chasers
off the scent every time. And intellectual
behavior is a sure sign that you are nobody.
Quote Chomsky, Lacan, Baudrillard, and, if
you're desperate, Henry James.

If you do get approached by paparazzi,
no need to hold a newspaper in front of your

eyes as in a perp walk situation, simply close
your eyes. They'll never use the blink shot.
If you are going to be riding in a car, always
wear underwear. Always give the wrong name
to the photographer who took your picture
and make it a generic name like John Smith
or Juan Sanchez. Many things may be written
about you, but due to certain loopholes in
the system, most publications still insist on
publishing facts and so when the fact checkers
call remember: deny everything. Usually fact
checkers are young people, little skilled in
deception and they take no greater pleasure
than deleting passages from a writer's account
of things. Remember: You didn't say it, that
was somebody else, you were somewhere else
entirely at the time, you never heard of the
person quoting you and in fact you are one
of triplets.

Certain professions should be studiously
avoided: big time criminal law, politics, usury,
slumlording. Show business careers are not
necessarily out of the question but film acting
and the hip hop industry are inadvisable
choices. Mime, string quartets, Shakespeare
and all forms of dance except lap are fairly
safe. Academics are safe. Becoming a poet,
novelist, or jazz musician almost ensures a
safe degree of anonymity. If you must write,
slug it fiction or risk the wrath of Oprah. Be
an essayist. No one will know who you are.

But if you have achieved something of
note or significance, simply credit others.
People will think that you are insane and
therefore uninteresting, which is a condition
of complete safety.

In most cases, thinking stealthily is
the key. Look at our bombers. They are
stealth bombers. Their edge is not speed or
power but going undetected. Do they want
to be famous? Certainly not. Anonymity
is a strategy. Develop a set of nicknames
for yourself and your friends. Talk in code
like the fellows in that imaginary group the

Cosa Nostra. Never say anything that could be understood by an eavesdropper. Do not participate in alumni associations or attend reunions. If your spouse is threatening to become famous adopt another name or change the spelling of yours.

The key to freedom is being invisible. William Burroughs who managed to be famous while being generally unrecognizable, said the key to invisibility is seeing the other person first. Burroughs became famous in his old age, and when he was famous he moved to Kansas to make sure that he would never be recognized, as those who knew him were on either coast. Johnny Carson always vacationed in Europe where he was virtually unknown.

Should you happen to be a real estate developer do not put your name on your buildings. Even if you are not a real estate developer do not own a model agency, or put out a bottled water or vodka.

If you become a blogger or participate in Internet chat, don't use your real name. Do not attempt to meet people on the Internet, even if they claim to be over 18. Avoid professions where a vow of chastity and/or poverty is required unless you can keep it.

Safe things to pursue: philosophy, stamp collecting, birdwatching, numismatics, and sports like curling or croquet.

The truth is for your friend, and sometimes it's hard to tell who they are. If you become famous the incentives to betray you are multiplied exponentially. Information should be give out on a need to know basis; tell them what you need them to know. I remember going out with Jean-Michel Basquiat right before he became unavoidably famous. When approached by people intrigued by his appearance and asked what he did he would reply "I'm the manager of a McDonalds." A perfect conversation stopper.

Discretion is said to be the better part of valor. The better part of discretion is candor, and/or modesty, the sure sign of a regular person and a non-celebrity. To avoid fame always attempt to tell the truth, exhibit impeccable manners and care about those less fortunate. Relevance is your ticket out of the limelight. "Why is irrelevancy so often taken for profundity?" said Fairfield Porter. Avoid irrelevancy at all costs. Ask tough questions. Be sincere and earnest. Know the facts. You will usually scare away those who would put you in jeopardy through their gratuitous glorification of you.

If you feel the temptation to do something idealistic or charitable, for God's sake keep it under your hat. Make anonymous donations and avoid charity balls and auctions.

Many celebrities talk about keeping it real. This is a tip-off that you should never keep it blatantly real. Always leaving them guessing. Bono may be real and relevant, and he's famous for that. It's unlikely anyone else can get away with it. If you must be an upright, honorable person and idealistic person, don't let on.

But don't take my word for it. I could be lying.

Bergdorf Goodman Magazine, 2007

181 KATE SIMON
William S. Burroughs, Shooting Practice,
September, 1987, at Fred Aldrich's farm, just
outside of Lawrence, Kansas, where William
Burroughs lived from 1981 until his passing
on August 2,1997
Image © Kate Simon

209 JESSE FROHMAN
Kurt Cobain, 1993
Image © Jesse Frohman

215 BOB COLACELLO
Studio 54, 1977-1982
Images © Bob Colacello

218 BOB COLACELLO
Studio 54, 1977-1982
Images © Bob Colacello

221 KATE SIMON
John Lydon, in repose, February, 1978,
at Hellshire Beach, Jamaica
Image © Kate Simon

230 HOOMAN MAJD
Glenn DJing, early 2000's
Image © Hooman Majd

241 LYNN GOLDSMITH
Miles Davis, 1989
Image © Lynn Goldsmith

264 RICHARD PRINCE
Untitled (Publicity), 2007
Image copyright Richard Prince

272 OLIVIER ZAHM,
 GLENN O'BRIEN
Film Still, Tea at the Beatrice with
Glenn O'Brien

273 MARIPOL
Polarold, Debbie Harry
Polaroid, Grace Jones
Image © Maripol

280 GEORGE DUBOSE
Biggie Smalls wearing Dapper Dan
Image © George DuBose

288 WAYNE MASER
Guigaro, 2000
Image © Wayne Maser

298 COVER, BALD EGO
 ISSUE 1, 2003
Photograph Jean Baptiste Mondino, 1999
Image © Jean Baptiste Mondino

309 UNKNOWN PHOTOGRAPHER
Polaroid, Glenn O'Brien and Sylvia Thin at
the Warhol Factory, circa 1974

324 RON GALELLA
Sean Penn and Madonna, 1989
Image © Ron Galella

Back Cover ANDREAS LAZLO KONRATH
Glenn O'Brien, 2014
Image © Andreas Lazlo Konrath

My husband Glenn did many things well, but he loved being a writer more than anything else. He was always grateful to have an audience, and of course editors and publishers who believed in him. I know he would want me to thank the people who published the words in this book and a few more, including Leonard Abrams, Mallory Andrews, Sardar Biglari, Andy Comer, Cecelia Dean, Brendan Dugan, Jefferson Hack, Michael Hainey, Kim Hastreiter, Ashley Heath, David Hershkovits, Gael Love, Christine Muhlke, Sophia Neophitou, Louise Neri, Jonathan Newhouse, André Saraiva, Alex Stipanovich, Shelley Wanger, Olivier Zahm, and in memoriam "the boss" Andy Warhol. Forgive me if I have forgotten anyone.

Thank you to the photographers and artists and other people who have contributed images, including Edo Bertoglio, Bob Colacello, Jean-Philippe Delhomme, George DuBose, Todd Eberle, Vincent Fremont, Jesse Frohman, Ron Galella, Nan Goldin, Lynn Goldsmith, Bobby Grossman, Sarah Hoover, Andreas Lazlo Konrath, Ari Marcopoulos, Maripol, Wayne Maser, Jean Baptiste Mondino, James Nares, Nick and Lucy Poe, Richard Prince, Walter Robinson, Stephen Shore, Kate Simon, Andy Spade, Christopher Wool.

Special thanks to Michael Zilkha, Hooman Majd, and Anne Kennedy.

— Gina Nanni O'Brien